THE LOOTING OF THE IRAQ MUSEUM, BAGHDAD

THE LOOTING OF THE IRAQ MUSEUM, BAGHDAD

THE LOST LEGACY OF ANCIENT MESOPOTAMIA

Edited by Milbry Polk and Angela M. H. Schuster

HARRY N. ABRAMS, INC., PUBLISHERS

A BOOK LABORATORY®BOOK

Project Managers
Book Laboratory: Manuela Dunn
Harry N. Abrams: Christopher Sweet
Cover and Interior Design: Victoria Pohlmann
Production Manager: Jane Searle

Library of Congress Cataloging-in-Publication Data

The looting of the Iraq Museum, Baghdad : the lost treasures of ancient Mesopotamia / edited by Milbry Polk and Angela M. H. Schuster.
 p. cm.
 Includes bibliographical references and index.
 ISBN 0–8109–5872–4 (hardcover: alk. paper)
 1. Iraq War, 2003—Destruction and pillage. 2. Archaeological thefts—Iraq. 3. Iraq—Antiquities. 4. Matòhaf al-'Iràaqài.
 I. Polk, Milbry. II. Schuster, Angela M. H.

 DS79.76.L66 2005
 935'.0074'56747—dc22

2004023525

Harry N. Abrams, Inc.
100 Fifth Avenue
New York, N.Y. 10011
www.abramsbooks.com

Abrams is a subsidiary of

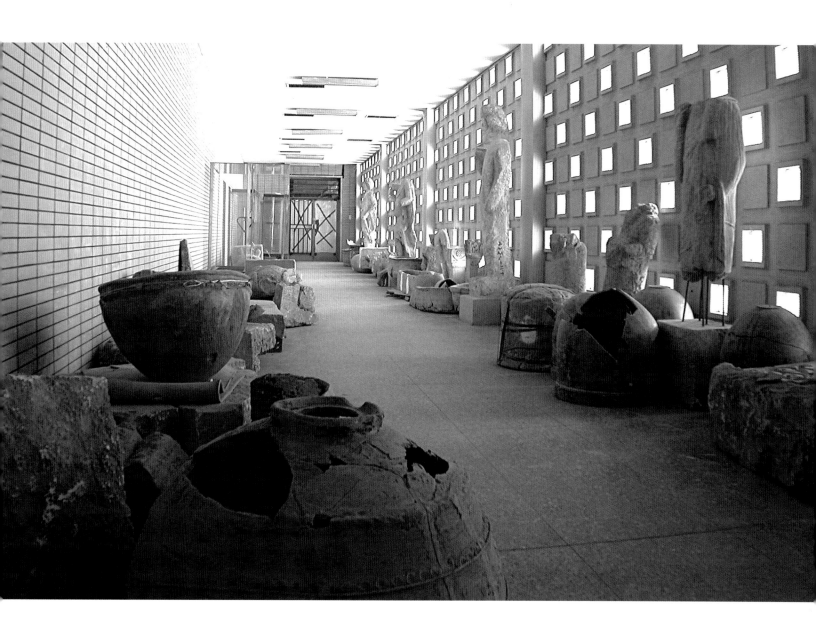

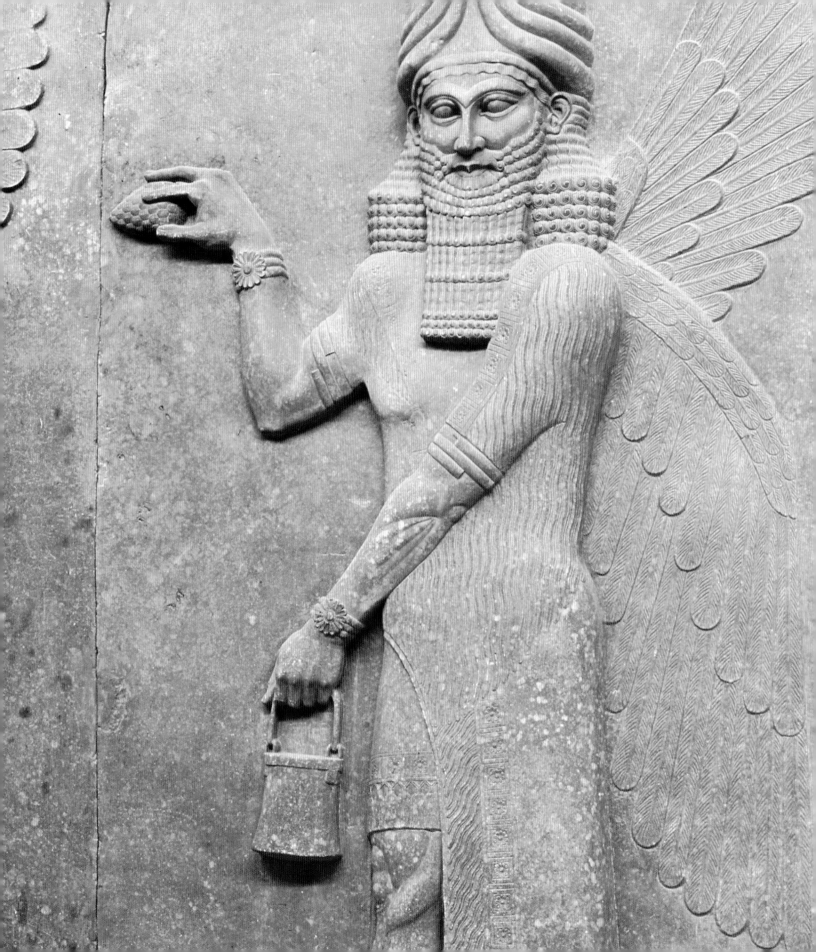

CONTENTS

TIMELINE OF ANCIENT MESOPOTAMIA

60,000 B.C.–1800 B.C.

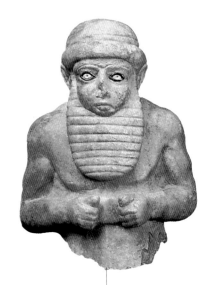

60,000–46,000 B.C.	10,600 B.C.	8000 B.C.	5500 B.C.	5000 B.C.	3500–3000 B.C.	3000–2900 B.C.
Shanidar Neanderthal burials	Proto-neolithic Shanidar	Early farming community at Nemrik	Samarra period	Ubaid period begins	Towns like Uruk grow into cities	Cuneiform signs used to write Sumerian

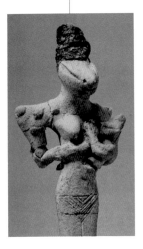

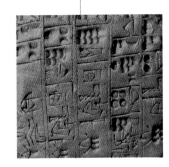

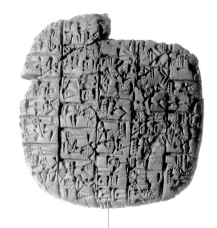

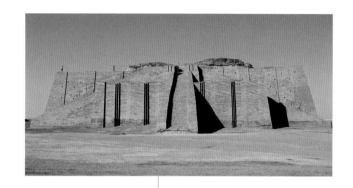

2800 B.C.	2600 B.C.	2500 B.C.	2300 B.C.	2100 B.C.	2000 B.C.	1800 B.C.
Cities ruled by kings like Gilgamesh	Literary texts written	Royal tombs of Ur	Mesopotamia united by kings of Agade	Ur becomes capital of the new empire	Ur destroyed by Elamites	Hammurabi of Babylon dominates Mesopotamia

TIMELINE OF ANCIENT MESOPOTAMIA

1500 B.C.–A.D. 1900

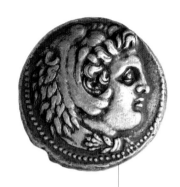

1500 B.C.	1300 B.C.	900 B.C.	700 B.C.	600 B.C.	300 B.C.	200 B.C.
Kassite kings rule Babylonia	Assyria becomes a major power	Nimrud established as Assyria's capital	Assyrian Empire stretches from Egypt to Iran	Babylon conquers Assyria	Seleucid Empire established	Parthian Empire established

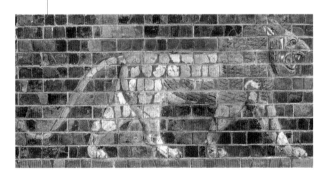

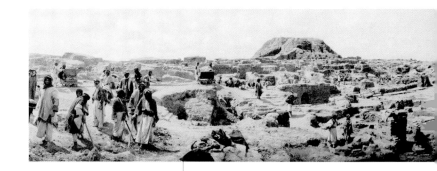

A.D. 200	A.D. 650	A.D. 750	A.D. 1250	A.D. 1500	A.D. 1800	A.D. 1900
Sasanian Empire established	Islamic conquest	Abbasid Dynasty established in Baghdad	Baghdad destroyed by Mongols	Ottoman Empire established	First excavations in Mesopotamia	Countries of Iraq and Syria founded

Preface

Within a month of the American invasion of Iraq in March 2003, people around the globe and from all walks of life were stunned by the news of the systematic looting and wanton destruction of the Iraq Museum in Baghdad, one of the world's great repositories of Western civilization. Within its vaults and display cases were artifacts chronicling more than 60,000 years of history; not just Iraqi history, but human history, our history.

Like so many, we desperately wanted to respond, but how? Then, one beautiful New York afternoon over a civilized cup of tea far from the tumult that engulfed Baghdad, Manuela Dunn, a visionary book creator, suggested that, in fact, there was something we could do. We could create a book that told the story of the museum, not of its horrific destruction but of its creation and the building of its remarkable collections. "Perhaps," she said, "we could give it renewed life as a virtual museum in a book that would tell not only its story, but the story of ancient Mesopotamia."

In the days that followed, we brought together a team that included Barbara A. Porter, a scholar of the ancient Near East who would guide us through the rarified world of Mesopotamian archaeology. Barbara and Iraqi archaeologist Zainab Bahrani aided us in assembling an exceptional cadre of archaeologists who had worked in Iraq before, during, and in the wake of Saddam Hussein's regime.

To our delight, those we contacted were not only eager to share their amazing stories with a larger audience, but vowed to do all they could to restore order in the wake of chaos. It is to these people and their continuing efforts that *The Looting of the Iraq Museum, Baghdad* is dedicated.

Milbry asked her father, William Polk, who had made a frantic but failed attempt to save the museum's collection just days before the war, to write the introduction. He brought Nadia Younes, who had been appointed as Kofi Annan's personal emissary to Iraq, to be our local contact. Sadly, she was killed in a bomb attack on UN Headquarters in Baghdad on August 19, 2003, well before our book project had come to fruition.

William Polk also introduced us to Raja Sidawi and Monique Duroc-Danner who have a longtime interest in the culture of Iraq. They immediately realized that the book had to have the best illustrations possible to convey the beauty of the objects and to that end made a most generous grant, which enabled us to acquire those images.

In gathering here in these pages the words of individual scholars who have worked so hard to unravel and piece together the complex history of the cradle of civilization, we hope to recapture an essence of what may be lost forever, not only things taken from the museum, but from ancient sites throughout Iraq, which, in the wake of war, have been pillaged and destroyed.

Although our project was born of despair, it grew into a labor of love. In producing this book we have been introduced to the small army of people who have dedicated the rest of their professional lives to re-creating the museum and preserving what they can of the fragile remains of the great cultures with which Iraq has been so endowed. We offer this book as a tribute to what was and what we hope will be again.

From the outset, we wanted to contribute far more than just a book. Angela, drawing on her experience in preservation of artistic and archaeological sites and editor of the preservation quarterly *ICON*, published by the World Monuments Fund (WMF), suggested that proceeds from the book benefit the museum and sites in Iraq. To that end, they will be donated to a fund for Iraqi antiquities administered by the WMF in partnership with the Getty Conservation Institute.

The Iraq Museum was everyman's museum. Its destruction affects people throughout the world and its loss will remain a hole as we go forward into the future. But if any good can come out of this catastrophic loss, it is in the lessons learned. Other institutions and repositories of human history around the world should take heed. As we have learned, time is of the essence.

Milbry Polk and Angela M. H. Schuster
New York
September 2004

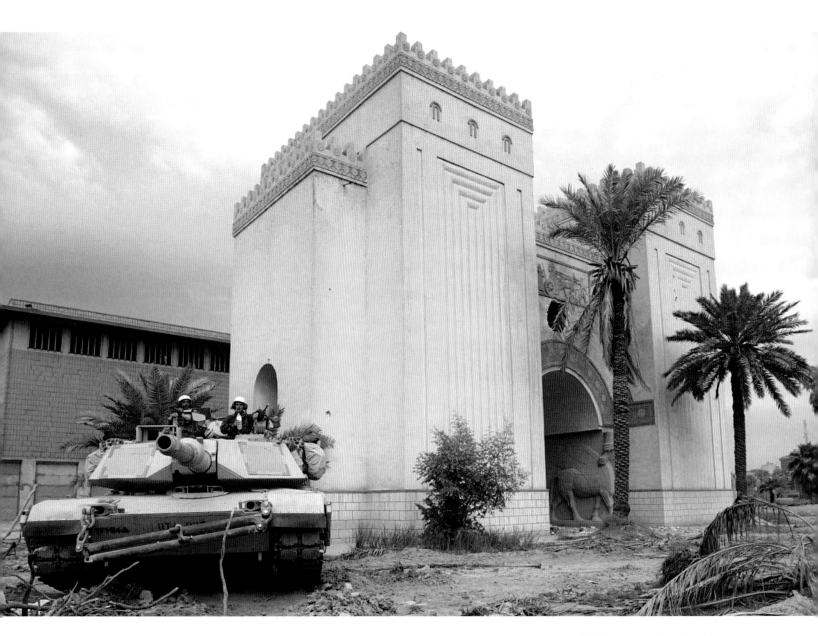

The "Assyrian Gate" of the Iraq Museum, designed by Seton Lloyd, showing a gaping hole made by a US tank.

Foreword

During the first Gulf War in 1991, regional museums in the provinces and site museums along with other official institutions, became a target for organized looters. In that time period, nine regional museums—in the provinces of Basra, Imara, Diwaniya, Kufa, Kut, Babylon, Kerkuk, and Duhuk, as well as some material from the Sulaymania Museum—were looted and destroyed. In the final estimation, more than 4,000 objects were taken from these museums, among them statues, cylinder seals, cuneiform clay tablets, metal objects, and different pottery material. With all the efforts done to retrieve these antiquities, only two or three objects were brought back.

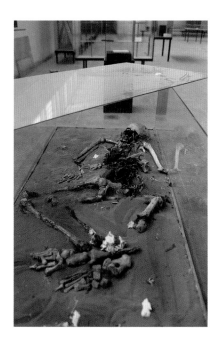

Looted display case in the Iraq Museum, after jewelry and artifacts were taken from this skeleton.

In the following years, organized looting activities were carried out on more regional and site museums. For instance, objects from the site museum in Ashur were stolen in 1995; in 1996 the Kut Museum was looted, and a few materials from the ancient city of Hatra were taken. At the Nebuchadnezzar Museum in Babylon, some forty-two cylinder seals, along with three cylinders inscribed with Nebuchadnezzar's historical writings, were also stolen. At that time the investigations for this museum and the missing material from Hatra led to suspects very close to the head of the former regime, but the investigations were always cut off and ended without any results, so that no one at the top of the regime was ever exposed.

The biggest crime that was committed involving Iraqi antiquities occurred a few days after the second Gulf War, April 10–12, 2003, when the Iraq Museum in Baghdad was broken into and most of its parts torn out. Fifteen thousand objects were stolen from the galleries and stores of the museum, including Abbasid wooden doors; Sumerian, Akkadian, and Hatraean statues; around five thousand cylinder seals from different periods; gold and silver material, along with necklaces and

pendants; and other pottery material. The looters broke through the main museum galleries and the store rooms, stealing and destroying everything they could get their hands on. In many cases, what they could not take they smashed and destroyed, including the head of a terra-cotta lion from Tell Harmal, from the Old Babylonian period around 1800 B.C., and Roman statutes found in the city of Hatra, from the first century B.C., in addition to a large number of pottery materials from the storerooms. Many empty showcases from the main halls of the museum were also smashed.

After this catastrophe, great international efforts were started in watching, searching, and closing many international borders. Museums around the world were alerted about what happened in the Iraq Museum, and information was published to raise awareness of the stolen Iraqi antiquities. All the international customs agencies—Interpol, UNESCO, ICOM, and all the cultural agencies in the world—were concerned. The internet generated great attention through a good number of websites that were dedicated to the subject of the lost objects from the Iraq Museum, among them the University of Chicago website and the Interpol website, in conjunction with personal efforts to support the Iraq Museum search campaign. As a result of all this goodwill effort, around 4,000 objects were returned to the Iraq Museum by Iraqis, the Iraqi police and customs, and the coalition MP units. A good number of antiquities were recovered in the neighboring countries as well: 1,054 objects in Jordan, about 200 in Syria, around 35 objects in Kuwait, a number in Saudi Arabia and Lebanon, more than 300 in Italy, and over 600 in the United States. We still get news of recovered material here and there almost every day.

In all, what was recovered makes up less than 50 percent of what was stolen from the museum. More than half of the looted material is still missing, which is a great loss for Iraq and for all of humanity. In this respect we thank all the institutions that have been involved in collecting the Iraqi antiquities, and all the museums around the world that have shown great

Broken-in door to the Museum's office after the looting.

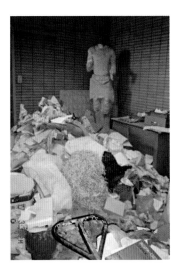

The lobby outside the Museum's administration offices, April 2003.

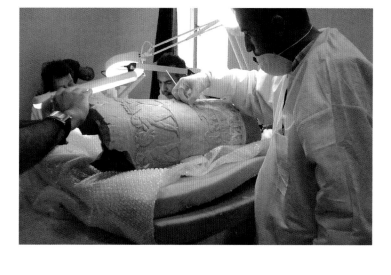

The Warka Vase being restored in the laboratory after it was brought back to the Museum.

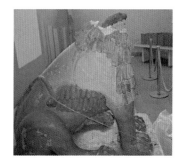

Beheaded lion statue.

concern for helping the Iraq Museum in restoring the antiquities that were damaged. We would like to thank the US State Department for its huge support, together with the Packard Foundation, which provided the Iraq Museum the means to stand again and help our staff deal with the tragedy and restore everything that was damaged and neglected for the past thirty years.

Efforts have now been intensified to restore a good number of the damaged antiquities in a newly restored laboratory by working together with the Iraqi-Italian Archaeological Institute, training young Iraqi conservators to clean the sculptures in the Assyrian grand hall of the museum in preparation for its reopening. Plans to reopen some of the Islamic halls in the near future are also in the works.

In other areas, efforts are still ongoing to finish an additional section for the museum storerooms, and a complete security system will be installed in the coming months for the entire State Board of Antiquities and Heritage building in Baghdad.

Dr. Donny George
Director of the Iraq Museum, Baghdad
September 2004

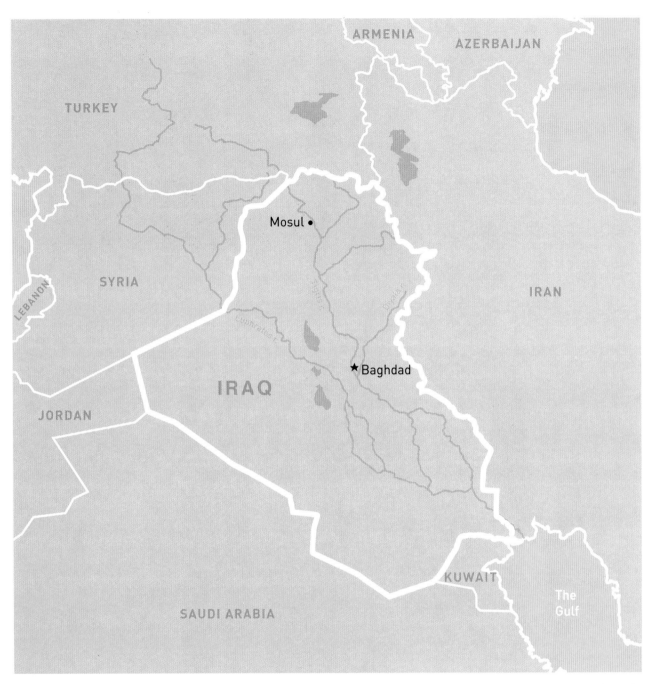

This map shows the modern borders and cities of Iraq, the heart of ancient Mesopotamia. For the sake of clarity, this same basic map is included in each chapter, showing modern cities in black and the cities relevant to the period discussed in the chapter in red.

Introduction

In a great arch stretching from the northern parts of what is today Iraq to the Mediterranean more than 10,000 years ago, men learned to select among wild plants seeds that promised to grow into dependable harvests. Soon they also learned how to channel water to the seedlings to increase their yield. The agricultural revolution had begun.

As agriculture grew more sophisticated, it required the services of large numbers of people to dig irrigation canals, plant and harvest grain, process it into flour, store it for future use, and trade it for exotic produce from other, less fertile areas. What had originally been just temporary campsites grew into villages. As each became more populous, it found itself compelled to organize increasingly complex stages of the new economy. Workers had to be marshaled, records had to be kept of obligations, and what had been customary had to be codified. All these efforts took vast amounts of labor, but gradually those with skill and cunning rose above the more mundane tasks and became professionals. As they accumulated wealth and power, they wanted more than food. Arts and crafts inevitably followed. Thus, slowly and inexorably, what we can call civilization was born and elaborated along the great Tigris and Euphrates Rivers and their network of tributaries.

It was the record of that remarkable set of steps—over some 9,000 or 10,000 years—that the Iraq Museum in Baghdad documented. The focus was not just on what happened in Iraq, but on the very seedbed of civilization itself. We can honestly say that it was there, in what the Greeks called Mesopotamia, that life as we know it today began: there people first began to speculate on philosophy and religion, developed concepts of international trade, made ideas of beauty into tangible forms, and, above all, developed the skill of writing.

Finding, assembling, recording, and interpreting this unique record was the work of hundreds of scholars from all over the world for more than a century. Now much of it has been scattered, smashed, and stolen. What happened in Baghdad in a few days in April 2003 is an incomparable loss to the entire world. I feel this with particular sadness as I was one of the last people to see the collection in its breathtaking entirety. Let me tell you what I saw then and what this beautiful volume, *The Looting of the Iraq Museum, Baghdad,* commemorates and attempts to recapture.

Standing alone in a corridor on the second floor of the Iraq Museum is a copy—fortunately, the original is in the Louvre in Paris; unhappily, it is one of the few copies the museum contained—of one of the most remarkable treasures of the ancient world. It was a stone stela depicting Hammurabi, the eighteenth-century B.C. ruler of Babylon, receiving one of the earliest known codes of law from the sun god and god of justice, Shamash. Shamash instructs Hammurabi "to cause justice to prevail in the land, to destroy the wicked and the evil, that the strong may not oppress the weak." Proudly, Hammurabi took as his title "King of Justice." The parallel with Abraham, said to have been born in Mesopotamia centuries later, receiving his laws from the Hebrew god Yahweh, is too striking to miss. As they did in so many things, the early people of the Tigris and Euphrates led the way in helping the whole world to understand how to deal with one another in justice and their conception of the purpose of life in divinity.

As I walked through the museum, I passed gigantic Assyrian wall carvings, some fifteen meters long and about five meters tall, showing ceremonies in ancient Nimrud and Khorsabad. Giant human-headed winged bulls that had once guarded the gates of the Assyrian capitals loomed overhead. Buried for thousands of years, they blazoned forth as though carved only

Early Iraqi lustre glassware, from Raqqa, late 8th century.

yesterday to proclaim the majesty of the greatest empire in the ancient world. Unconsciously, Cyrus, Ashoka, Alexander, Caesar, and Napoleon would tread the path the Assyrian emperors had staked out, creating their own arches, towers, temples, and wall friezes. Grandiose public display, indeed civic propaganda itself, had been invented.

Scores of glass cases displayed thousands of tiny masterpieces of the earliest Mesopotamian craftsmen. In some cases were hundreds of stone cylinders, each the size of a child's finger. Painstakingly incised in reverse, they captured vivid images of griffins, sphinxes, and other mythological beasts when rolled across wet clay. One collection had been called the first ever state archive.

In other cases were some of the earliest known pieces of elaborate pottery, jewelry, and statues from Ur, Babylon, Nineveh, Nimrud, Ashur, and the score of cities scattered along the Tigris and Euphrates Rivers. Still other cases contained examples of clay tablets on which the ancient Mesopotamians wrote contracts, letters, and decrees that give us such a vivid, fresh picture of their civilizations.

All in all, the Iraq Museum was one of the greatest collections of cultural treasures in our world. And today it is no more.

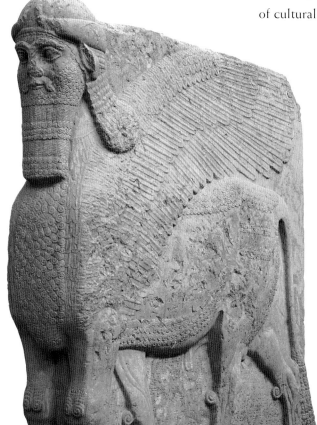

Human-headed winged bull: yellow limestone, from Nimrud, about 865 B.C., Ht. 240 cm. They were used as guardian figures in Assyrian palaces and temples.

Foreseeing the terrible danger posed to the museum by the American invasion, I called on the man then in charge of the museum just a few days before the war began to ask him what precautions had been taken to protect his irreplaceable collection. In reply he simply raised his hands and eyebrows in a gesture of resignation, saying, "What can I do?" He was right. In the fog of war, nothing could be safe. He and staff members did manage to store some of the most valuable (commercially) or at least most movable pieces in the museum's underground vaults. That did little good. Even massive steel doors gave way or were blasted apart. But, arguably, these spectacular, golden, and precious stone-encrusted pieces were not the most important. Others, less imposing to the eye, often were more important in documenting the rise of civilization.

I had gone to the museum with a last-minute proposal that might have saved the collection by arranging to ship it to a safer location. Alas, I arrived too late and, in the impending storm, no one had time for what we would all soon so bitterly regret.

As it turned out, the museum was not hit by any one of the hundreds of bombs dropped on Baghdad. But there was a further danger. About it, there was little the museum director or anyone else could do. In the confusion of the invasion, the museum was looted. In Baghdad, as elsewhere, when law and order break down and people are driven to desperation, some will certainly take the opportunity to seize what they can to sell for food or just to enrich themselves. In Baghdad, gangs of looters swarmed into the museum. Some appear to have been professional, acting in concert with international dealers and even with resident diplomats. They knew what they wanted and rushed to get what was most saleable. Others, probably amateurs, took sledge hammers and chain saws to giant statues and wall carvings or simply grabbed what they could from the shattered glass cases of museum collections. An "antiquities mafia" quickly sprang into existence, or perhaps already was positioned to take advantage of the opportunity.

Upper Floor

Lower Floor

Of all the terrible casualties of war, this would rank among the most costly.

Bits and pieces of the collection have been retrieved. Doubtless more will come to light as time passes, but, as a collection, the museum as it was is no more. That is why a group of outstanding scholars have decided to create what we might think of as a "virtual" museum—not a collection of scholarly papers, but a personal and visual record of what they devoted much of their lives to create, and which now can probably only exist in this form.

The editors decided that to give the reader as complete a picture of the great collection as possible, they would begin with the earliest periods, when the peoples of the area first began to accumulate the basis of settled life; then show where and how the hard work and new skills of these peoples enabled them to lay the foundations of the fabled cities of the Tigris-Euphrates network of waterways; then how, in the growing wealth and sophistication of the new urban society, they turned their attention to art, religion, law, and philosophy. Each of the authors in this collection is a world-famous specialist. Each has accepted a new definition of "expert," a person whose assured knowledge enables him or her to share an appreciation of their subject in a way scholars rarely have the leisure to do, with what can only be described as devotion.

For each of us, this has been a labor of love, a requiem for a departed companion of many rewarding years, a tribute through memory to our devastating loss. It is, as I have said, the closest we have been able to come to a "virtual" Iraq Museum.

William R. Polk
Vence, France
September 2004

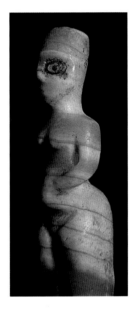

Tiny female statuette in alabaster from Tell es Sawwan. 9.8 x 2.9 cm.

THEFT OF TIME

Angela M. H. Schuster

A multibillion-dollar business, the trade in antiquities ranks third in international monetary terms, behind drug smuggling and weapons sales. As the demand for antiquities increases, so do the illicit means to acquire them, either by the plundering of archaeological sites or by the looting of museums. Although most antiquities-rich countries have strict laws prohibiting the clandestine excavation and export of archaeological material, new finds continue to enter the market at an alarming rate.

For war-torn countries such as Iraq, the problem is far greater as a lawless environment foments the trade in antiquities, while weak border controls facilitate export of material. Although United Nations Security Resolution 1483, which passed on May 22, 2003, bans international trade in Iraqi cultural property and other archaeological, historical, cultural, religious, and rare scientific items illegally removed from the Iraq Museum, and the National Library, as well as other institutions, it has been difficult to enforce such measures, given the ongoing civil unrest in the country. Moreover, the resolution has done little in terms of site protection. Sites, plundered at night by teams of several hundred looters—namely farmers or the unemployed—continue to supply a market thirsty for ancient Near Eastern antiquities. Portable items such as cylinder seals or small tablets fetch an estimated $50 in the field, an average of ten times that on the open market. However, the more ancient and important pieces—such as finely carved seals bearing scenes of mythological or historical events or cuneiform tablets recounting the same—can sell for hundreds of thousands of dollars as witnessed at a Christie's auction in New York on June 11, 2001. Thousands of such artifacts remain missing from the museum; countless others have been clandestinely unearthed. Although Resolution 1546, adopted

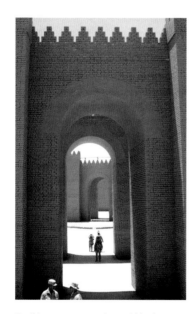

Coalition troops, seen here within the rebuilt walls, occupy the ancient city of Babylon.

by the United Nations Security Council on June 8, 2004, further stressed the need for site protection, it unfortunately ranks low on the list of priorities in reestablishing order in the country.

One of the first international measures taken to control the illicit trade in antiquities was the ratification by seventy countries of the UNESCO Convention on the Means of Prohibiting and Preventing the Illicit Import, Export, and Transfer of Ownership of Cultural Property. The convention, which was adopted by the United Nations Educational, Scientific, and Cultural Organization during its sixteenth session on November 14, 1970, encourages each of the 130 countries that were party to the convention to protect its own cultural patrimony, as well as to join in an international effort to assist other nations in stopping the illicit traffic of antiquities.

Above and following pages: Antiquites recovered by Iraqi police in June 2004. These items were part of a collection of 3,000 objects seized in a raid in Baghdad. They had been wrapped in toilet paper and newsprint, and were packed in several cardboard boxes for shipment outside the country.

Although it is believed that the UNESCO convention has curbed much of the looting of large-scale antiquities like temple fragments and statuary, the most effective controls have come as a result of import bans that went into effect under the convention on specific artifacts from specific areas.

For importation into the United States, these bans include pre-Hispanic ceramics and stone artifacts from the Cara Sucia region (occupied 1500 B.C.–A.D. 1500) of El Salvador (effective September 11, 1987); antique ceremonial textiles from Coroma, Bolivia (effective May 7, 1990); Maya ceramic, jade, shell, and bone artifacts from the Petén region (600 B.C. –A.D. 600) of Guatemala (effective April 15, 1991); Pre-columbian archaeological material from Nicaragua (effective October 20, 2000); pre-classical, classical, and Imperial Roman

archaeological material from Italy (effective January 19, 2001); Precolumbian material, particularly Moche artifacts from the Sipan archaeological region of northern Peru (effective May 7, 1990), and colonial material from throughout the country (ban amended July 9, 2002); pre-classical and classical vessels, sculpture, mosaics, inscriptions, architectural elements, and jewelry from the island of Cyprus (effective July 19, 2002); material from the Niger River Valley region and the Tellem burial caves of Bandiagara Escarpment in Mali (effective September 23, 1993; extended in September 2002); Khmer archaeological material from Cambodia (effective September 19, 2003); and Precolumbian artifacts from Honduras (effective March 12, 2004). More recently, China has issued a request for import restrictions on archaeological material dating from the Paleolithic period through the Qing Dynasty.

Unfortunately, such import bans are put in place only following the appearance of looted material on the international art market and after massive site destruction has occurred, rather than preventing such incidents in the first place. However late in coming, the bans do require the importer to prove that antiquities were legally acquired, whereas the convention relies on a country's ability to report a theft and accurately describe stolen objects—an impossible task when a site has been plundered. Such is the case with the majority of material leaving Iraq.

Because of the perceived inadequacy of the UNESCO convention, legislation to protect and recover cultural property within a broader framework is currently being drafted. Known as the Unidroit Convention on the International Protection of Cultural Property (drafted by the International Institute for the Unification of Private Law at Rome), this body of law differs from the UNESCO convention in that it enables the recovery of stolen property through private law rather than through international treaties and conventions. Although most of the proposed legislation already exists under current United States law, the Unidroit convention has the added feature of providing the United States and other countries access to foreign courts.

Looted ceramic figurine of a mother and child from a group of recently recovered objects.

For any international legislation to succeed, it is mandatory that all nations participate in its enforcement. Otherwise, the illicit trade will simply shift to nonsignatory nations. In addition, it is equally important that collecting institutions, both public and private, as well as individuals, reevaluate their collecting policies. Significant measures to amend museum acquisitions policies have already been taken with the adoption of the Code of Professional Ethics by the International Council of Museums (ICOM) in 1986. The code has guidelines that specifically address the acquisition of illicit material. These guidelines state in part that museums must recognize the connection between the acquisition of illicit material and the often destructive means to obtain it. The guidelines stipulate that for a museum to acquire any object, whether by purchase, gift, bequest, or exchange, the institution's governing body must be able to obtain valid title to the object. The title must ensure that the object was not acquired in or exported from any country in violation of that country's cultural property laws, that recently excavated material is not the product of unscientific investigation or destruction of an ancient monument or site, and that finds were not removed from a site without the knowledge of the landowner or governing authority. Accordingly, scholars must not only condemn the illicit commerce in antiquities, but refrain from assisting those acquiring antiquities without proper provenance or export permit in order to enhance either the market value or the perceived importance of the objects in question by publishing them for the first time.

The acquisition of antiquities by illicit means invariably results in the irretrievable loss of information critical to the understanding of both the artifacts in question and the culture that produced them. For the people of Iraq, such loss is not only a local loss but a loss for all of humanity, as it is our shared history that is at stake, and, in the wake of war, one that is vanishing chapter by chapter.

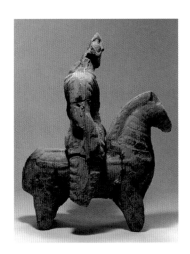

Retrieved ceramic figurine of a rider and horse.

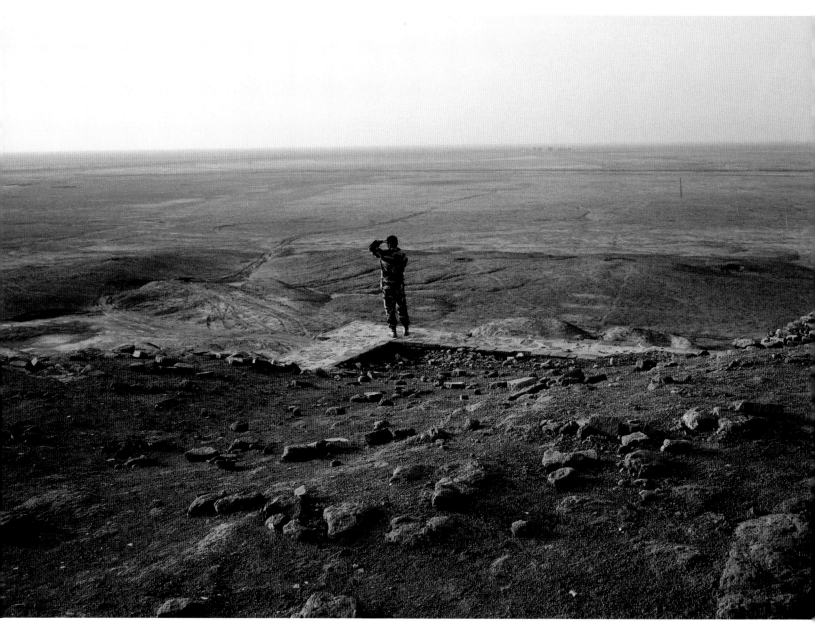

Above: An Italian soldier looks out across the surrounding desert from the top of the Ziggurat of Ur, January 2004. Soldiers visit the site on a daily basis, climbing the Ziggurat to have their picture taken.

Left: A cylinder with cuneiform writing, wrapped in toilet paper, was just one of over 3,000 pieces found in a raid by Iraqi police. The objects, looted from archaeological sites, had been packaged for shipment out of the country.

ERASING THE PAST: LOOTING OF ARCHAEOLOGICAL SITES IN SOUTHERN IRAQ

Micah Garen and Marie-Hélène Carleton

The fate of archaeological sites in southern Iraq is, simply put, a tragedy. According to Aristotle, tragedy illustrates the universal rather than the particulars of history—illuminating through catharsis what is possible and what can likely happen in the future. The loss of history does not strike us with the pathos of tragedy if we focus only on the particulars. In the same way, for instance, that the historical fact of the defeat of Lugalzagezi, king of Uruk, at the hands of Sargon of Akkad does not provoke much feeling, we may not respond emotionally to the fact that 1,000 clay tablets are lost, or a number of pieces of pottery are broken, or even a hundred holes containing who-knows-what were dug by looters in some mound in the desert.

But if we come to understand the story of looting in its universal aspects—that great volumes of information about our past have been destroyed, that great works of literature and poetry no longer exist, that chapters in our understanding of human development will never be written—then we can begin to feel the scope and depth of our loss.

In more than a year's worth of work traveling throughout southern Iraq, our efforts in documenting this tragedy were aimed at understanding not so much the particulars of what had happened in Iraq, but rather what is happening now and can happen in the future—and why. Like most tragedies, the story is both simple and complex.

The history of looting of archaeological sites in southern Iraq dates back over 200 years, with tablets from sites such as Umma appearing on the market since the beginning of the nineteenth century.

However, the periods following the 1991 Gulf War and the 2003 Gulf War were turning points in the history of looting. After the 1991 war, southern Iraq was severely impacted by the economic sanctions imposed on the country by the international community, and a new brutal period of suppression

Marie-Hélène Carleton, leaning out from an Italian helicopter, films the devastation caused by looters at the archaeological site of Umma, in southern Iraq.

of the Shi'ites by Saddam Hussein. The effect was more than a decade of rampant poverty and a growing power vacuum that was slowly filled by tribal and religious leadership.

By some accounts, the looting at archaeological sites started in the wake of the 1992 Saddam Canal project that cut a path through the desert from Baghdad to Basra, destroying dozens of archaeological sites and unearthing many artifacts. Seeing the treasures led neighboring villagers to begin looting en masse. Other accounts point to the chance digging by a man from Fajr who stumbled upon a great treasury. His instant wealth from selling his finds inspired many others in Fajr to start looting as well.

Whatever the exact origins, it is clear that impoverished southern villages like Fajr and Raffae have grown wealthy from what people refer to as "farming antiquities." Hundreds of people from the surrounding areas dig, sometimes during the day but mostly at night, in small teams of five to ten. There are dozens of antiquities kingpins, who organize large-scale looting, moving thousands of objects out of Iraq each year.

Above: A small cuneiform text, wrapped in newspaper, found in a raid by Iraqi police in Baghdad.

Below: Antiquities inspectors and site guards at the archaeological site of Umma find a recently unearthed jar left behind by looters.

Italian carabinieri stand guard during a helicopter patrol of the heavily looted site of Umma.

The impoverishment of the south from 1991 to 2003 may have created a motive for looting, but the growing lack of authority provided the opportunity. After the start of the 2003 war, with the complete collapse of the government, looting increased at an unprecedented rate. The US-led coalition had no plan to protect archaeological and cultural sites in Iraq, many of which are located in remote areas. It simply was not a priority. By some estimates, the amount of looting that took place in the first few months after the war equaled the total amount that had taken place in the previous ten years.

There is a direct relationship between security and looting—looting happens in the absence of authority. This direct relationship is most evident during short periods of increased insecurity. In the spring of 2004, on days when clashes erupted between coalition forces and the Mehdi army in southern Iraq, looting at the archaeological sites increased dramatically.

As happens during most tragedies, people who make heroic efforts emerge. Abdul Amir-Hamdani, inspector of antiquities for the Dhi Qar province, went to work right after the 2003 war began and enlisted the support of sympathetic US Marines and later, the Italian carabinieri to help protect the sites, demonstrating that not only is the appreciation for the marvels of Mesopotamia universal, but also individuals can make a difference.

Despite these individual efforts, the toll on the Sumerian city-states located along the ancient riverbeds in southern Iraq has been devastating. Although there are more than 800 archaeological sites in the Dhi Qar province alone, there are only eighteen major Sumerian city-states in southern Mesopotamia from the Early Dynastic period (2900–2334 B.C.): Sippar,

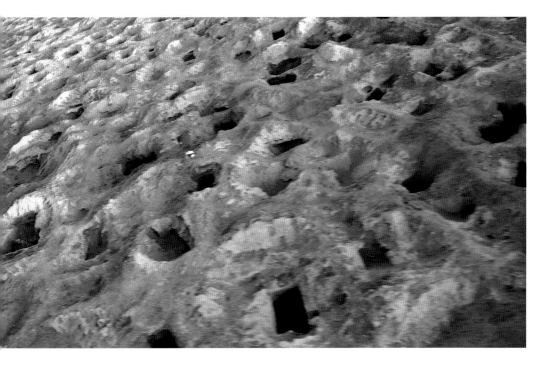

Kish, Akshak, Larak, Isin, Nippur, Adab, Zabalam, Shuruppak, Umma, Girsu, Lagash, Nina, Badtibira, Uruk, Larsa, Ur, and Eridu.[1] Sites such as Isin, Adab, Zabalam, Shuruppak, and Umma have been so badly damaged that almost nothing remains of the top three meters.

Many of these sites have been only partially excavated, or not at all. Umma, located in the desert several hours north of Nasariya, was one of the most important of the Sumerian city-states. After a long rivalry with Lagash, under the leadership of Lugalzagezi, Umma for the first time conquered and united all of the other Sumerian city-states until Sargon of Akkad defeated Lugalzagezi at Uruk, ushering in the dynasty of Akkad. Umma was never officially excavated until the Iraqi State Board of Antiquities and Heritage, prompted by increasing looting at the site, decided to do an emergency excavation in 1996.

We made several visits to Umma by land, but flying by helicopter over the site reveals an unimaginably grim reality, a scene of complete destruction that unfolds before you as a sea of holes in the desert—negative spaces in history—a pockmarked landscape with craters up to five meters deep. A landscape as desolate as the surface of the moon during the day springs to life after sunset with generators, lightbulbs, trucks, and shovels, as hundreds of looters dig till dawn.

[1]*Ancient Iraq*, George Roux, Penguin Books, 1992.

Looking down at the succession of holes that was once Umma, one can only wonder at the loss of history, the untold number of looted artifacts and documents of our collective past that will never make it to the Iraq Museum and into the world's consciousness.

Perhaps the greatest irony in this story—the disappearance of history—is that southern Iraq is the birthplace of history, where writing was invented 5,000 years ago. Arguably mankind's most important invention, writing—etched on clay tablets— gave life to ideas and created the possibility of immortality. Through writing, history and ideas could now be passed along, reaching an evergrowing number of people, not limited by geography or time.

When he first read the *Epic of Gilgamesh*, German poet Rainer Maria Rilke, "intoxicated with pleasure," is reported to have said, "Gilgamesh is stupendous."[2] One of the greatest works of literature, the *Epic of Gilgamesh*, still incomplete after having been compiled from dozens of fragmentary cuneiform texts, is a story about universal ideas—heroism, friendship, and our fear of death. Although we return to dust, Gilgamesh learns— and we learn—that immortality can only be achieved by living on in historical memory through our achievements. In other words, recorded history is our only way to achieve immortality.

As we watch the documents and artifacts of our past being rapidly destroyed, the magnitude of this tragedy is just now becoming evident. Tragedy is as much about our present and our future as it is about our past. As the looting continues, sadly we are still waiting for the catharsis that will make sense of this sorrow. Not to understand and value our history is our tragic flaw.

[2] *The Epic of Gilgamesh*, Andrew George, Penguin Books, 1999.

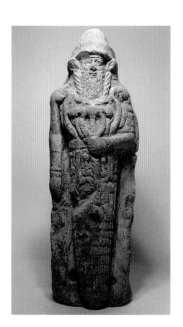

Above: Statue of a king found in a raid by Iraqi police to recover looted antiquities in Baghdad.

Right: The back of a broken statue with cuneiform writing, recovered during a raid on antiquities dealers in Fajr.

A SHORT HISTORY
OF THE IRAQ NATIONAL MUSEUM

Usam Ghaidan and Anna Paolini

Professor John Russell, the previous assistant to the senior cultural advisor of the Coalition Provisional Authority (CPA), has described Iraq as a country of firsts: the earliest villages, cities, writing, poetry, epic literature, temples, codified religion, armies, warfare, world economy, and empire. The Iraq National Museum[1] in Baghdad is a unique repository of millennia of history and of different cultures. It is within the territory of modern Iraq that the earliest urban culture was established and flourished. Large fortified towns, vast and complex palaces, and religious structures that developed and evolved with continuity through many centuries mark the landscape of this land between rivers. Much of what we know of Mesopotamia comes from archaeological research. Virtually all of Iraq is an archaeological site. More than 10,000 sites have been identified in Iraq and many more await discovery. About 1,500 have been researched. Apart from some important objects housed in major institutions such as the British Museum and the Louvre, almost all the finds recovered from these sites are housed in the Iraq National Museum of Baghdad.

This important institution began its life in 1923 to house select artifacts yielded by excavations being carried out at Assyrian, Babylonian, and Sumerian sites. It consisted of one room situated within al-Qushlah, Iraq's government building in Baghdad on the east bank of the River Tigris. Due to the growing numbers of archaeological finds, a separate building became necessary and this was founded on the same side of the river at the foot of al-Shuhada bridge and was named the Iraq

[1]The Iraq Museum, Iraq National Museum, and Iraq Museum in Baghdad are all used to identify the Museum. For consistency's sake, the editors have chosen to use Iraq Museum throughout the text except in the case of this article, which has been copyrighted using the name Iraq National Museum.

Museum. Gertrude Bell, the famous Arabist of British origin, an explorer and amateur archaeologist, became its director and remained so until her death in 1926.

The museum continued to accommodate the steadily increasing collections until 1966 when a larger, purpose-built structure was inaugurated on the west side of the river and renamed the Iraq National Museum. It is a two-storey brick structure with a basement. The galleries form rectangular blocks, thirteen to eighteen meters wide, arranged around a planted square court-yard measuring fifty meters in length, surrounded by covered verandas.

The building was extended twenty years later, when another square courtyard structure of identical design was added, bringing the number of public galleries to twenty, covering a surface area of 11,000 square meters. The galleries are arranged chronologically. Prehistoric and Sumerian periods are on the first floor, while the ground floor is used to display finds from the Assyrian and Islamic eras. The most inspiring gallery is that of the Assyrian antiquities. Its walls are covered with gigantic carvings some fifteen meters long and about five meters tall, depicting ceremonies in ancient Nimrud and Khorsabad. Giant human-headed, winged bulls that had once guarded the gates of the Assyrian capitals stand on pedestals.

Islamic section of the Iraq National Museum before its destruction.

In the remaining galleries more than 10,000 items were displayed, ranging from tiny cylinder seals to monumental statues. They comprised objects made of clay, pottery, metal, bone, cloth, paper, glass, wood, limestone, and alabaster, spanning some 10,000 years of human civilization from prehistoric times through the Sumerian, Babylonian, Assyrian, Hatraean, Parthian, Sasanian to the Islamic eras. The items on display represented fewer than three percent of Iraq's holdings, among which are more than 100,000 cuneiform tablets, including the earliest collection of proto-cuneiform writing from Uruk (3200 B.C.), one of mankind's oldest codes of law (eighteenth century B.C.) as well as the invaluable Sippar archives of some 800 clay tablets from the Neo-Babylonian period (625–539 B.C.). These invaluable holdings make the Iraq National Museum one of the world's greatest repositories of cultural treasures of the ancient Near East and an inescapable place for the study of its history.

During the Gulf War of 1991, the Ministry of Communications, located across the road in front of the museum, was bombed, and the resulting tremors shattered a number of the museum's showcases. The museum was closed down and, to protect objects from bombardment, the staff decided to remove the displayed artifacts to a safer place. Believing the war was not going to last more than a few months, they wrapped the precious objects of ceramics, ivory, cuneiform tablets, etc., in cotton wool and the metal ones in rubber padding. These were placed in metal trunks, locked, and taken to the basement of the museum's old storage building.

Unfortunately, events took a different turn. Not only did the bombs not stop, but also, because of the irregular electricity supply due to the destruction of generators and the sanctions that followed, the pumps that had been installed to empty groundwater from the basements stopped functioning and the floor became flooded. The metal trunks corroded, allowing humidity to reach the protective cotton wool and rubber padding and turn them into nesting ground for bacteria,

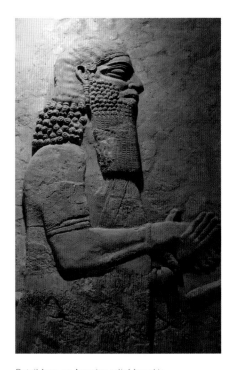

Detail from an Assyrian relief found in Khorsabad and now displayed in the Assyrian Room, showing a royal ceremony saluting the Assyrian commander-in-chief, Turtanu. This figure is one of those paying tribute to the king.

moths, and other harmful organisms. Hundreds of items were disintegrating under the eyes of the museum's laboratory staff, who were rendered helpless for want of the necessary chemicals to preserve the collection, the import of which was not authorized by the Sanctions Committee. Hundreds of objects that had managed to survive 2,000 to 3,000 years were damaged, some of them irretrievably.

In February 2003, almost exactly three years later, the museum was again forced to close its doors and look for safer places for its collections. The impact this time was more devastating. The shattered public order in the aftermath of the war brought waves of theft and pillaging. In an unchecked frenzy of cultural theft, looters who pillaged government buildings and businesses after the fall of Baghdad also targeted the museum, stealing and destroying artifacts, some dating back 7,000 years. Much of the looting occurred on Thursday, April 10. The museum guards stood by as hordes broke into the museum with wheelbarrows and carts and stole priceless statues, bowls, and clay tablets, etc., leaving its galleries empty except for shattered glass display cases and cracked pottery bowls that littered the floors.

On July 3, the Coalition Provisional Authority organized a one-day exhibition at the Iraq National Museum. On display were gold pieces from the royal tombs of Ur, as well as some recovered artifacts, such as the Warka Vase. But the star of the show was the treasure of Nimrud, consisting of gold jewelry excavated by Iraqi archaeologists at Nimrud between 1988 and 1990. At this Neo-Assyrian capital, just southeast of Mosul, four tombs were discovered under a floor of the Northwest Palace of King Ashurnasirpal II (883–859 B.C.). This treasure had been placed in the vaults of the Iraqi Central Bank since the 1991 Gulf War. When the renowned Romisch-Germanische Zentral Museum in Mainz, Germany, attempted to set up an exhibition of this treasure some years ago, no insurance company was willing to insure the treasure. It was considered to be too valuable.

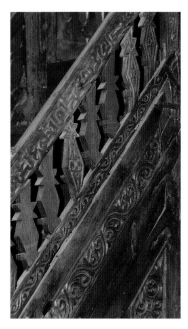

Detail of the wooden Minbar (pulpit) from Al-Amadiyah Mosque, Mosul, A.D. 1153 Ht. 548 cm. It is carved with geometric patterns in the bevelled style commonly known as the third Samarra style (although this is three centuries later), and it has Kufic inscriptions giving the date of its manufacture as A.D. 1153. It was brought from Al-Amadiyah Mosque in the Dohuk Governorate.

With the July exhibition, the Coalition Provisional Authority wanted to show that there was a return to normality. Sadly, only a few hours after the exhibition closed, a US soldier standing guard at the museum was killed by a sniper, and a couple of days later a British journalist was assassinated just across the street.

A LOSS FOR THE WHOLE OF HUMANITY

Today, the Iraq National Museum is but a mere shadow of its former self. According to the latest inquiries, more than thirty large items and 12,000 smaller ones have disappeared. Each is an irreplaceable masterpiece in its own right. Each is unique, with its own story to tell. The sum of those stories is a fundamental part of who we are today. Our archaeological heritage is a nonrenewable resource, and when a part is destroyed, that part is lost forever.

It is the responsibility of the world community to work together to put this important repository of the history of humanity back on its feet. To this end, UNESCO, in its capacity as the sole international agency whose duty is to safeguard human heritage, has taken numerous actions during the period of sanctions, immediately before the recent armed conflict and up until today. In 1999, UNESCO contributed to reinstalling the air-conditioning and security systems at the museum. UNESCO is committed to continue its action in favor of the preservation of the rich cultural heritage of Iraq.

At present, UNESCO is coordinating international actions for the restoration of the museum. All sectors of the museum are in need of intervention, and consistent efforts will be needed to respond. Besides the display areas and the offices, which have been sacked and vandalized, the conservation laboratories have suffered serious damage. The years of embargo made it very difficult for the conservators of the museum to update their knowledge of the use of new equipment and proper

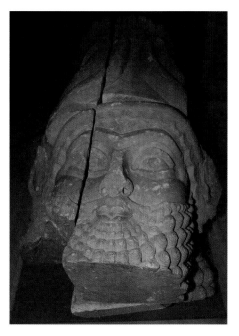

This sculpted head from Khorsabad, fortunately recovered by the Iraqi authorities, had been looted from a site and cut into pieces for its illicit export.

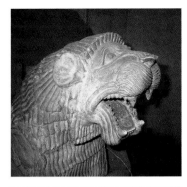

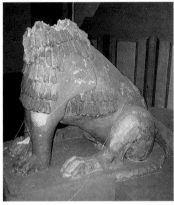

During the looting in the Iraq National Museum, the head of the guardian lion of the main temple at Tell Harmal was broken and its body smashed. (See page 129).

materials. Most of the materials required were chemical products, the import of which was forbidden. The extensive pillaging during and after the recent armed conflict worsened the situation in the laboratories, which now have to be fully refurbished and reequipped. Like the other fixtures at the museum, the security system was also smashed. Damage to this essential facility is being assessed before a decision can be made on the best security system to be installed to protect the collection effectively from risks of fire, vandalism, theft, etc. The museological program for the permanent exhibitions will probably be reviewed and the design of the galleries will have to be readapted to emphasize the historical value of this unique and exceptional collection.

In this instance, the museum's human resources were more than an important component in the way it functioned. It was thanks to their dedication that most of the collections were saved. Committed to helping reestablish a "normal situation," the staff needs training in many fields of museum studies. The eventual modernization and modification of equipment will require appropriate action to sustain training in the longer term.

The rehabilitation of the Iraq National Museum and of its invaluable collections deserves urgent attention and is the responsibility of the entire international community. The appeal has already been received positively by professional organizations and prestigious cultural institutions, and this strong international collaboration will enable the museum of Baghdad to take up its rightful place among the other museums of the world.

This article first appeared in *MUSEUM International*, UNESCO's journal for cultural heritage and museums.

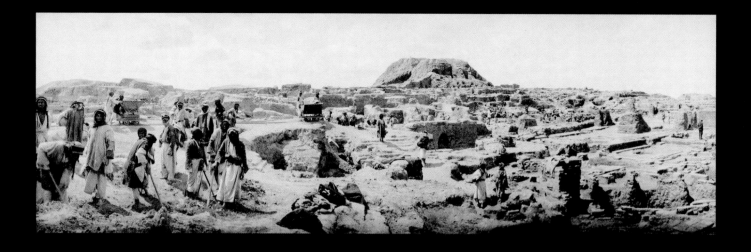

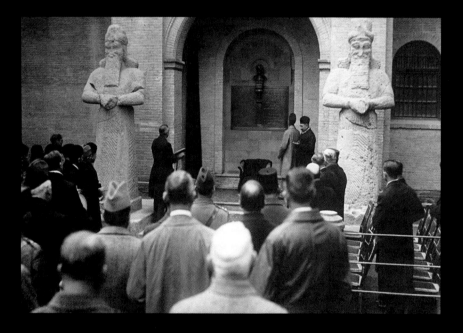

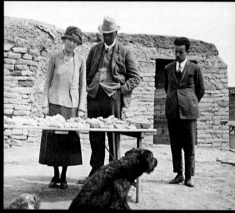

Top: General view of excavation site and workers. Above: Gertrude Bell with excavation finds at Kish, 1926.

Left: King Faisal I unveils a bust of Gertude Bell at the opening of the Baghdad Museum. The inscription is reproduced beneath the photo.

GERTRUDE BELL
Whose memory the Arabs will ever hold in reverence and affections
Created this Museum in 1923
Being then Honorary Director of Antiquities for the Iraq
With wonderful knowledge and devotion
She assembled the most precious objects in it
And through the heat of the Summer
Worked on them until the day of her death
On 12th July, 1926
King Faisal and the Government of Iraq
In gratitude for her great deeds in this country
Have ordered that the Principal Wing shall bear her name
And with their permission
Her friends have erected this Tablet.

Chapter I

A MUSEUM IS BORN

Lamia Al-Gailani Werr

Workers at excavation site.
"...isn't it fantastic to be selecting pots and things four to six thousand years old! I got a marvelous stone inlay of a Sumerian king leading captives and not being at all nice to them and a mother of pearl inlay of a king and his wives—inscribed with his name. We worked from 1:30 to 10:30, with brief intervals for tea and dinner, choosing and packing, till I felt absolutely broken with fatigue...."
—from the letters of Gertrude Bell

For all of us who felt such a great loss at the sacking of the Iraq Museum, it was far more than mourning a relatively modern building filled with relics of a seemingly distant past. For those of us who had worked to display and interpret its extraordinary collections, it was the loss of nearly two centuries of exploration and scholarship in the land between two rivers.

As we prepared its collections for presentation a mere four decades ago, we realized that we stood on the shoulders of giants—of the great excavators who first cast Iraq on the world archaeological stage—British luminaries such Leonard Woolley, Henry Layard, and Max Mallowan, and the Iraqi archaeologists Taha Baqir, Fuad Safar, and Fraj Basmachi, who shaped the field of Near Eastern studies well beyond their years. Perhaps most of all, we were indebted to a pluckish young Englishwoman who left Britain on the Orient Express in 1892, bound for Persia and a life devoted to the Middle East. Her name was Gertrude Bell.

The daughter of a wealthy English industrialist, Bell attended Oxford University, where she became enamored with the Middle East. In the years before World War I she traveled extensively throughout Iraq, Arabia, and Persia learning Farsi, Arabic, and a few local dialects, as well as surveying the region's numerous archaeological sites. Because of her abilities as a linguist and her familiarity with the Arab tribes, she was recruited by British Intelligence to work in their Arab Bureau in Cairo during the war. After the war she was appointed the Oriental secretary to the British High Commission in Iraq. In

this capacity she was instrumental in establishing Hashemite leadership in Iraq and putting her friend King Faisal on the throne. Because of her interest in and knowledge of archaeological sites, she was appointed to serve as Iraq's Director of Antiquities in 1923. In this role, Bell approved applications for archaeologists from around the world to dig. She took the teams to the sites and visited them to report on their progress. It was to her credit that so many finds remained in Iraq rather than being exported with each expedition.

When Bell died in 1926, in the heat of an Iraqi summer at the age of fifty-eight, she left behind an extraordinary list of accomplishments. Her most enduring legacy, however, was the creation of the Iraq Museum. As her vast archive of letters and documents attests, Bell had been involved in every aspect of the creation of the museum—from designing the building and cases to collecting and restoring its artifacts. In her will she left £50,000 to the museum to ensure that her mission would continue. And continue it did despite the unsettled political landscape.

Iraq has suffered and grown under various regimes since King Faisal died unexpectedly in 1933, just days after Iraq achieved its uneasy independence from British rule. Faisal's son was followed by his grandson, King Faisal II, who reigned until he was murdered in a bloody coup in 1958. The constitutional monarchy was briefly replaced by a military junta led by Abdul Karem Kassim. From 1963 on, Iraq's rulership continued to change as a result of numerous coups; that is, until 1979, when Saddam Hussein seized power, appointed himself an army general, and ruled Iraq with an iron fist until his regime was toppled in the spring of 2003.

Despite Iraq's ever-changing and often unsettled political climate, archaeologists representing museums and universities from around the globe have worked diligently over the decades, excavating the sites throughout the country and building the Iraq Museum into one of the world's great cultural institutions.

Bell picnicking with King Faisal I (second from right) at Ctesiphon, once capital of the Parthian and Sasanid empires. May 22, 1921, Baghdad.
"Darling Father...We're debating what we can do to strengthen the foundations of Ctesiphon so as to save that great facade wall. There's no immediate prospect of its falling but it has a very marked list out-wards. We have dug some holes down to the foundations and I went out early on Saturday morning with Major Wilson (the architect, you remember) to look at them. We took breakfast with us—it was a very nice expedition."
—from the letters of Gertrude Bell

Among the most famous of the early campaigns was the 1922 joint expedition of the British Museum and the University of Pennsylvania Museum of Archaeology and Anthropology, which brought to light extraordinary finds from the 4,500-year-old royal cemetery at Ur—crowns, daggers, earrings, and all the funerary furniture. At about the same time, the French were digging at Kish, another Sumerian city just north of Babylon where a Sumerian palace and a cemetery were discovered, and the Germans began excavating at the ancient city of Warka where they unearthed a number of temples and important finds. Among these were the famous vase and portrait head that later made headlines, when they were among those artifacts stolen by looters in April 2003. Fortunately, both have since been recovered.

The 1930s were dominated by the Oriental Institute at the University of Chicago excavations of the Diyala sites of Asmar, Khafajeh, and Agrab, where important and remarkable Sumerian sculpture and outstanding monumental temples were discovered. While western expeditions were excavating ancient sites, Sati' al-Husri, who was in charge of Iraq's Department of Antiquities between 1934 and 1941, was busy promoting the excavations of Arab-Islamic cities in Kufa, Basra, and Wasit, as well as encouraging the restoration of many of the old buildings of Baghdad.

In the late 1940s and 1950s, Max Mallowan carried out excavations at Nimrud, resuming the work of the nineteenth century British explorer Henry Layard, who had carried many Assyrian reliefs to the British Museum. Mallowan found numerous sculptures and carved ivories, which held such a

General view of an excavation site and workmen in Assur, with an unidentified German archaeologist in foreground, April 1911.

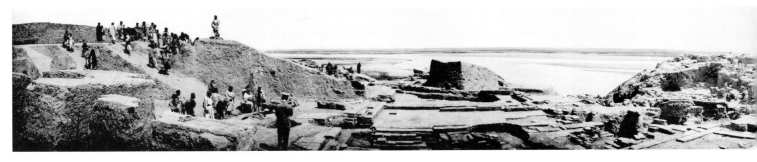

prominent place in the museum. Other expeditions, such as Ralph Solecki's excavation of Shanidar Cave in the Kurdish region of northeastern Iraq, were beginning to challenge previously held notions of early human migration into the region and origins of spirituality and agriculture.

When I joined the museum staff in 1961, it was an exhilarating time, a period of extraordinary transition for the museum itself and for the field of ancient Near Eastern studies. The Iraq Museum, which had long since outgrown its facility near the old souq on the east bank of the Tigris, was preparing to move across the river where ground had been broken for a new facility four years earlier. Plans for the new museum had undergone a number of revisions since the first designs for its building had been approved in the 1940s, resulting in the art deco structure that exists today. Its twenty-eight halls would be arranged chronologically from the prehistoric through the Sumerian, Babylonian, Assyrian, and Islamic periods; side galleries off the main halls would be devoted to sites such as Hatra and Ur, from which so many of the extraordinary finds came.

We had only a handful of employees and there was little space for anyone to work at the old museum, let alone accommodate the parade of visiting scholars that came through our doors. At that time, we perhaps had a dozen international archaeological campaigns at work in the country; numerous others were awaiting permits for the coming seasons.

It was clear that the new facility would have to be able to accommodate, conserve, and present the seemingly endless influx of fantastic material that continued to come to light as a result of these campaigns.

Having just graduated from Cambridge University, where I studied archaeology and anthropology, I had been invited to the museum by its then director Faraj Basmachi to catalog and make clay impressions of its vast collection of cylinder seals, which bore not only cuneiform texts, but elaborate scenes of various sorts. I was born in Iraq and it was a joy to return to my country. I was given a postage stamp-size work space

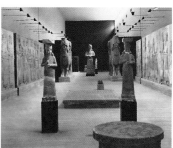

Top: The Assyrian Hall of the old Iraq Museum.
"One big room downstairs, The Babylonian Stone Room, is now finished and I am only waiting for the catalogue, which I have written, to be translated and printed, to ask the King to open it—just to show them that we are doing something. But this is the easiest of all the rooms, big objects not under glass, it is when I come to the upstairs rooms and all the little objects that the difficulties begin. The mere cataloguing and numbering of them is terrific...."
—from the letters of Gertrude Bell, May 26, 1926

Bottom: The Assyrian Hall of the new Iraq Museum.

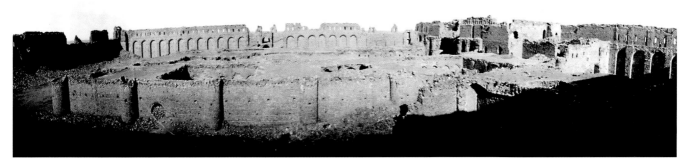

A general view of Al-Ukhaidhir, an Abbasid palace dated to the second half of the 8th century A.D. The photograph was taken by Gertrude Bell, who was instrumental in dating the site to the Islamic period.

alongside another Assyriologist in the so-called tablet room at the top of the stairs, which led to the museum's exhibition halls. The cylinder seal project was one of many curatorial initiatives carried out in preparation for the big move. In addition to documenting the collection, I was personally to select which of the seals were to go on permanent display. As I remember the challenge of narrowing the collection down from 7,000 to around 200, by no means an easy task, I cannot help but think that just prior to the museum's destruction in the spring of 2003, the collection of seals had grown to well over 15,000.

By the time the new museum opened its doors in 1966, the number of active archaeological excavations in the country had swelled to more than thirty. The Italians had reopened trenches at Selucia, first excavated by an American team from the University of Michigan in the 1920s. And there were expeditions from various institutions in the United States, including the Oriental Institute at the University of Chicago. And of course, there were numerous projects under Iraqi direction.

The early 1960s were formative years, not only for the Iraq Museum and for Near Eastern scholarship, but for the increasing opportunities that were afforded women in a field previously dominated by men, particularly in Iraq.

Naturally, as a newly graduate archaeologist, my ambition was to go out digging, but being a woman was an obstacle in conservative Iraq. Being a first, I needed to convince the authorities that I could do it. Then Director General of Antiquities Taha Baqir, being true to his liberal politics, agreed

to let me go into the field as long as I excavated within the vicinity of Baghdad. My family was happy about that, because it meant that I would still be living at home.

I began working at Tell al-Dhibai on the outskirts of Baghdad, where we discovered a second-millenium B.C. Babylonian town with quite an imposing temple, an administrative building, and many houses. The finds from the site, while not visually spectacular, were incredibly important. There were more than 600 cuneiform tablets mostly dealing with business contracts and agricultural matters, but one was unique—it was a mathematical text that was later read by Taha Baqir and identified as a proof of the Pythagorean theorem, worked out some 2,000 years before the Greek mathematician's lifetime.

This site also yielded the discovery of a coppersmith's workshop, complete with crucibles, moulds, and bellows—the best examples of their kind from the ancient Near East.

Selma Al-Radi, who had joined the museum in 1962, broke still another barrier, serving as the Department of Antiquities' representative at Warka, where she worked with the German expedition. Among the most daring of our upstart group was Rajiha al-Ni'ami, who had came from a very conservative Shi'ite family. Encouraged by our successes, she, too, joined the German expedition at Warka.

Collectively, our endeavors paved the way for a much larger participation of women in the field of excavations and research in Iraq. This proved to be valuable at a time when archaeologists were in high demand, particularly during the 1970s, when so many development projects necessitated rescue excavations. Visiting the Hamrin Basin Project in the late 1970s, I was surprised to find so many young female archaeologists working side by side with their male Iraqi colleagues.

In the spring of 2003, forty-seven of the museum's fifty-three employees were female archaeologists. Three of the museum's past directors are also women—Bahija Khalil, Hanaa

Top: Archaeologists working on the inventory of tablets after the looting.

Bottom: Haji Abid in the museum storerooms. Abid is a janitor who has been working at the museum since 1941.

Abdulkhaliq, and Nawala al-Mutwali. Nawala is known for her excavation at the Sumerian city of Umma (Tell Chokha) and her numerous articles deciphering many cuneiform tablets. Hanaa became the director of excavations.

In some ways, it is only fitting that a museum born of the iron will of Gertrude Bell would become the training ground for a new generation of Iraqi women.

As I look back through Bell's diaries and letters, I realize how far the museum had come, until those fateful days in April 2003, when the museum was sacked. Some 10,000 years of human history were destroyed along with well over a century of scholarship.

Prior to its destruction, the museum housed artifacts numbering 200,000. More than 10,000 remain missing, among them many illustrated in this book.

Little did I know when I first joined the museum how closely the challenges facing the museum would come to mirror those of its predecessor a century ago. As in 1923, we are in desperate need of proper facilities, cases, and research materials—basic items Bell had to work so hard to acquire. In building the first museum, Bell turned to her friends in the international community—to the British Museum, the University of Pennsylvania, the Oriental Institute, and other governmental agencies. We must now do the same if the Iraq Museum is to return to once again take its place on the international cultural stage.

Frontal view of the Iraq Museum. Built in the 1960s and expanded 20 years later, this 2-story brick structure holds 20 public galleries and covers 11,000 sq. m. Its relative modernity stands in great contrast to the ancient treasures within its galleries.

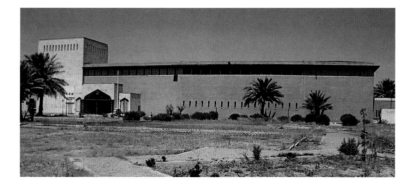

IN THE BEGINNING

Ralph Solecki

In distant prehistory, a group of Stone Age peoples took up residence near the Greater Zab River, a branch of the Tigris that snakes its way past the Bardost Mountains, one of the western folds of the great Zagros chain in the northernmost reaches of what is now modern-day Iraq. The region's hard, dolomitic limestone is riddled with caves and shelters hewn out of the living rock by percolating water over countless eons of geological time. It was within one such cave in the Shanidar Valley that an extraordinary series of discoveries was made that revolutionized our understanding of the earliest history of the ancient Near East. For it was here, more than 46,000 years ago, that a far-wandering group of Neanderthals took shelter in the cave, appropriating a portion of it as a burial ground. There, they interred at least one of their dead with bouquets of wildflowers, a touching sign of affection and one of the earliest known examples of ceremonial burial by any human ancestor. Thirty-five thousand years later, the cave would again be used as a sacred burial ground, this time for a community living on the very threshold of the Neolithic revolution. Collectively, the finds from Shanidar chronicle humankind's progression from a precarious hunting-gathering existence to a more certain livelihood based on the use and domestication of plants and animals—the very foundation upon which higher civilization was built—in an area that to this day remains relatively unknown to the outside world.

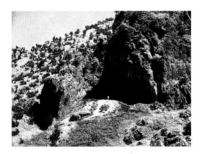

Above: The exterior opening of the Shanidar Cave, in the Baradost Mountain, part of the Zagros Mountains in Kurdistan, Iraq. The rock is limestone.

Opposite: Frontal view of the Shanidar V cranium, one of the largest known for the Neanderthals.

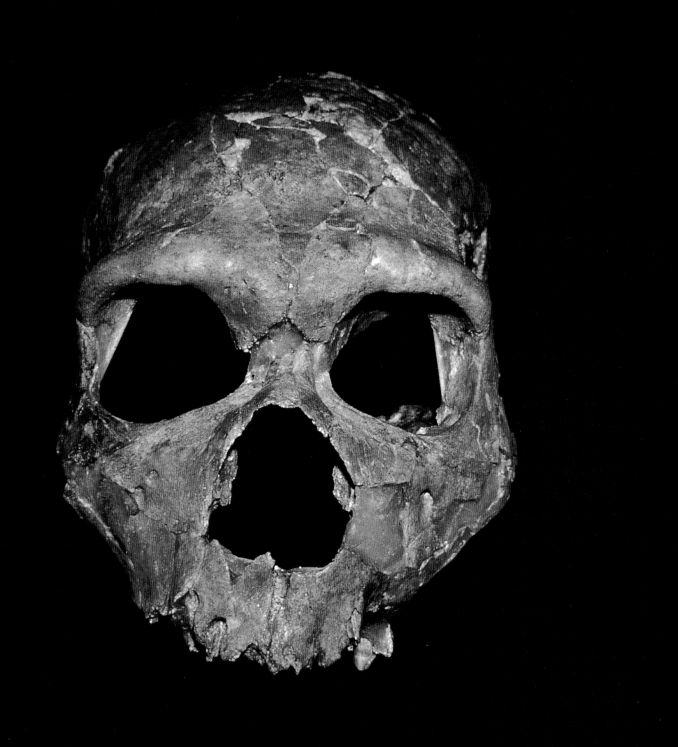

The Near East, being the "crossroads of the world," the junction between the continents of Eurasia and Africa, has long held a fascination for archaeologists. It is a place of constant ferment, from distant prehistory through to the present. It was James Henry Breasted, founder of the University of Chicago's Oriental Institute, who first coined the phrase "Fertile Crescent" in 1914, to describe the cultivable fringe between mountain and desert, which arcs its way across the Near Eastern landscape like a giant sickle with its handle in Palestine and its tip at the north end of the Gulf. The Taurus-Zagros Mountains form the very backbone of this wellspring of Western civilization, and it is here, in this region of breathtaking mountain vistas, that Shanidar is located.

The Shanidar Valley is especially beautiful in the spring, when the hillsides are blanketed in multicolored wildflowers. The principal local trees are oak and, in the higher elevations, juniper. Wild animals such as foxes, porcupines, and even wild boars and an occasional bear, are still to be seen in the valley and the mountains. Birds of prey and small game birds are

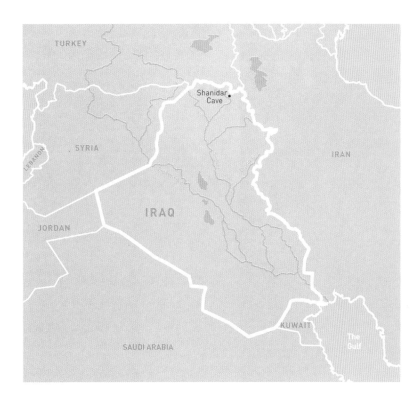

frequently observed. Large fish such as carp are found in abundance in the Greater Zab River, which flows through the valley, coursing its way to the southwest where, after joining forces with the Rowanduz River, it emerges in the foothills of the Mesopotamian Steppe.

I first came to this region in May of 1951, at the invitation of George Cameron of the University of Michigan. He had come to the Smithsonian Institution with which I was affiliated the previous year looking to fill out a multidisciplinary expedition he was planning to the Kurdish region of northeastern Iraq. While his interests were focused primarily on epigraphy and cultural anthropology—namely the recording of several cuneiform inscriptions on a large stela at Topzawa and Kaleshin —my goal was to elucidate one of the earliest chapters in the human history in the region.

At that time, the prehistory of Iraq was still largely unknown, save for what had come to light during Dorothy A.E. Garrod's pioneering work in a series of caves to the southeast in the Zagros in the late 1920s. She was the first female professor at Cambridge and the first prehistorian to focus on Iraq. Working at Kirkuk in the area of the Lesser Zab River drainage, she recovered numerous Mousterian flints and stone tools, which attested a Neanderthal presence in the area. These lithics are most commonly associated with this early hominid. Aside from Garrod's brief explorations, however, the ancient Near East, east of the Levant, remained a virtual blank in terms of humankind's cultural evolution.

It was following Cameron's expedition that I had an opportunity to survey a suite of cave sites in the greater Rowanduz area, some 400 kilometers north of Baghdad. Accompanied by the *qaimaqam* or district governor of Rowanduz, and Mahmud al Amin, a representative of the Iraq General Directorate of Antiquities, I recorded some forty caves and shelters over the course of several weeks in July. Of all of the sites we prospected, Shanidar showed the most promise based on its comfortable size, idyllic location—easily accessible on foot

The author, Dr. Ralph Solecki, with his wife Rose, outside their quarters in the Shanidar police post in 1957.

with a permanent water supply and sunlight streaming in a good part of the day—and its vaulted ceiling blackened by the soot of countless fires, evidence that pointed to the cave's long-term occupation. Scattered potsherds and flints found in the cave's forward scree slope reassured me that the cave had great archaeological potential.

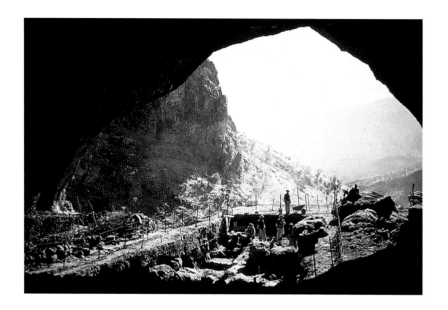

View from inside the Shanidar Cave, looking out. The excavation represents about one tenth of the estimated volume of deposits. Modern tribal Kurds still use the cave to this day: one can see the animal corrals and seasonal dwellings on the left of the image.

There is a rationale for looking for traces of earliest humanity in caves. There, deposits generally accrue without too much disturbance, preserving more or less a continuous chronology of occupation, where as open sites, those on a mountainside or on a river terrace, often vanish within a few thousand years or can suddenly be destroyed should a river change course or there be a landslide. But cave sites can also be inordinately complex affairs and are often difficult to excavate, primarily because of rockfalls.

The cave opening, which forms a large triangle, is about twenty-five meters wide and eight meters high and faces southwest, offering a grand view of the river. The cave floor covers an area of 1,000 square meters, most of which is unusually unencumbered by rockfalls, a common occurrence in an area prone to seismic activity.

When I first visited the cave, it seemed to be unoccupied. Yet I knew from the presence of temporary huts and twig animal corrals that ringed its interior that the cave had clearly been used in the recent past. I later learned that a small group of perhaps forty-five Sherwani tribal Kurds and their livestock took shelter here during the harsh winter months between November and April. The central area toward the front of the cave, however, was free of structures, so it seemed an ideal spot to begin excavation.

With the summer's end, Cameron and his crew had returned home while I remained in Baghdad to wrap up the expedition's affairs. During this time, I saw Naji al Asil, the Director General of Antiquities for Iraq, and gave him a full report of my brief investigations at Shanidar, emphasizing my belief in the site's archaeological potential.

Following these discussions, Naji Beg, as he was known, asked if I would continue work at the cave. I returned to Shanidar in the fall, this time under the auspices of the Iraqi Department of Antiquities, which underwrote the project and provided a vehicle, a driver, and a government representative to assist me in the field. Over the course of a month we were able to put in an exploratory trench, which cut through the upper levels of the cave deposits and yielded material that was Mousterian and Upper Paleolithic in date. I could tell that the cave's well-stratified deposits ran far deeper, yet any further exploration would have to wait for the following season.

Dinner in the Herki tribal chieftain's tent during their annual summer migration to the cooler mountains in 1957. From the left, the head sheikh of the tribe, Shuan Agha; the headman of the Shanidar village; Mr. Sabri Shukri, representing the Iraq General Directorate of Antiquities; the *qaimaqam*, or Iraq government district head, and Rose Solecki.

I had returned to Baghdad to write up our findings when I learned of a new Fulbright program between the United States and Iraq. Naturally, I applied for a scholarship, hoping that it would enable me to continue work at Shanidar. Upon my return to the States that spring, I received a notice saying that I had indeed been awarded a Fulbright scholarship, monies that would eventually be complemented by a Bruce Hughes Fund grant from the Smithsonian Institution. I would return to Shanidar in the fall, this time leading a joint expedition of the Smithsonian Institution and the Iraqi Department of Antiquities.

It was near the end of that second field season, in the spring of 1953, that we came upon the remains of our first Neanderthal skeleton—that of an infant, whose fragile bones came to light at a depth of nearly eight meters, buried in a flexed position some 60,000 years ago. The baby's remains were found in a dense loamy layer rich in human occupation. The infant's remains were entrusted to Muzaffer Senyürek of Ankara University who would study them in Baghdad. It was clear that Shanidar was a rich site indeed, one warranting far greater exploration of the cave and the manpower to do so.

I returned to the States to orchestrate a major archaeological campaign, enlisting a couple of Harvard friends—Philip Smith, George Maranjian, and Dexter Perkins Jr.—and Rose Lilian Solecki of Columbia University, an accomplished anthropologist who had recently become my wife.

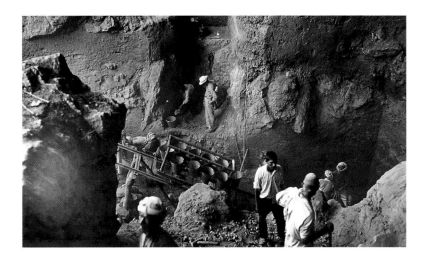

T. Dale Stewart supervising the excavation of the find spot of Shanidar Neanderthal II. The two workmen in the foreground are standing on the find spot of Shanidar Neanderthal I. The excavation reached a depth of bedrock of about 13.5 m.

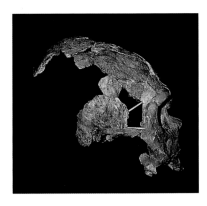

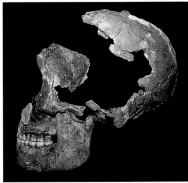

Top: Left lateral view of the Shanidar V cranium. This view shows the relatively flat frontal and curved parietal regions similar to those of Shanidar I and indicative of mild artificial cranial deformation.

Bottom: Right lateral view of the Shanidar II skull. It shows a large brain case similar in overall shape to those of other Neanderthals, relatively strong neck muscle marking at the back of the skull and in the cheek region.

We finally returned to the field in the fall of 1956. In addition to resuming work in the cave itself, we would begin the exploration of what appeared to be an ancient village site on the east bank of the Greater Zab River, which I had noticed during my earlier area surveys and just a stone's throw from the cave site. While Rose headed up the village excavation, Phil and I resumed work in the cave, reopening the trenches from the previous season and expanding them to the east and west. Work proceeded at a greater pace this season as we had the luxury of equipment lent to us by the Iraq Petroleum Company, courtesy of a family friend in New York.

The annual use of the cave by the tribal Kurds presented a curious circumstance over the course of our work at Shanidar as one by one the cave's seasonal inhabitants returned to the shelter with their animals. At its peak, the cave's occupants numbered perhaps forty-five; with our full field crew that season we made for more than sixty, carrying on our respective daily toil as doves and swallows constantly flew in and out of the cave.

We were breaking for tea on the afternoon of April 27, 1957, when Phil reported finding a second burial in the cave. It was a rainy Thursday and Phil had been up at the site supervising the removal of a bulge of earth near the top of the eastern wall of our excavation, which was threatening to collapse into our trench. At that time, the excavation resembled an inverted wedding cake, stepping down to bedrock fifteen meters below the cave floor. It was during this operation that Phil uncovered at first a calvarium, or topmost portion of a human skull, at a depth of five meters, then slowly he laid bare great broken eye sockets, which stared out hollowly from under a warped heavy brow ridge, behind which was the characteristic slanting Neanderthal brow. My notes from that day sum up the discovery: "A Neanderthal if I ever saw one."

In the literature he would come to be known as Shanidar I. To us he was "Nandy." It was clear from his bashed-in skull,

displaced lower jaw, and the unnatural twist of his skull relative to the rest of his body, which was badly broken, that Nandy had met a tragic end, crushed instantly in a violent rockfall.

According to physical anthropologist T. Dale Stewart of the Smithsonian Institution, who would later study all of the Neanderthals—save for the remains of the infant found in 1953—Shanidar I had been crippled, yet he lived to the relatively old age of forty, a very old man by Neanderthal standards, the equivalent of a man of eighty today. His collarbone and right shoulder blade had never fully grown from birth, and he had a useless right arm, which had been amputated just above the elbow early in his life. Furthermore, there was extensive bone scar tissue on the left side of his face; most likely he was blind in his left eye. There was evidence that the top right side of his skull had received some damage, which had begun to heal well before his time of death. He was also plagued by arthritis, a common ailment in Neanderthals.

What was clear was that despite these handicaps, Nandy had lived and had been cared for. Although he was born into a brutal and savage environment, Shanidar I provides proof that his people were not lacking in compassion. Shanidar I was at a distinct disadvantage in an environment in which even the strongest have a difficult time. He could barely forage or fend for himself, and we must assume that he was accepted and supported by his people up to the day he died.

Any manpower must have been an asset to this ancient little community, especially since it undoubtedly took group activity to hunt and provide sustenance. It is likely that our Nandy made himself useful around the hearth. From the unusual wear observed on his teeth, we believe he used his jaws for grasping things, manipulating them with his one good hand. It was clear, however, that he could not move fast enough to evacuate the cave when the ground began to shake. Others of his clan clearly did escape, for it was evident in our excavation that someone returned to the cave shortly after the rockfall and

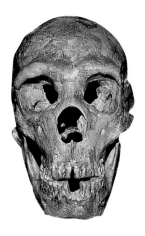

Top: Frontal view of Shanidar I, showing the exceptional length of the face.

Bottom: Right lateral view of the Shanidar I skull. This is the most complete skull known for the Shanidar Neanderthals.

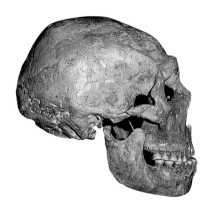

heaped upon Nandy's badly broken body a pile of stones to mark his grave. In and around the burial cairn, we found abundant food remains, perhaps the detritus of a funeral meal. Collectively, these finds suggest that even in death, Nandy was an object of some esteem, if not respect, born out of close association against a hostile world.

Within a month of our discovery of Shanidar I, the remains of a second Neanderthal came to light during the last week of our field season. Like Nandy, Shanidar II had also been crushed by a rockfall—his exposed skull shattered. The excavation of the rest of his remains, which, if they had survived, lay within the wall beyond our current trench, would have to wait until our next season—in June of 1960.

By that time, our expedition had grown to include T. Dale Stewart and Jacques Bordaz from Columbia University and Ibrahim el Zayri from the Directorate General of Antiquities of Iraq—a team that was augmented by a number of Kurdish helpers.

By the end of our 1960 field season, we had recovered remains of eight Neanderthals within the cave, four interred within a single grave not far from where we had found our infant in 1953. With the confirmation of the identification of that baby's bones as those of a Neanderthal, our total came to nine.

As each set of bones came to light, they were stabilized in situ and encased in a plaster cast so that they could be transported along with their surrounding matrix for careful cleaning, preparation, and study under laboratory conditions. It was during this process that one of the most extraordinary aspects of our discoveries came to light—the inclusion of wildflowers with the remains of Shanidar IV. The remains of this individual, a male, had been found along with those of two females and an infant in what appeared to be natural hollow among the rocks. It was clear that he had been buried in a fetal position well after the others had been interred; their remains had been shoved aside to make room for his, resulting in a scrambled mix of bones belonging to the three earlier burials.

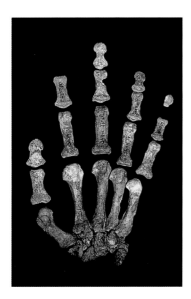

Palmar view of the Shanidar IV hand skeleton. It is the most complete known for a Neanderthal, and shows some evidence of slight wrist arthritis.

Mousterian points of flint found in Layer D, contemporary with the Neanderthal period in Shanidar Cave.

Throughout our excavation, we had meticulously collected soil samples in concert with the faunal remains in an effort to document climatic change over the occupation history of the cave. But it would be several years before these samples could be analyzed.

The samples were sent to Arlette Leroi-Gourhan, a well-known paleobotanist in Paris. In the course of examining the six samples taken from the grave of Shanidar IV, she was surprised to discover traces of not only the usual pollens and grasses that tended to blow into the cave, but the remains of pollens and flower fragments from at least eight species of plants—among them grape hyacinth, hollyhock, and a yellow flowering groundsel. She immediately contacted me to confirm the precise locations of the wildflower specimens in relation to the burial. The rich flower-bearing samples had been taken from the very same level the skeleton lay.

Although pollens were found throughout the excavation, none were found in such high concentrations as they were with Shanidar IV; according to Leroi-Gourhan, neither birds nor any other animal could have so carefully placed a collection of flowers in such a manner. Moreover, the hollyhock, a very large, pretty flower, grows in individual stands rather than in a bed with other flowers. Therefore, she concluded, someone during the last Ice Age ranged the mountainside in late May or early June, carrying out the mournful task of collecting funeral

flowers. The bouquets may have been woven into the branches of a pinelike shrub—traces of which were also found in the burial—to make a funeral bier upon which Shanidar IV was placed. It is interesting to note that taken together, the plants were not the most ornamental in the area, even during the last Ice Age. Two of the plants—the Joint Pine or Woody Horse Tail (genus *Ephedra*) and the hollyhock (genus *Althaea*)—have medicinal properties, the latter still used in the region to treat toothaches and spasms; it is considered the poor man's aspirin.

If this was the only instance of such ritual burial at such an early date we cannot say, as until our work no one had thought to look for such telltale evidence. What we can say is that it is clear from these finds that these early cave dwellers had cared for their aged, nursed their wounded, and buried their dead with extreme respect and care, clearly human traits for a relative whose relationship and place in the human family tree remains uncertain to this day.

Beyond the skeletal material we recovered nearly 800 Mousterian artifacts, the nature of which suggested that initially the cave was used as a semipermanent dwelling, but later saw light seasonal use as a way station for itinerate hunter-gatherers. Tools found in the deep deposits consisted primarily of flints, scrapers, and perforators, all of which would have been part of a basecamp toolkit. In addition to the tools, we found abundant food remains, namely the bones of goats and deer. We do know that our Neanderthals had other favorites, as Nandy and Shanidar V appeared to have been sharing a meal of fire-cooked turtle beside a hearth when a violent rockfall ended their lives.

As any archaeologist will tell you, the most critical finds from any given site seem to only emerge at the end of a field season, when time has run out, academic years have begun, and local field hands have since returned to their seasonal labors. Such was the case with our discovery of a 12,000-year-old proto-neolithic cemetery in the uppermost levels of the cave, which was made in the last days of our 1960 field season.

We decided to extend an exploratory trench toward the back of the cave from our main excavation to gauge the extent of the cave deposits. We had not progressed very far when we came upon our first burial, that of an adolescent found in a flexed position. As we only had a couple of weeks available, we limited our explorations to an area measuring some six-by-six meters, which was differentiated from the surrounding sediments being capped with a yellow loam. In this area alone, we excavated the remains of thirty-five individuals in twenty-six graves, most concentrated in an ovate area of less than eight square meters and arranged in and around a series of stone features.

What makes this cemetery important is that a special assemblage of burial goods was associated with the interments. Those of infants and children contained the most abundant grave goods, such as items of personal adornment including many strings of stone beads and a single copper ore bead (malachite), while those of adults held more utilitarian objects such as tools of stone and bone. One of the bone tools, a dagger, had been perforated for suspension. The richness and types of burial goods found with infants and children suggest that parents lavished much affection on their young, a very human trait.

The bone tools from the Proto-Neolithic cemetery in Shanidar Cave, Layer B, about 10,700 years old, by carbon–14 dating, uncalibrated.

As our work progressed on the proto-neolithic cemetery, Rose and her crew continued work at the village site, which had begun to yield abundant cultural material—namely tools— that were nearly identical to what we were finding in the cave. Later radiocarbon dating of the finds from both sites would show that the riverbank village of Zawi Chemi Shanidar and the proto-neolithic cemetery were in use at the same time.

Although Shanidar Cave lies out of the main trade routes, its inhabitants clearly maintained trade contacts with distant areas to obtain non-local materials such as obsidian for toolmaking, bitumen adhesive, and exotic stones for well-made beads. What is also evident is experimentation with new types and uses of materials. Among the finds were a bone sickle handle and another bone handle that held a flint blade secured in place with bitumen.

In addition, flora and fauna found both in the cave and at the village site show a gradual change in diet, from one based on the hunting of wild red deer and wild sheep to a dependence on domesticated sheep. Snails were added to the diet at some point, along with cultivated grains and cereals.

Stone beads, a stone bead spacer, a copper mineral pendant, a limestone pendant, a polished limestone object of unknown purpose, and a rubbing stone associated with the proto-neolithic horizon found at Shanidar Cave.

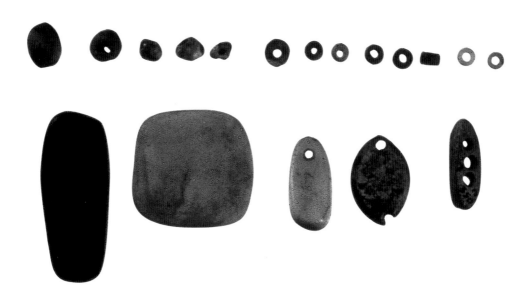

Some 12,000 years ago, when the proto-neolithic sites were occupied, this part of the world experienced a period of great climatic change. It was a time when the Shanidar Valley may have offered refuge during the cold winter months, much as it does today.

We believe that the proto-neolithic peoples, like the modern Sherwani Kurds, lived at the village site during the summer, taking shelter in the cave during the harsh winter months and interring their dead in the rear of the cave, in a place set aside for burials.

The only prehistoric cemetery site of its kind east of the Mediterranean area, Shanidar Cave adds a new geographic perspective to the study of the proto-neolithic era, which has been dominated by findings from the more extensively investigated Levant area to the west. It suggests unexpected patterns of trade and cultural interactions and offers clues to the hitherto unknown role of the Zagros-Taurus Mountains area in the prehistory of the Near East.

Over the course of four seasons, between 1951 and 1960, we laid bare some 10 percent of the cave's sediments. We would have continued had our efforts not been thwarted by civil unrest in the region, which prevented further investigation. Nonetheless, in nearly a decade of work at the site, the cave yielded far more data than we could have ever imagined. I had suspected the cave had a long occupation history. Little did I know that it would come to span more than 60,000 years of human history preserved in some fourteen meters of strata. Shanidar has proven to be the oldest prehistoric site with the longest period of occupation in Iraq.

In the decades following our discoveries, far more has come to light as the artifacts and human remains from Shanidar have been carefully prepared and studied, and, in some cases, restudied as our analytical methods have improved.

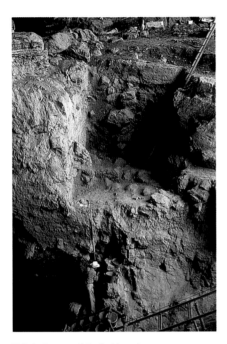

T. Dale Stewart of the Smithsonian Institution, at work on Shanidar Neanderthal IV. The find spots of Neanderthals I, III, V, and VI are also shown. The relative position of Layer B, location of the proto-neolithic cemetery is about 1 m. from the top.

Further investigations of the Neanderthal skeletons by Erik Trinkaus in the 1980s revealed that, in addition to being more heavily boned and muscled in comparison to modern humans, the most recent of the individuals were practicing ritual head deformation. And, only recently, a reassessment of the proto-neolithic remains carried out by one of my graduate students, Anagnostis Agelerakis, revealed evidence not only of trade and ritual but environmental stress such as prolonged exposure to cold temperatures and poor diet—the hallmarks of which have been forever preserved in bone. Many suffered ear infections and other maladies; traces of the body's attempt to combat such ailments are evident in so-called periosteal layers found on cranial bones. They also lived violent and strenuous lives evidenced by a preponderance of depressed skull fractures and herniated discs, the latter thought to have been wrought by labor in the fields and increased competition for resources. Those who did not survive beyond infancy often died of scurvy or rickets.

Following our work, the majority of our finds were sent to the Iraq Museum in Baghdad, which had been instrumental in providing assistance throughout the Shanidar project, for safe-keeping and study. When we learned of the museum's sacking in the spring of 2003, we were sure that the Shanidar finds were lost forever. To our great relief, they somehow survived; perhaps they visually paled in comparison to the artifacts that were taken, or maybe it was fate.

We believe, however, that we have not heard the last of Shanidar. It is likely that far more survives in the cave awaiting discovery, pushing back the clock still further, into the deepest depths of human history in the land between two rivers.

THE DAWN OF CIVILIZATION

Harriet Crawford

A great museum is a window into distant worlds. It is not always easy to understand what we see through the window, as much of the past lies in fragments, damaged, incomplete, and so far from our own experience as to be almost incomprehensible. In spite of this, glimpses of the life our ancestors led are offered by the objects that they made. If we look long and hard these can tell us something of how they lived, what was important to them, and what they held dear, even if we do not fully understand the significance of each piece. Some of these artifacts are objects of great beauty born of high technical skill, which also leave us full of admiration for the ingenuity and ability of the early men and women of the prehistoric world.

The Iraq Museum was one such window, now sadly, badly cracked with many panes of glass missing, into a past with which we too have much in common. It contained thousands of objects dug from the soil of Mesopotamia: From the prehistoric periods the physical remains of the people themselves, often retrieved from their graves; their beautifully made tools of flint, obsidian, or clay, and later, of metal; pottery, stone vessels, beads, pendants, necklaces, seals, and figurines. Among these things there are a few objects that apparently had particular significance for these early men and women, as they are made with special care and sometimes have no obvious practical purpose. They seem to show us something about the way these people viewed their world and may even

Fig. 1. Female from Choga Mami, c. 5500 B.C.

50

suggest something about their religious beliefs. In this chapter we will first look at this group of "special" objects and then at more everyday artifacts from the same period of time. The museum's galleries housed an even greater variety of artifacts from later historic periods—clay tablets, magnificent jewelry, fine bas-reliefs, and delicate ivories—objects that will be discussed by other authors in this volume.

The earliest inhabitants of Iraq were hunter-gatherers who collected seeds and berries and followed the movements of the wildlife of the mountain valleys of the Zagros (see Chapter II). About 11,000 or 12,000 years ago, more people found their way onto the rolling plains of the Jazirah of northern Iraq. They seem to have arrived from the west, coming from the Levant and North Syria, once again probably following the movements of the wild game, the gazelle and other animals, on whom they still relied for food. By about 10,000 years ago, some had settled in small hamlets in the foothills and on the plain itself. In some cases they began to build little huts or even more substantial houses, first of branches and handfuls of mud, later of mud brick and stone, in which they spent at least part of the year. Sometimes these houses were grouped together to form small communities probably lived in by family groups which, a little later, might be protected by heavy walls.

People soon began to experiment with taming the wild animals around them. Sheep and goats seem to have been the first domestic animals, together with the dogs who helped to guard them, and the earliest evidence for their domestication comes not from Iraq, but from the Levant. Soon other animals such as pigs and cattle were added to the farmyard. Donkeys were a late arrival, being domesticated about 3500 B.C., while domestic horses are not found until the early second millennium and camels a thousand years after that.

The settlers also began to try, by trial and error, to grow the wild cereals and pulses that formed an important part of their diet. The soil is good and easily broken up in this part of

Fig. 3. Three views of a stone bird head found at Nemrik, Ht. about 8 cm, c. 8000 B.C. Possibly an idol or a decorated grinding tool, the shape of its beak suggests it depicts a bird of prey.

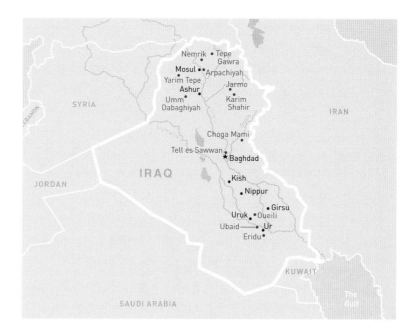

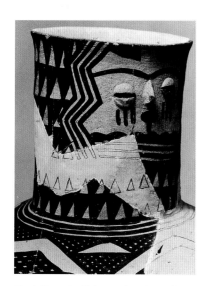

Fig. 4. Clay pot with human face decorating neck of the vessel, from the Samarra period.

northern Iraq, and there is enough rain to make irrigation unnecessary. They soon succeeded with a variety of crops, including barley, wheat, lentils, and peas, among other things. It may seem surprising to us, but the introduction of farming meant an increase in the workload for both men and women, as cultivating the ground with simple tools and looking after the animals was more time-consuming and harder work than hunting and gathering had been.

In spite of this, life was not too difficult for the earliest settlers of northern Iraq. There was ample game to supplement the farming and when the work was done, there was time to make portraits of some of the wild creatures that were still an important part of their lives, perhaps for magical purposes, perhaps just out of love or admiration. One of the first such portraits is a magnificent stone bird's head about eight centimeters tall, carved on a cigar-shaped piece of stone; the shape of its beak suggests that it represents a great bird of prey. It was found, together with other similar pieces at the small, perhaps seasonally occupied site of Nemrik, which was inhabited about 10,000 years ago and lies not far from the modern town of Tell Afar. The inhabitants of Nemrik lived in substantial

houses and were already herding sheep and goats, although hunting remained an important source of protein (fig. 3).

We do not know whether the birds were some kind of idols, sympathetic magic, or just decorated grinding tools, but it is interesting to note that at an even earlier site called Karim Shahir, in the foothills of the Zagros mountains, a team of archaeologists from Chicago under the leadership of Robert J. Braidwood found a heap of bones from the wings of a number of great predator birds, vultures, and eagles, along with birds' skulls. The archaeologists suggested that these remains may originally have been used in shamanistic rituals, when men dressed themselves in the remains of these powerful birds. This may indicate a magic function for the Nemrik birds, too. We do not know whether the Nemrik bird's head, and the nineteen other similar pieces, escaped the looting of the Iraq Museum or not. It is feared they may have been stolen.

Other animals, too, were depicted in a variety of ways. Another, more recent, site called Umm Dabaghiyah, which dates to about 6000 B.C., and was probably also only seasonally occupied, was used primarily for hunting the wild asses or onagers that lived in the desert on the edge of the Wadi Tharthar, west of the Tigris, on the plain between the two rivers. As agricultural villages are known at the same period in the more fertile areas of the Jazirah, as this great plain was known, it may be that some of the farmers came out to Umm Dabaghiyah at certain times of the year just to hunt. One of the most extraordinary things about this site is that the walls of some of the small, snug houses were decorated with paintings. Most of the paintings are very battered now and it is difficult to make out what they depicted, but the best preserved work, which was carefully restored and transported to the Iraq Museum, shows a hunting scene with onagers apparently being driven into a trap made up of nets pegged to the ground. This is the first evidence for a hunting technique that is also depicted on the walls of the famous painted hunting lodges in Jordan of the Ummayyad period dating to the first millennium A.D.,

Fig. 5. A pot modeled in the shape of a woman, from the Mesopotamian village of Yarim Tepe II, Halaf period, c. 6th millennium B.C.

about seven thousand years later. The Umm Dabaghiyah painting is the first depiction of a tradition that was to last thousands of years. After the hunt, every part of the animal was probably used, from meat to hides as well as horns and sinews. A large storage block made up of small, square rooms, too small for people to live in, stood in the middle of the archaeological site, and it is thought that it was probably used to store the remains of the hunted animals.

A fully agricultural way of life spread slowly across northern Iraq and into the foothills of the Zagros mountains where at the small village site of Jarmo, also excavated by the Chicago team, the inhabitants modeled a range of clay farm animals and the dogs which looked after them, in addition to the wild creatures we've seen from earlier times. My own favorite model is of a dog with a curly tail, much less intimidating than the hulking mastiffs that guard villages in the countryside of Iraq today, terrifying passersby with their attacks. There are a few rather schematic human figures as well with barely defined features. They are mostly female, as is so often the case in early societies, but at least one male was found. It is interesting that throughout the period covered by this book, the modeling of animals is almost always livelier and more realistic than that of people. Even in the great hunting reliefs of the Assyrian Empire, the lions are moving representations from life, while the human figures tend to be rather wooden stereotypes of kings or priests.

It is in these early farming villages that we find the earliest attempts at making pottery. Initially it is ugly stuff, handmade, barely fired at all, and often seems to imitate the shapes of the skin bags that people had previously used as containers. Gradually the quality improves and by about 5500 B.C. in the so-called Samarra period, we find fine pots being used to portray animals and people, too, as well as the normal range of plates, bowls, and jars. Some elegant jars of fine paste have the outside of the tall neck of the vessel decorated with human faces painted in reddish paint. These faces have slanting eyes

Fig. 6. Zoomorphic pot in the shape of à porcupine, from Arpachiyah, Halaf period, 6th millennium B.C.

shaped like coffee beans that are occasionally inlaid with small pieces of shiny black stone to make them glitter. The cheeks and foreheads are painted with elaborate patterns that may represent tattooing, a fashion still seen on many people in the countryside of Iraq today (fig. 4).

There is another slightly later example where the whole pot is modeled in the shape of a woman. It comes from the early sixth millennium Halaf period site of Yarim Tepe II, a prosperous village in north Mesopotamia, excavated by a Russian team, and shows a headless female figure holding her breasts. She is shown elegantly clad in all her painted beads and what looks like a flower in her navel and not much else; wavy lines descend down her back from a collar or necklace, perhaps her long curling hair. Her body ends below the thighs in a circular stand decorated with painted triangles (fig. 5). She may have had a ritual significance, as it is difficult to see what practical purpose she can have fulfilled, and she had been carefully buried in a pit below the earliest levels of the site, perhaps as an offering to the local deity. Some pieces are more frivolous, like the delightful animal pot found in an adjacent pit. The neck of the pot rises from the middle of its back and the animal is painted with complex patterns, but unfortunately the head is absent, and it is difficult to know what animal it represents. A somewhat similar pot from Arpachiyah, another important Halaf site, seems to be a model of a porcupine (fig. 6).

The representation of human figures becomes more sophisticated as time passed and some of the most remarkable early examples date to the early sixth millennium B.C. and come from a site close to the great Islamic city of Samarra called Tell es Sawwan, north of modern Baghdad. This was a farming village and stands almost at the junction between north and south Mesopotamia. It had a dozen or more large, well-planned houses with a protective wall around them and a great ditch which may have acted as a sort of moat, as well as bringing water to the settlement. Here a cemetery was uncovered below the buildings. There were a large number of graves, about 130 of which have been excavated. Many of them contained

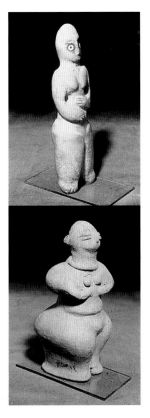

Fig. 7a–b. Female figures from the cemetery at Tell es Sawwan, 6th millennium B.C.

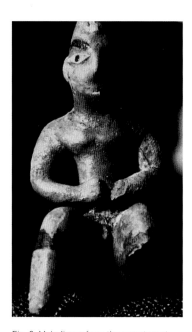

Fig. 8. Male figure from the cemetery at
Tell es Sawwan, early 6th millennium B.C.

curious little stone figures of curvaceous, fat-bottomed
women, often decorated with necklaces of small beads. (See
Chapter IV for more details and analysis.) The figures have
schematic features and staring inlaid eyes, while the size of
their behinds means that many of them cannot stand upright
without falling over (figs. 7a–b)! Does this tell us something
about the ideals of female beauty at the time? Was being
plump associated with prosperity, contentment, and fecundity?
There is also one male figure, made of pottery covered in a
pinkish slip, that was found in one of the very early buildings
at the site. He sits with his knees apart in a somewhat aggres-
sive pose and wears painted bands below his knees, perhaps
representing the decorated hem of his trousers, and what looks
like a Phrygian stocking cap or perhaps a Mohican hairstyle
(fig. 8). The cemetery also has yielded some beautifully made
stone vases, apparently made locally of imported material, on
which the natural banding in the stone has been used to great
effect to provide the decoration. The craftsmanship of these
pieces is very fine indeed and a reminder of the skills of these
ancient peoples (fig. 9). We do not know whether these
human figures were self-portraits, representations of family
members dead or alive, of protective deities, or, even in some
cases, where they are found with children's burials, just toys.
Their presence, and that of other items in the graves, does
suggest a belief in an afterlife. Why else should such care be
taken to furnish the graves?

It was about this time in the late sixth millennium B.C. that
people settled permanently in the southern plain of Sumer,
because here much of the land was marsh and the rainfall was
so low that simple irrigation systems were essential before the
land could be farmed. Once an irrigation system was in place
that could drain the land and then bring water to the fields
when it was needed, as well as protecting them from the
floods that occurred every spring, the land was immensely
fertile, and the marshes teemed with fish and wild fowl. The
earliest villages in southern Iraq belonged to the so-called
Ubaid period which began before 5000 B.C. and lasted

about a thousand years. About 500 years after it was established in Sumer, this Ubaid pottery is found all over North Mesopotamia as well, and even occurs in Syria and Iran. This wide distribution cannot be taken as evidence for political unity of any sort, but the cultural homogeneity is remarkable. The Ubaid farmers built fine houses and from the very beginning of the Ubaid period some strange, very powerful heads of humans and monstrous beings begin to emerge, showing considerable technical skill and a vivid imagination. Dr. Joan Oates, at that time working with the British School of Archaeology in Baghdad, found a number of such heads, some more realistic than others, in her excavations in the 1960s at Choga Mami, east of the Tigris River. They are made of clay, decorated with purplish paint, and one of the best preserved represents a person with a plait of hair wound round her head, coffee bean-shaped eyes with long painted lashes, possible tattooing on the cheeks, and studs in her nose and lip (figs.1, 10). Body piercing is nothing new! Others have different styles of decoration and different hairstyles. One of the heads even has what resembles a pig's snout. It is sometimes difficult to tell what gender the figurines represent as none of them is still attached to its body, but most appear to have been female.

The heads had apparently originally been inserted into the necks of modeled clay bodies, examples of which were found too, each wearing a necklace and with the same big buttocks we saw on the Sawwan figurines. One might almost say that the two groups of figurines look like distant cousins; they certainly have a family resemblance in spite of the difference in the materials from which they are made. The Choga Mami figurines come from debris among houses with multiple rooms in what seems to be a small, perhaps fortified, agricultural village, rather than from graves. We do not know if they had religious or magical significance, or if they were just children's toys as we suggested before. Perhaps the more realistic ones may have been dolls, while the monstrous heads may have come from figurines intended to protect the community by scaring off even more hideous, ill-intentioned demons and

Fig. 9. Stone vase with natural banding from cemetery at Tell es Sawwan, 6th millennium B.C.

monsters, a practice for which there is much anthropological evidence. Many of our great cathedrals, for instance, are decorated outside, on this principle, with hideous figures of stone gargoyles to scare away evil spirits.

By the middle of the Ubaid period, about 4500 B.C., there is evidence that a significant transformation occurred in society. Some communities grow considerably larger and more complex than others and for the first time, we find buildings in these larger villages or small towns that are certainly shrines or small temples. Their presence suggests that religion played a central place in the life of these people, although, in the absence of written evidence, we have little idea of what their beliefs were. A long series of seventeen superimposed buildings, of which at least the top six were temples, was built at one of these new small towns in southern Iraq called Eridu. Eridu was reputed in Sumerian myth to be the first town in the world and was also thought of as the home of the water god Ea/Enki (see below). The temples at Eridu are elaborate rectangular mud brick buildings with their façades decorated with buttresses and recesses. Inside are three rows of rooms, the large central one being the main shrine with an altar, and an offering place where fish seem to have been burnt as an offering to the water god. This shrine is flanked by two rows of smaller rooms. Some fascinating objects were recovered from these temples and one of the most mysterious is a pottery snake, its head originally attached to the body by means of holes in such a way that it was mobile and could have been perhaps used in divination ceremonies to nod or shake its head. Part of the snake was actually found inside the boxlike altar of one of the temples, underlining its importance. The Eridu temples not only demonstrate the importance of religion in the Ubaid period, but are also convincing evidence of a considerable degree of skill in mathematics and engineering within the community, which allowed them to design and build such structures. The society must also have been prosperous enough to provide food and tools for the huge number of people needed to erect such major public buildings.

Fig. 10. Side view of clay female head, from Choga Mami, c. 5500 B.C.

One of the other famous finds from Eridu is a charming model of a boat that is made of clay found outside the temples. It apparently originally had a mast in the center to support a sail (fig.11). Water was the most important means of transport in these early days before the invention of the wheel, and subsequently of proper roads, so boats were a vital means of communication and transport to the people of the marshes and rivers. The waterways also brought irrigation water to the inhabitants of the settlements, to the fields where the all-important barley was grown, and to the date gardens that were also an important resource. The canals and streams were also a rich source of food, as they teemed with the fish and wild fowl that formed a crucial part of the diet. No wonder the patron god of water Ea/Enki was seen in the Sumerian myths as the friend of mankind! It was he, according to the Epic of Gilgamesh, who warned Ziusudra, the Sumerian Noah, of the impending flood sent by the gods to destroy mankind. Ea instructed Ziusudra to build an ark and so saved the human race.

A large cemetery laid on the edge of the settlement at Eridu and from it came more mysterious humanoid figurines. The most impressive is a male figure standing 14.4 centimeters high, found in a female grave (fig.12). It has a human body and a lizard-like head that has some affinity with the earlier Choga Mami heads; the back of the head is improbably elongated upward, the eyes are again shaped like coffee beans, while the nose and vestigial mouth come forward into a snout. The figure has a wasp waist and its hands are held together at waist height. In one hand he holds a stick of some kind, the other end of which rests on his forearm in a pose that is curiously Egyptian looking. Round blobs of clay decorate the upper arms, shoulders, and chest. There are similar pieces depicting females as well, but all are broken. Fortunately, better-preserved examples are known from nearby Ubaid (fig.13) and from the more recently excavated site of Oueili to the east, in the center of the Sumerian plain. Some of these females are suckling infants who have exactly the same elongated heads.

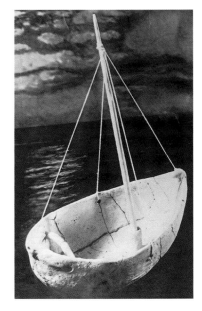

Fig. 11. Model of a boat, terra-cotta, from Eridu, Ubaid period, c. 4000 B.C.

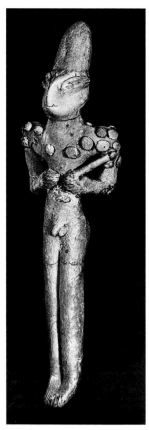

Fig. 12. Humanoid male figure from the cemetery at Eridu, Ht. 14.4 cm.

Fig. 13. Humanoid female figure suckling an infant, from Ubaid.

Do these figurines represent a special group of elite human beings whose heads were monstrously distorted by cranial binding at an early age, or are they representations of some supernatural creatures? Was the protrusion just a way of attaching some elaborate headdress, or did it indicate their standing in the community? Certainly the presence of bitumen, a black gluey substance, on some of the protuberances suggests the attachment of either wigs or some other kind of headdress to the figurines. There is some skeletal evidence for skull binding in the sixth millennium Halaf period in north Mesopotamia, in which the backs of some skulls were found elongated into an unnatural shape, apparently by binding in infancy. On this evidence our southern figurines could be an artistic exaggeration of real life, but many other explanations are possible. We could once again be looking at protective creatures, for example, or at evil demons. We cannot tell what the right answer is.

So far we have only considered what we earlier called the "special objects" housed at the Iraq Museum, but the skill devoted to more everyday objects has also produced beautiful artifacts. Flaked obsidian blades, some only a few centimeters long, are exquisite as well as extremely sharp. Polished stone axes, often made of fine-grained colored stones, are supremely well adapted to their task and sit satisfyingly in the hand. And then there is the pottery. Large round dishes from sites of the so-called Samarra period (see figs. 14 and 16 and Chapter IV) which is contemporary with the earliest Ubaid levels in the south about 5000 B.C. are covered with rather spiky designs that whirl around the center of the plates with an energy that is tangible. Some show women with flying hair, others schematic animals or birds, others geometric forms. Halaf pottery, which is made slightly later, reaches standards of design and production hard to match even today, but here the designs are mainly geometric; the size of the plates are enormous, up to eighty-five centimeters in diameter, and the best of them are painted in three or more vibrant colors —black,

white, and shades of red and orange (fig.15). The paste is so fine and the firing so hard it is difficult to believe that they were made by hand about 7,000 years ago. By contrast the Ubaid period has produced delicate goblets of greenish clay painted with soft, sweeping designs in a paint that is often almost deep purple. The Iraq Museum has examples of all these beautiful representations of the potters' art and of many more. It is hard to believe that the most sophisticated examples of these pottery styles were not made by specialist potters probably working in their own homes, but more mundane examples were probably produced by each household for its own immediate needs.

Even at this early stage in mankind's history, people seem to have felt the need to be able to demonstrate ownership of goods and chattels by marking their belongings with special symbols and design patterns. There are many ways of doing this that will not survive in the archaeological record. Fortunately, one of the favored methods of marking objects involved the use of stone or clay seals, each decorated with a unique design specific to its owner. This design was stamped onto a piece of clay stuck to the item in question or its container. The technique is a very old one that may have originated in Syria or in Anatolia, but the Iraq Museum has a fascinating collection spanning literally thousands of years. Some of the earliest are so-called stamp seals, which date back to before 4000 B.C. at sites such as Tepe Gawra, a small manufacturing town in the northeast of the country. Here circular and rectangular seals were found, often pierced so they could be suspended around their owner's necks or wrists for safekeeping. When stamp seals first appear they are decorated with simple geometric designs, and then by the end of the Ubaid period, about 4000 B.C. with scenes of animals and people (fig. 17). There are also a number of small clay counters in various shapes and sizes, which seem to be an early tool for recording the number and type of goods involved in various transac-

Fig. 14. Dishes decorated with geometric designs, representative of the pottery of the Samarra period, c. 5500 B.C.

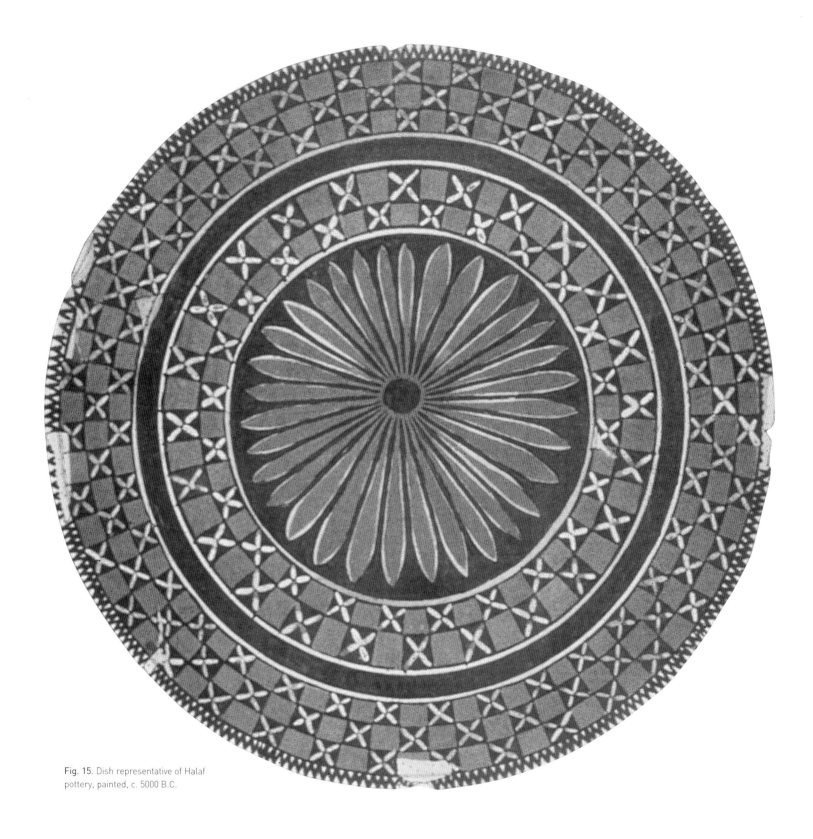

Fig. 15. Dish representative of Halaf pottery, painted, c. 5000 B.C.

tions. It has been suggested that the seals and the counters represent some of the precursors of what was later to develop into the first writing system that the world will know (see Chapter VI).

By the end of the Ubaid period there had been a great increase in the settled population and we can trace an evolution from isolated agricultural villages and hamlets in the north of the country, to one where the whole of Mesopotamia had been settled by people who lived in a variety of communities, some of which were larger than others and boasted monumental temples. An irrigation system was in place in the south of the country, which allowed an immensely productive agricultural regime to flourish. It produced cereals and garden crops, especially dates; this vegetable produce was augmented by flocks of sheep and goats, and herds of cattle that were also used as draft animals. Part of the surplus produce derived from the fertile land was used to feed the specialist craftsmen within society who produced the elite goods we have described, while some of the produce could also be exchanged to acquire the exotic raw materials that Mesopotamia lacked.

Fig. 16. Dish decorated with geometric birds, representative of the pottery of the Samarra period, c. 5000 B.C.

It is important to remember that many people may well have chosen not to settle and preferred to remain nomadic. Indeed, the presence of nomadic groups who lived by herding flocks of sheep and goats on the periphery of the agricultural zone is a feature of life throughout the history of Mesopotamia. There is little evidence for their presence in the museum, as they left little trace in the archaeological record; much of their material culture was made of perishable materials such as skins and wool, and they lived in tents. We have only textual references in the cuneiform sources and the modern ethnographic examples to help us visualize their life.

The people living in these new towns possessed all the skills necessary for the great leap toward an urban, literate society which produced wonderful objects of art, which is the subject of the next chapter. Without the achievements of these earlier

inhabitants of the Mesopotamian plain, great works of art like the famous Warka Vase would not have been possible. It is only when there is an agricultural surplus that craftsmen can specialize full-time in their own crafts. When the population reaches a certain size there is also a market for such goods and the potential for the beginnings of a social hierarchy. The emergence of elite groups provides a market for the goods of these craftsmen. This increasingly complex society demands more formal administrative systems. These become a powerful incentive toward the development of new technologies such as writing, with which increasingly complicated transactions can be recorded and the information about them stored. All these complex sociological, economic, and technological developments can be identified by the end of the Ubaid period and were to be seen reflected in the collections of the Iraq Museum before the second Gulf War. How much of this evidence has been lost, stolen, or smashed to smithereens, we do not know.

Only a fraction of the evidence present has so far been recovered from the soil of Mesopotamia, and much more remains for us to find. New treasures certainly remain buried and await the excavator's trowel. Sadly, the looting of sites that is taking place in the unrest following the second Gulf War and the growth in the trade in illicit antiquities is imperiling these unknown objects, too. This book is an attempt to preserve at least the memory of the pieces that have been lost, and to give fresh impetus to efforts to give Iraq's heritage a brighter future.

Fig. 17. Stamp seal with scene of animals and people, c. 4000 B.C.

Chapter IV

SMALL TREASURES OF THE IRAQ MUSEUM

Fiorella Ippolitoni Strika

Fig 1. Pottery fragment featuring painted "Mazinga" figure, with straight fan-shaped hair, three-pronged hands, and fan-shaped foot, Samarran, from Tell es Sawwan.

Fig 2. Standing female statuette in alabaster from Tell es Sawwan.

Aside from the death, destruction, and toll on the cultural heritage of Iraq, the Gulf Wars had the single positive result of awakening international interest for the culture of Mesopotamia. Thousands of people the world over discovered that Iraq means something more than oil. For most, however, this awareness is of Mesopotamia's high cultures and its contribution to civilization both East and West—writing, architecture, and sculpture—executed on a grand scale. Yet few people are familiar with the prehistoric cultures of Iraq that laid the groundwork for and gave rise to Sumer, Ur, and the later empires.

For those who had the opportunity to visit the Iraq Museum in Baghdad, its first gallery provided just such a primer on prehistory. Within its many cases were myriad artifacts chronicling some 60,000 years of human history. While the finds exhibited in this gallery seemed to pale in comparison to those elsewhere in the museum in terms of sheer artistic merit, they could hardly be considered minor art forms, for they bear witness to humanity's first experimentation with agriculture and pottery making, and, in some cases, the codification of religious ideas. Of particular importance are the stone and clay statuettes and painted vases first discovered in 1964 by Iraqi archaeologists at the site of Tell es Sawwan, on the left bank of the Tigris, a few kilometers south of the town of Samarra.

Five archaeological layers have been uncovered at this late Neolithic village. The pre-ceramic base Level I, beneath which the burials containing the stone statuettes were found, has been dated by radiocarbon at 5573–5506 B.C. It is characterized, as is Level II—also relatively poor in pottery—by large, tripartite buildings with several rectangular rooms and a regular layout, and by a ditch excavated all around the settlement. By Level III, dated at 5349–5150 B.C. or earlier, the ditch was lined by a wall, and several buildings with a peculiar T-shape outline were built inside it. By Level III we have the explosion of the classic Samarran pottery, painted with charming geometric and naturalistic patterns, somehow echoing textiles, but also displaying plain, incised, and incised and painted types of patterns. By Level V we have the Halaf painted pottery, and the late Levels IV–V show a trend toward heavier and coarser designs, resembling the transitional Samarra-Ubaid artifacts (see Chapter III: The Dawn of Civilization), well known from Choga Mami in the Mandali area.

A look at the map may help to explain why such a peculiar village was built at this site. It is certainly not a coincidence that Baghdad lies in a central position at the point where the Tigris and Euphrates are very close. In the same way, we see that Sawwan was built at a point on the Tigris River that was

Fig 3. Samarra pottery, with centre designs of swastikas and figures set in rotational patterns, c. 5350–5150 B.C.

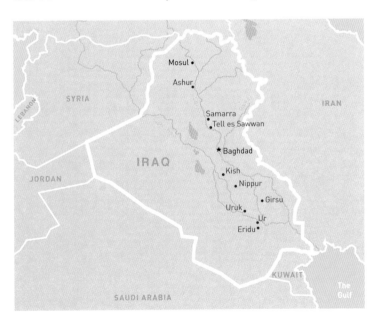

Fig. 4. Bowl painted with zigzags in black, white, and red fugitive colors. Polichromy is rare in Samarra pottery but witnessed in this exceptional, possibly experimental, piece from Tell es Sawwan.

Fig. 5. A Venus figure with streaming hair is painted on a greenish sherd, Samarran, from Tell es Sawwan.

Fig. 6. Incised "Mazinga" figure, with straight fan-shaped hair, three-pronged hands, and fan-shaped foot, Samarran, from Tell es Sawwan

easily reachable by seminomadic peoples traveling eastward from the Syrian Middle Euphrates area, crossing a desert interrupted by wetlands and Lake Tharthar. Indeed, several traits link early Sawwan with pre-pottery Syrian sites on the Middle Euphrates, such as Bouqras, and the Samarran pottery from Sawwan closely resembles the pottery from the Syrian site of Baghouz, on the left bank of the Euphrates.

My suggestion, in order to explain the uniqueness of the Sawwan stone statuettes, is that Sawwan was conceived as a religious as well as an economic center for people who had begun to abandon the early village-farming way of life that was linked to domestic production, and had developed a mechanism of production for specialized goods with the creation of a tributarian economy based on wealth surplus, expansion of trade, and cultural relations with both nearby and faraway villages.

Although many stone statuettes are now unfortunately reported as missing from the Iraq Museum, I was able study and photograph them soon after their discovery[1] in 1970–1971 and in subsequent years, when their fragile materials and appliqué decorations were still perfectly intact, and I managed to get a rich series of data on the context of their finding, studying the unpublished Arab files in the Iraq Museum (which are also reported as partly missing).

[1]For the permission to study the Sawwan materials, many thanks are due to the excavators of Tell es Sawwan, especially Drs. B. Abu es-Soof, K. Al 'Adhami, W. Yasin and D. Youkhana, to the Iraq Museum directors and employees, who encouraged and helped me in different ways, even during periods of troubles in the country. Zuhair Samarrai helped me with the Museum Arab files.

The site of Tell es Sawwan is considered the type-site of Samarran pottery, which was first discovered in the Islamic town. We have plain, incised, and painted wares, the latter characterized by the neat geometry and enigmatic naturalism of their patterns (figs. 2–6): meanders and triangles, chevrons and cables frame trees and suns, monstrous human beings and swastikas—shown for the first time as such—and also patterns involving humans and animals in whirling motion. The idea of perennial, cosmic movement seems confirmed by a tiny bone pendant with four running legs found at the earlier Syrian site of Bouqras (fig. 7). Primitive as these images may seem, they have endured, remaining part of the visual canon well into modern times.

Though there is no evident link between the stone statuettes and the Samarran pottery found at Sawwan, we must emphasize that both share the same skill for abstraction and geometric rendering of nature and volume that can also be seen in the site's well-planned architecture, which was built according to an architectural unity of measure (fig. 9).

The most impressive discoveries from Tell es Sawwan were hundreds of stone statuettes, all displaying various anthropomorphic characteristics, hinting at different genders and ages, which were found mainly within graves belonging to the two earliest levels of the site. Their presence in such deep antiquity implies a society endowed with a special concern for anthropomorphism, apparently with a care for details and a concern for showing true individual portraits (figs. 8, 10–19). They are a unique witness to the skill in art forms of early mankind in the ancient Near East, a true "statuary" created almost three millennia before the earliest known proto-Sumerian sculptures of the third millennium B.C. and a milestone in cultural history.

Investigating the ways in which preliterate people imaged humanity has yielded deep insights into the society that created this art. In short, body language speaks volumes. It is a silent

Fig. 7. Bone pendant from the Syrian site of Tell Bouqras, roughly contemporary with early Sawwan, Deir ez-Zor Museum.

language of highly stylized anthropomorphic figures, which can be decoded through the close examination of details such as gestures, gender, features, positions, and ornaments.

Nowhere is this more evident than at Tell es Sawwan, a site whose artistic representations do not consist of a few isolated examples—as it is usually the case for most prehistoric sites—but form a rich and varied body of work. Moreover, the artistic conventions exhibited on the statuettes are echoed in other artifacts found at the site, in the human figures painted on pottery and in stone and clay vessels adorned with human features.

For the past thirty years I have focused my research on the extraordinary collection of clay and stone statuettes, examining them and sorting them based on a variety of criteria. In the process, a series of distinct patterns has emerged, enabling us to begin to decipher and understand the meaning of what might at first glance appear to be a corpus of sometimes idealized but otherwise extremely individualized figures. When

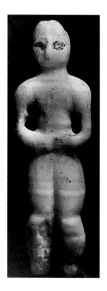

Fig. 8. Standing male statuette in alabaster from Tell es Sawwan. The arms are shown in a prayer attitude, while the thin waist emphasizes the rounded shoulders and the well-proportioned legs show some movement.

Fig. 9. Map of the archaeological site Tell es Sawwan, on the left bank of the Tigris.

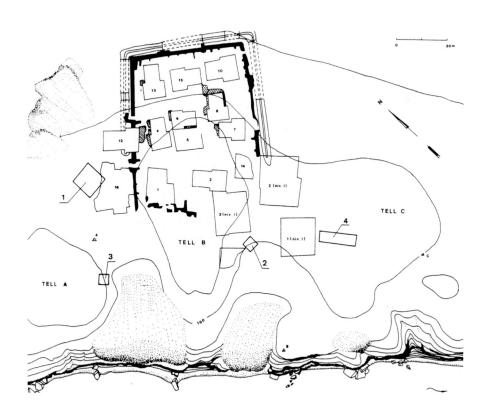

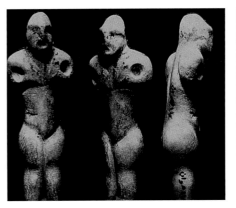

viewed in such light, these early images of the human form convey both values and socio-religious concerns that are far more complex and sophisticated than our previous typological analyses have implied (Most early studies, it should be noted, have dismissed more commonly found clay figures as nothing more than a minor art related to a fertility cult.)

Aside from the disparate plasticity of clay and stone, the two groups of figurines are stylistically linked yet there are differences. In the stone statuettes, a standing position predominates, whereas the clay figurines are represented almost exclusively in sitting or semi-reclining position. Also different is the context in which the statues were found—the stone ones were recovered from burials while those of clay were found inside houses. Both groups of statues nonetheless have much in common—their postures and hairdos, applied eyes and necklaces, and the use of bitumen, a black tar-like substance found throughout the Near East, to highlight certain physical features. More generally, we can trace practically all types of clay figurines to stone prototypes.

The subtlety of the artists' craftsmanship in making each statue can be understood only when it is viewed at various angles or in radiant light, varying shadows creating volume and perspective. Indeed, the statuettes' various parts, such as the head, torso, or lower body, change dramatically even in relation to one another depending upon the inclination of the light.

Fig. 10. Standing male statuette in alabaster, with powerful muscles, thin waist, and shoulders stylized in roundish blocks, from Tell es Sawwan. 10 x 3.6 cm.

Fig. 11. Very stylized figure, with flattened upper body featureless face and short plump legs, from Tell es Sawwan. 9.5 x 3 cm.

Fig. 12. Standing female statuette in alabaster from Tell es Sawwan. She has a pointed headdress, arms in Venus attitude, and very elegant proportions of upper and lower body. 13 x 3.5 cm.

Fig 13. Standing female statuette in alabaster from Tell es Sawwan. The headdress is flattened; the protruding lips, the staring eyes, the shiny surface with reddish stripes characterize this enchanted lady. 9.8 x 2.9 cm.

Fig. 14. Standing headless female statuette in alabaster from Tell es Sawwan. The concave neck and dimple nipples were possibly intended to hold separate head and breasts. Very well proportioned with naturalistic buttocks and legs. 5.9 x 2.8 cm.

Fig. 15. Semi-reclining doll-like statuette in alabaster, from Tell es Sawwan. The round head with well-proportioned ears and nose, has romboidal applied shell eyes. The short neck bears a double turquoise necklace, applied over a bitumen pectoral. The figure has lightly relieved breasts and a highly polished surface. 13.2 x 5.5 cm.

Fig. 16. Seal-like base of a Sawwan statuette.

Among the most striking differences within the statues are related to gender—those that are clearly male or female, and those of indeterminate gender or hermaphroditic. Aside from the presence of sexual features, males and females differ in the positions of their arms and hands. Males are most often shown in a so-called "prayer pose"—a pose well-known in later Sumerian sculpture—their arms down and their hands gently clasped at their navels (fig. 8). Their chests are broad with squarish, flattened, or slightly relieved breasts. Females, by contrast, appear in the classical "Venus pose" with one hand across the chest, the other on a hip or near the navel. (figs. 12, 13). It is possible that statues of individuals seemingly devoid of gender in either features or pose represent children or adolescents, while those bearing both male and female genitalia might be interpreted as shamans, deities, or persons of elevated rank (figs.15, 17, 19, 21).

Incidentally, the special shared features found in both stone and clay statuettes such as cranial deformation and body decorations like paints, tattoos, jewels, and hairdos may give us clues as to what may have been long-established ethnic-cultural relations. The roughly incised pattern underneath a seated statuette (fig.16) and the seal-like appearance of some others, together with the presence of anthropomorphic seals at the Syrian site of Sabi Abyad and of a seal with anthropomorphic characteristics at Sawwan, suggest a possible use of the statuettes as identification devices, but they could as well have been conceived as ancestors protecting buried goods. We know the importance of protectors for nomads, and in the Sawwan cemetery assemblage we see a regard for storage and treasuring, very similar to those found in the necropolises of nomad tribes.

Among the clay figurines, the most impressive is the "red male" (fig. 21), a jeweled baked-clay statuette represented in semi-reclining position, with arms at waist and bulging breasts. It can be considered unique and the earliest "naturalistic" rendering of the male figure in the Near East.

It is depicted in a typically male-assertive pose, with legs spread apart to show the genitalia, the head with a peculiar hairdo combed to a central bun, almost in Native American style. It is also echoed by the kneeling green stone statuette of Sawwan (fig. 19), and can be assumed to be the rendering of the hair-style of some special person.

The only standing clay figure, which I should name "the offerer," or "the singer" (fig. 22), is almost to be considered a vase, insofar as it is empty and has a hole on the head. In profile it resembles a few peculiar steatopygous "male" stone statuettes with overly emphasized hips and legs; its upper body, with rounded arms and small pellet-breasts (which seems to be just a more stylized version of the "red male" posture) closely associates it with some round-shouldered stone statuettes (fig. 8, 10). Samarran pottery vessels with zoomorphic or human features (fig. 20) are a peculiar group related to some special religious meaning or function. We know from other findings in temples the importance of zoomorphic-handled cups in Sumerian rituals: We find a literary echo of this in the myth of Inanna and Enki when the god addresses Isimud and tells him: "Give her to drink date wine in the 'face of the lion'" (Kramer, 1961, p.65), meaning that a lion-headed vase was used for the gods.

I believe that the Sawwan stone and clay statuettes represent the climax of a long tradition, as well as the departure point for new, more mature experiences which would culminate later in the Early Dynastic sculptures. I also believe that it is necessary to set them within a general context of prehistoric sculpture that includes clay figurines, stone and clay reliefs, stone-carved bowls, bracelets, amulets, and last but not least, carved seals. The Tell es Sawwan art should be approached also through a comparative evaluation of the "artistic" achievements and stylistic trends among contemporary findings, something often dismissed by archaeologists.

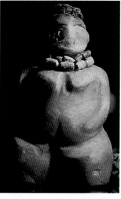
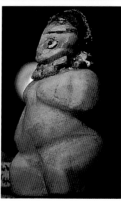

Fig. 17. Two views of a seated statuette in alabaster, with bitumen arranged in curls, bitumen inlaid eyebrows, and applied almond-shaped eyes in shell. Also an applied double turquoise necklace. From Tell es Sawwan. 9.4 x 5 cm.

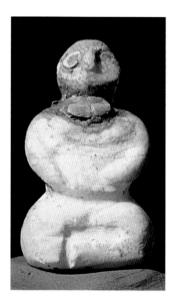

Fig. 18. Tiny seated statuette in alabaster with big nose, applied eye, applied turquoise necklace, and crossed legs. From Tell es Sawwan. 3.6 x 2.1 cm.

Fig. 19. Kneeling male statuette in green alabaster from Tell es Sawwan. The big nose, the elongated head with protruding ears, the special stone employed, and the unique position give the small statuette a hieratic outlook. 3.8 x 1.5 cm.

Fig. 20. Anthropomorphic vase in veined, shiny alabaster, with legs and foot from Tell es Sawwan. 7 x 5 cm.

Alabaster predominates in Sawwan and emphasizes the similarity with proto-Sumerian sculptures, together with shared features such as inlaid eyebrows or eyes, large use of bitumen, sometimes worked in relief to represent headdresses (fig.17), and face and body details—all elements also still in use in later Early Dynastic sculptures. Also common to both groups is the impression of some sort of "monumentality," notwithstanding the small size. The Sawwan sculptors developed a method of rendering the human figure in scale, and had learned to master geometry of volumes to obtain an expressionistic result, and this is why some statuettes seem mini-models of bigger statues. A eurythmic effect derives from those canons, adhered to at the site through centuries, and is reflected in sculpture, architecture, and in the neat proportions of the classical Samarran painted pottery. It seems also that the more inventive creations from Sawwan induce a feeling of harmony upon the observer through different devices: our eyes see some of them as impressive and monumental since when looking at them we unconsciously expand their measurements to life-size. We are also intrinsically affected by the feelings expressed by the statuettes—such power and strength, beauty, social role, or individualized personalities. Sometimes

monumentality has little to do with size. It seems, however, that while being a distinguished work of art, the Sawwan stone sculptures retain a somewhat ambiguous position, since they can no longer be considered minor art but are still far from the richness and complexity of the stone sculpture of later, historical times.

Affinities with the Mesopotamian proto-Sumerian sculptures of the third millennium B.C. should be interpreted as a genetic link and not as a coincidence or curiosity: it is evident that there exists continuity in architecture and culture, mediated through the long Ubeid period. Probably at Sawwan different conventions and abstract or naturalistic styles were employed to illustrate different types of people, and the variations hint at an oral tradition of shared values. We may exercise our fantasy—the smiling young boy (fig. 8) or the mature power-ful hero, a true Ulysses, with emphasis on muscles (fig. 10), are far from the cold elegance of an authoritarian goddess (fig. 12) and from the splendid shine of an enchanted lady (fig. 13), or from the delicately carved buttocks of a headless figure, with marked umbilicus and dimpled nipples (fig.14). We could almost name the statuettes one by one.

On the other hand it is intriguing to think of the Sawwan house as a microcosm: beneath the earth, the underworld is mirrored in the paleness, stillness, and coldness of the alabaster statuettes. Above the earth, in the world of the living, we have warm-colored clay figures, and we must remember the importance that clay has always had in shaping humanity in creation myths.

Summing up, it seems that the domination of space by the planning in architecture, the articulation of canons in art, the use of geometry and symbolism in pottery painting—in other words, the capacity for abstract thought—together with the richness derived from agriculture, herding, trading, and long-range relations, led the Samarran people on the virtuous path

Fig. 21. Semi-reclining, fragmentary, ithyphallic, male clay figurine, character-ized by a red wash. The dolichocephalic head, with relieved and painted topknot and protruding ears, echoes the "green male" (fig. 18). The figure has long painted eyebrows, applied almond-shaped shell eyes, traces of painted necklace and girdle, and painted bands on legs. From Tell es Sawwan. Ht. 6.7 cm.

toward the development of civilization, which was to be achieved in later times. All that is being discovered in these early phases may add tesserae to the Mesopotamian cultural mosaic, and it is our task, in an effort to bridge prehistory and history, to identify all those special types and signs that seem to occur midway between literacy and orality and challenge the attitude of reference to shared meanings deeper into prehistory. A careful reorganization of the Iraq Museum's exhibits, stores, and files will do much for a better knowledge and understanding of our cultural roots.

Fig. 22. Standing clay figurine from Tell es Sawwan. The rounded head has relieved nose and ears, incised eyebrows and applied coffee bean shaped eyes. The body is characterized by the applied collar, big rounded shoulders, applied button-breasts, a low girdle and exaggerated hips and legs. Ht. 11.5 cm.

The Lion Hunt Stela

Diana McDonald

The Lion Hunt Stela, one of the earliest stone monuments in the Iraq Museum, comes from the Southern Mesopotamian city of Uruk and reflects some of the earliest Mesopotamian concepts of kingship and the natural order. It uses artistic conventions that would continue to characterize Mesopotamian art for many centuries. This basalt relief carving, created in the late fourth millennium B.C., is a form of visual propaganda that records the beginnings of kingship and power and most likely imparts a spiritual dimension to the hunt.

The two male figures carved in low relief at the left of the stela are in fact the same person depicted twice: in one case spearing a lion (above) and in the other, shooting two lions with arrows (below). This man is no common hunter. We know from other contexts—stone stelae, cylinder seals, and figurines of this and the subsequent Sumerian era—that the man's headgear, a cap with a rim, is a symbol that indicates leadership or priest-king status, much as a crown would indicate the same to us today. The man sports a beard and the kiltlike garment common in that period. This monument is one of the first to employ the typical Sumerian convention of using registers, or strips, to indicate separate or subsequent actions.

Why is the priest-king shown in the act of hunting lions? This was no ordinary hunt for meat or sport. We know, not only from later Mesopotamian sources but from other cultures such as ancient Egypt that the lion embodied the evil and destructive forces of nature, no doubt because it was a dangerous beast that preyed upon precious flocks of sheep, goats, and cattle, and sometimes people as well. The populace needed to be kept safe from such predators, and it was the king's duty to assure that safety. On a metaphorical level, he created a sense of security in his territory by depicting his victory in the hunt. Demonstrating this ability to fight off dangerous lions proved the ruler's physical stamina and his manhood, and established him as a person with power and the aura of moral authority, for the conquering of the lion symbolized the righting of wrongs in the land and the creation of order out of the chaos of nature. The spiritual authority of the ruler could thus be seen in his use of force against the wild enemy. This righting of wrongs is seen much later, in a different aspect, in the famous Code of Hammurabi, which establishes a written record of laws of the land and depicts them as handed to the ruler by the sun god, Shamash.

The Asiatic lion (*panthera leo persica*) ranged through the Near East until its extinction there in the early twentieth century. It was recorded even then that young men were expected to kill a lion to prove their manhood. This notion is still widespread and known today among Nilotic and other tribal groups of sub-Saharan Africa. Lions, unlike many other predators, are not afraid and will stand their ground when challenged. They thus also conversely represent courage and nobility. In terms of early human development, the most prized abilities included excellence in hunting and fending off depredation. The lion, shown larger than the king and rearing up against him in the upper register,

seems to be attempting to fend off the spear with its inevitable consequence of death—dramatized by the diagonal thrust downward—while in the lower register, two smaller lions—perhaps dead already—seem to bow their heads under the weight of the two arrows they have both already taken in their necks. The much larger man appears triumphant as he shoots off yet another arrow straight into the head of one of the lions.

We see the same theme illustrated with more sophistication and detail more than two millennia later in the famous Assyrian reliefs of lion hunts from Nineveh, originally in the Palace of Assurbanipal (c. 668–630 B.C.). Here the lion hunt is staged, as the artist shows in a series of reliefs depicting the lions' cages and their release, but the king nevertheless demonstrates his bravery and ability to vanquish the most intimidating of beasts. The notion of lion hunting as proof of courage and kingly authority persists for several thousand years as a favored motif in Near Eastern art.

The Warka Vase

Diana McDonald

The Warka Vase, also known as the Uruk Vase, is one of the most important objects in the Iraq Museum. It is one of the first illustrations of the ritual and religious practices that were the basis of Mesopotamian society, and comes from the most important city in Mesopotamia in the fourth millennium B.C.—Uruk, the modern Warka and biblical Erech. This extraordinary alabaster object is not only a testament to early artistic skill in stone carving, but also presents a narrative which helps us understand the civilization that created it. It dates to around 3300–3100 B.C.

The main theme of the vase is the presentation of gifts to the temple of the goddess Inanna, the city goddess of Uruk, who symbolized the fertility of the earth. At a time when the survival of individual humans was still so very precarious, and when organized agriculture and cattle breeding were still fairly novel, the gifts of life and food were the most serious concerns of people. This concern is illustrated by the individual registers, or bands, of carving, which encircle the meter-tall vase.

For instance, the bottommost registers show us the natural and agricultural foundations of Mesopotomia. At the base, a ripple of water—often a scarce resource in Mesopotamia—most likely represented a river, and above it sprout plants that appear to be the grains that the farmers grew. The register above depicts the animals—sheep, alternating ewes, and rams—which were the basis of stockbreeding in the Near East and formed the temple herds.

The middle register consists of a file of naked, slightly plump men, bearing gifts or offerings such as food or wine in pots, and maybe baskets. They walk in a determined fashion but in the opposite direction to the animals below.

The uppermost register is the most damaged (in antiquity) and complex. It concerns the realm of the ruler and the gods. A fragmentary priest-king appears before the goddess Inanna or her priestess, with an interceding offering bearer. Inanna, or her priestess, is identifiable because of the bundled reeds—her symbol—which appear behind her. Another offering bearer behind the ruler holds out a girdle, or sash, as a gift. Behind the goddess appears first a ram with a stepped platform on its back, which bears two smaller offering bearers. Also visible in the field behind the animal are two cult vases identical in shape to the one on which they are depicted, and more vessels with food offerings and two animal-shaped vessels with spouts. The headdress which would have indicated whether the woman shown was actually a deity had been broken off in antiquity, and there are holes where an attempt was made to repair the piece. The ruler figure is also fragmentary, but wears a long kilt as opposed to the naked interceding priest in front of him and the short-kilted figure behind.

The vase itself narrates, perhaps for the first time in the history of humans, the procession and rituals that surround both rulership and the cult of a divinity. The rites themselves, however, are not the only stories told here. The temples

of the theocratic city-states of Mesopotamia were supported by agriculture and other gifts given by the ruler and the populace. The people, in return, expected to be supported in times of need by their own benevolent goddess. The surpluses accrued by the temple made this possible. The ruler, by showing himself as the most important person relative to the priestess or goddess Inanna, demonstrated both his legitimacy and his piousness. Thus we can see in the vase that already at this early date, we have a complexly organized society with spiritual, moral, and practical functions all localized in the cult of a city goddess, to whom reverence is paid in the form of gifts, but who in turn was expected to provide for her people.

Chapter V

FROM VILLAGE TO EMPIRE: THE RISE OF SUMER AND AKKAD

Paul Collins

Of all the remarkable cultural achievements represented by objects in the Iraq Museum, none are more extraordinary than those that chart the rise of the world's first cities, surely one of the most significant legacies of ancient Iraq. By the end of the fourth millennium B.C., a few of the small farming and fishing communities of southern Iraq that had existed for millennia had developed into highly organized cities with some of the world's first writing, monumental buildings, and narrative art. While the roots of this process remain poorly understood—based on scant information in the archaeological record by which to reconstruct the transformation of the towns and villages to enormous settlements—it is quite possible that by the middle of the fourth millennium B.C., the lush vegetation that had once blanketed the lowlands of Iraq and the Zagros mountains that divide Iraq from Iran to the east, had begun to recede in the face of a dryer climate. Such a scenario may have encouraged people to gather at specific locations, especially along the banks of the Euphrates and its tributaries, under the leadership of families who effectively managed the natural resources, including the irrigation of the very fertile soil of the flat alluvial plains. Flanking the riverbanks were stands of reeds, poplar, tamarisk, and willow trees that could be cleared for gardens and date orchards. Further inland, fields for cereals, legumes, and flax could be fed by irrigation ditches and feeder canals. At the very edge of the

Fig. 1. Votive female statue, greenstone, gold, lapis lazuli, from the Temple of Inanna, Nippur, c. 2500 B.C.

Fig. 2. Golden bull head, lyre, from Ur, c. 2500 B.C. Bulls represented some of the most powerful animals in ancient Iraq, but the head decorating this lyre may represent a heavily bearded wild bison. Bison were associated with the eastern Zagros Mountains and in some Sumerian traditions the dead traveled toward these mountains on their way to the netherworld. Since this musical instrument was buried at the Royal Graves at Ur, it may have been designed for such a journey. The animal's head may also have signified the sound produced by the instrument.

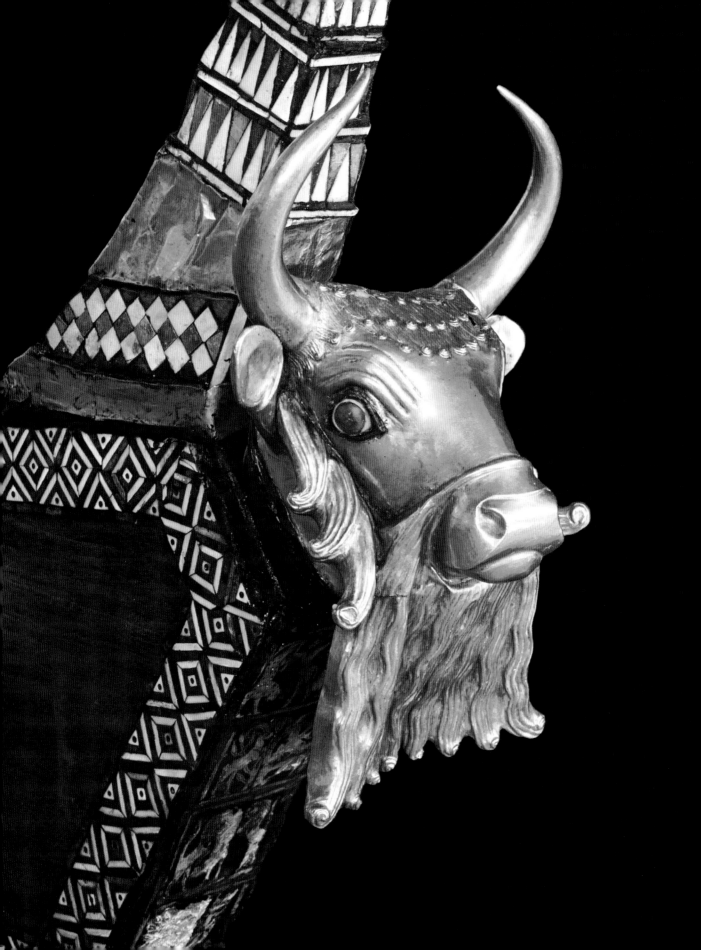

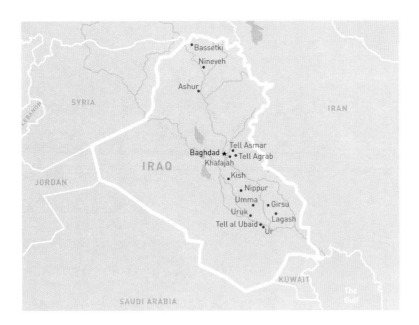

cultivated land were a patchwork of marshes and desert that could provide grazing for sheep, goats, and cattle tended by seminomadic pastoralist groups.

The multiple branches of the rivers also provided cheap transportation and easy communication between settlements. The land could be bountiful when efficiently managed, or a harsh environment exposed to searing heat in summer and torrential storms of rain and sand. It was also populated by predatory animals such as lions and leopards.

This extraordinary landscape, which presented an ever-present struggle and contrast between fertility and aridity, served as the backdrop against which civilization emerged.

Although large settlements developed across Iraq and Syria during the so-called Middle and Late Uruk periods (c. 3500–3000 B.C.), urbanism took its most spectacular form in southern Iraq. It was here that the first great cities emerged at the head of the Gulf, connected to the sea (and trade routes) by rivers, canals, and natural lagoons. The largest site (2.5 square kilometers or nearly one square mile) and the one that has provided the most extensive evidence for the late fourth millennium B.C. is that of Uruk (modern Warka, biblical Erech). Excavated by

German archaeologists beginning in 1912 and continuing with breaks until the recent war, the city was dominated by two ceremonial and religious areas. The first, later dedicated to the heaven god Anu, consisted of a temple constructed on top of a high terrace built of thousands of small rectangular mudbricks, which rose with sloping and recessed walls. To the east of the Anu terrace was the so-called E-anna precinct, probably dedicated as later texts reveal to the fertility goddess Inanna. This area had a variety of truly monumental buildings that perhaps served as palaces and ceremonial gathering places. The sheer scale of the buildings points to the presence of specialists such as architects, as well as administrators and supervisors of the hundreds of workers who built the massive terraces and platforms on which the buildings stood.

We know from early written records on clay tablets, discarded and used as part of the packing material for the foundations of some of E-anna's monumental buildings, that some of these workers were fed from rations stored by the central authorities. Administrators within the cities developed new ways of recording information. Representations of objects issued as rations, or stored for future use, were drawn on pieces of clay as memory aids, the pictographs made by drawing a sharp stick or reed across the clay. The surface of some tablets was impressed with a stone cylinder seal, the surface of which was carved with a design, so that when rolled on clay the cylinder would leave a continuous impression of the design, reversed and in relief (fig.3). These diminutive objects represent some

Fig. 3. Stone cylinder seals, late Uruk-Jemdet Nasr, c. 3000–2900 B.C. The cylinder seal was invented around 3500 B.C. in southern Iraq or southwestern Iran. They were linked to the invention of cuneiform writing on clay and were used as an administrative tool but also as jewelry and magical amulets. Early cylinder seals, like those shown here, were often decorated at the top with an animal figure or a loop for suspension. It has been suggested that some of the designs may reflect different administrative offices within the early cities of southern Iraq.

of the earliest-known narrative art. They depict an ordered world with rows of domesticated animals or scenes of conflict between wild animals and their prey. One of the most common subjects depicted on these seals is the so-called "priest-king," recognizable by his fillet with hair in a bun, his beard without mustache, and skirt to the knee or ankle, which is often cross-hatched like a net. He seems to represent a leading authority in the city and is often shown feeding domesticated animals or engaged in cultic activities.

The relationship between the elite and the divine world is reflected in both sculpture in the round and in relief, which appear for the first time in the Late Uruk period. Until recently, the Iraq Museum housed some of the most exquisite examples known from this time. A new realism becomes apparent in the treatment of the human form. One of the finest images of the priest-king was excavated at Uruk (fig. 5). He is preserved from the waist up and there is an emphasis on the musculature of the chest and arms, which continues as a tradition in Mesopotamian portrayals of kings. His clenched hands held apart on his torso may prefigure the clasped hands observed on later dedicatory sculptures. The delicate carving of his face with inlaid eyes presents an image of power and authority. Also from Uruk comes the famed Lion Hunt Stela, on which either two priest-kings or one man shown twice attacks a lion, once with a spear, a second time with a bow and arrow (fig. 4). This is the earliest example of the subject that has come to be known as the "royal lion hunt," which is a frequent theme in later Mesopotamian art. The repetition of the figure within a single composition suggests a form of narrative, later developed in Mesopotamian art, and certainly one of the great contributions to the history of world art.

It appears that statuary was intended for the express purpose of confronting the divine. A unique and beautifully carved limestone mask of a woman from Uruk, which had once been part of a composite statue, was presumably intended for the precinct of the goddess Inanna where it was discovered (fig. 6).

Fig. 4. Lion Hunt Stela, basalt, Ht. 80 cm, from Uruk, c. 3000 B.C. Man's confrontation with the dangerous forces of nature is a common theme in the art of ancient Iraq during the fourth and third millennia B.C. Lions represented one of the most powerful creatures in Mesopotamia and are often depicted attacking domestic animals or being vanquished by kings. The motif of the heroic man challenging the lion is found in Mesopotamian cylinder seals and relief carvings throughout the following two and a half thousand years. (See page 78.)

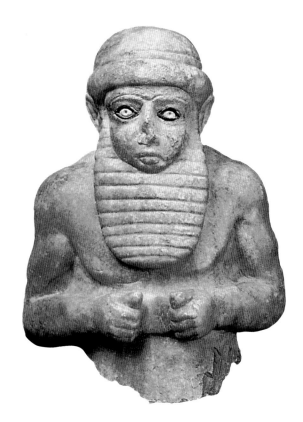

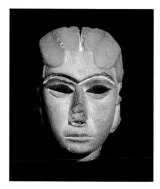

Fig. 6. Female head, limestone, Ht. 21 cm,
from Uruk, c. 3000 B.C. This sculpted
mask was discovered at Uruk within the
precinct of Inanna, the Sumerian goddess
of fertility and abundance. Originally it
would have been inlaid with colored stones
and metal.

Fig. 7. Decorated ewer, limestone, Ht. 20.5
cm, from Uruk, c. 3000–2900 B.C. Lions
stand guard at the spout of this elaborately
carved stone vessel, one of the finest
examples of many variously shaped
vessels from this period.

The method of constructing statues from different materials
was popular in ancient Iraq and was probably a regular method
of making divine images that, according to later texts, would
have been formed from precious stones and metals. The mask
is flat on the back so as to allow for its attachment to an
unknown surface. The eyes, eyebrows, and hair would have
originally been inlaid, creating a much more colorful and
dramatic appearance. What is particularly striking about the
piece, however, is the sensitive carving of the cheeks, chin,
and mouth. It reflects an interest in presenting a realistic
representation of the world, very different from the simple,
abstract female figurines of earlier periods.

This realistic approach is extended to sculptures of animals—
cattle, sheep, and goats—which were a staple of the ancient
Mesopotamian economy. Moreover, the animals stood for the
divine world and nature's fecundity. They appear on many
carved stone bowls of the Late Uruk and the following Jemdet
Nasr period (c. 3000–2900 B.C.) (fig. 7). Processions of
animals, usually cattle, are carved so that the heads are in the

round and turned out to face the viewer. The most famous vessel of the period is the so-called Warka Vase that is more than one meter high (fig. 8). Like designs on cylinder seals of the period, it portrays an ordered world. The vase is divided into registers, each representing one aspect of the fecundity of the land. The upper frieze is interpreted as the presentation of offerings to Inanna or her priestess by the priest-king (whose image is largely broken away) as intermediary between man and the gods. In the cultic performance represented on the vase, the priestess and the ruler become Inanna and her husband, the shepherd Dumuzi, known from later myths and poems, and thus embody the fertility of the land. The whole of southern Iraq shared the forms of architecture, administration, and art found at Uruk, and these were carried into the neighboring regions of Iran, northern Iraq, and Syria where new cities were founded and colonies established inside existing local towns. The settlements may have been mercantile in origin, created to acquire stones and metals not found in the south, or to exploit new grazing lands or even represent the political expansion of southern city-states. Around 3000 B.C. these colonies were abandoned for reasons that remain unclear, and the widespread influence of southern Iraq declined. However, the cities of the south continued to flourish. By the beginning of the third millennium the administrators had developed their pictographic writing to express the local Sumerian language, and the signs gradually became more abstract as the end of a reed or stick was simply pressed at an angle a number of times into the clay to form the design. The signs were thus made up of wedge-like lines, or cuneiform (the Latin for wedge is cuneus). Most of the early cuneiform tablets come from Uruk, and it may have been here that this form of writing was invented.

During the succeeding Early Dynastic period (c. 2900–2300 B.C.), Sumer, the region in the far south of Iraq, consisted of a number of rival city-states controlled by powerful dynasties of rulers. We still know very little about the early centuries of

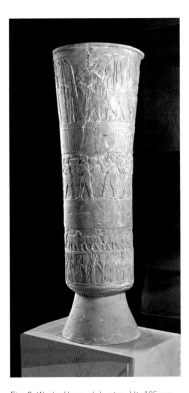

Fig. 8. Warka Vase, alabaster, Ht. 105 cm, from Uruk, c. 3000 B.C. This spectacular object was almost certainly used in the cult of the goddess Inanna. Her symbol, a post with ring and streamer, appears three times in the top register. The vessel was buried with many other finely carved objects soon after 3000 B.C. (See page 80.)

Fig. 9. Vase carved in relief, chlorite, Ht. 14.2 cm, from the Temple of Inanna, Nippur, c. 2500 B.C. Elaborate vessels carved from chlorite or steatite and often inlaid, were produced in southern Iran and the eastern coast of Arabia during the third millennium B.C. They share a distinctive repertoire of figural and geometric imagery and must have been highly valued in ancient Sumer, as examples have been found in tombs or, like this one, deposited in temples. One of the most important themes is the struggle between two powerful creatures, the leopard and snake.

this period. Much of our evidence derives from the cities of Nippur and Ur and sites in eastern Iraq around the Diyala River (a major tributary of the Tigris). Late Sumerian tradition recalls some of the names of rulers of this period such as Gilgamesh, who is credited with building a wall around his city of Uruk, as well as extraordinary heroic exploits. Other written documents have allowed modern scholars to reconstruct the names of the dynasties of other Sumerian states. As in earlier times, the ruler was extolled in relation to the gods as the supreme priest, warrior, and hunter. However, in the Early Dynastic period some of his greatest achievements were perceived to be the building of temples for the gods.

A common culture existed across Sumer, with much of life focused on the temples. While individual deities were thought to own their own cities and territories, the various temples across the alluvial plain represented a shared system of belief in gods who were closely related. Temples were like medieval monasteries in that they consisted of a number of buildings that served various functions. The kitchens, breweries, workshops, orchards, and agricultural land sustained the gods and the personnel of the huge estates that included farmers, fishermen, weavers, craftsmen, and scribal administrators as well as priests. Fine objects such as stone wall plaques carved in relief and delicate metal sculptures were produced for the gods, commissioned by the ruler and the elite either as furnishings necessary for the cult or as votive objects (fig. 9).

The central shrine of the temple buildings seem, from limited excavated examples, to have been quite small, certainly only large enough to accommodate a few priests. They were not congregational buildings. It is therefore possible that the development and manufacture of votive figurines during the Early Dynastic period was the only way the elite could hope to have themselves (albeit in sculptured form) brought into the god's presence (figs. 10, 11, 12). These carved stone images of standing or seated worshippers depict men wearing fringed or tufted fleece skirts and women wearing fringed dresses

draped over one shoulder. Many have inlaid eyes and painted hair. Short cuneiform inscriptions found on some statues identify the donor who commissioned them, their profession, as well as the name of the god to whom they are dedicated. The figures clasp their hands at the waist or chest in a pose of perpetual attendance before the deity. Groups of these statues were often buried beneath the floor of a temple, perhaps when the building was refurbished. Among the most remarkable of these early votive statues is one of Enmetena (c. 2400 B.C.) (fig. 13), king of the city-state of Lagash that dominated a large area of southern Iraq. Made of diorite and inscribed with a long text that details a land transaction—suggesting that the figure was made to record a gift—the statue is regrettably still missing from the Iraq Museum at the time of this writing.

Temples were built of mud brick and continuously repaired and rebuilt one on top of the other. The remains of a temple dedicated to the goddess Ninhursag, often described in texts as "mother of the gods," at Tell al Ubaid, close to the city of

Fig. 10. Votive statues, Ht. 72 cm (male), 59 cm (female), from Tell Asmar, c. 2600 B.C. These unusually tall votive figures were discovered at the site of Tell Asmar and were identified as the god Abu and his wife, but they probably represent members of the wealthy elite who could afford to commission images of themselves to be placed in temples.

Fig. 11. Votive couple, limestone, Ht. 14.5 cm, from Temple of Inanna, Nippur, c. 2500 B.C. This delightful couple comes from the Nippur temple of Inanna, goddess of abundance, and is a rare form of votive statue with two figures seated together. We might assume that they represent a husband and wife.

Fig. 12. Votive female statue, Ht. 14.6 cm, from the Temple of Inanna, Nippur, c. 2500 B.C. The face is made from gold foil and eyes inlaid with lapis lazuli. Typically her right shoulder is left bare. Composite statues were popular in Mesopotamia and her missing hair or wig would have been fashioned from stone or metal.

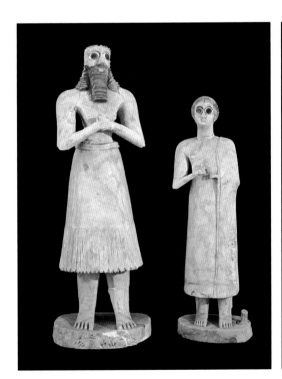

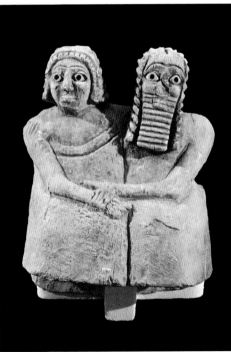

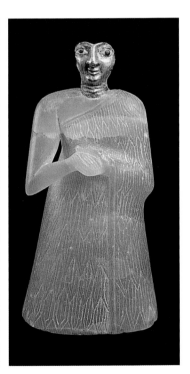

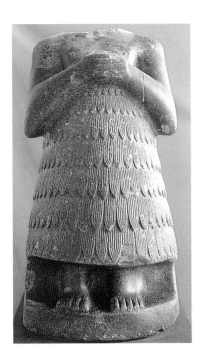

Fig. 13. Statue of Enmetena, diorite, Ht. 76 cm, from Ur, c. 2400 B.C. This statue of King Enmetena of the city-state of Lagash is a victim of the latest war in Iraq. The head was missing when the statue was excavated at Ur. Although the statue represents a powerful ruler, Enmetena wears the typical outfit of a votive male figure: a fleece skirt with a tassel at the back. The cuneiform inscription on his upper right arm includes a special name given to the statue, "Enlil (the supreme Sumerian god) loves Enmetena."

Ur, suggests that its façade was lavishly decorated with friezes and freestanding sculpture of metal and stone. Concepts of fertility and procreation were clearly important in the decoration. A frieze once stretched across the front of the building that consists of a line of limestone cattle, appropriate decoration on a temple whose goddess was symbolized by the cow. One section of the frieze depicts a reed structure from which calves emerge (fig. 14). To the left of the hut, workers dressed in fringed skirts hold jars and a funnel. They are apparently preparing milk products, while to the right of the birthing hut cows are being milked.

Although united by a common approach to the world through the gods, Sumer was politically fragmented. The territorial boundaries of states were often disputed, leading to quarrels and sometimes war. The best-known conflict was between the city-states of Umma and Lagash. The dispute over some farmland lasted on and off for more than a century. A sophisticated technological achievement in warfare was the development of donkey-drawn chariots. Donkeys had been domesticated in the fourth millennium B.C. and, since they can carry much heavier loads over greater distances than humans, helped to transform the societies within the emerging cities of ancient Iraq. By 3000 B.C. it is clear that the wheel had been invented, as images of carts appear scratched as pictograms on clay tablets. From these early vehicles the chariot was developed in the early third millennium B.C. Examples are depicted in stone reliefs and inlay, but one of the most spectacular representations comes from a temple at the site of Tell Agrab in eastern Iraq, where it was possibly left as a votive gift (fig. 15). The sculpture is cast in copper, itself a considerable accomplishment. The four donkeys pulling the chariot have their eyes inlaid with shell. The driver rides on a seat mounted on the vehicle's axle and holds the reigns in his left hand. His skirt and hair fall backward as if caught by the forward movement of the chariot.

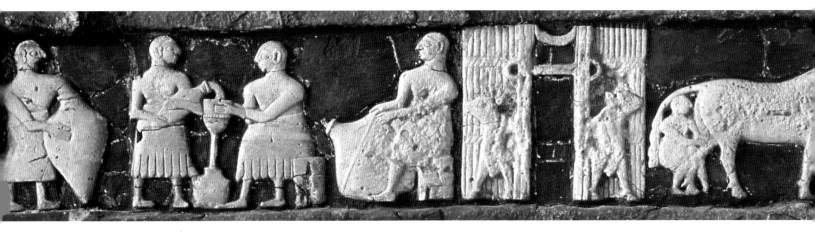

Some of the most significant information about the Sumerians preserved in the Iraq Museum was recovered from the Royal Cemetery at Ur. In the late 1920s, a joint expedition by the British Museum and the University of Pennsylvania Museum of Archaeology and Anthropology, led by Leonard Woolley, excavated nearly 2,000 burials in a vast cemetery close to major religious buildings in the city of Ur. Of these, 600 interments dated to the Early Dynastic period. The majority were simple inhumations, in which the body, wrapped in reed matting or placed in a coffin, was set at the bottom of a rectangular pit. Clothed and accompanied by personal belongings, the deceased generally held a terra-cotta cup. However, sixteen burials stood apart in terms of their wealth, architecture, and evidence of ritual, including human sacrifice. Woolley called these "royal tombs," assuming they contained Ur's deceased kings and queens. The human attendants, who lay around the main burial entombed within a stone structure on the floor of the pit, were adorned with elaborate jewelry, including beads of gold, lapis lazuli, carnelian, and agate (fig. 16). Some seem to have had specific duties, such as musicians, since they are associated with instruments such as harps and lyres. Male attendants were dressed as soldiers or as grooms for donkeys or oxen that had been attached to chariots and carts. Woolley assumed that these people had died from poison in order to accompany their dead ruler, but the exact details and reasons for their deaths still elude us.

Fig. 14. Milking scene from Temple of Ninhursag, from Tell al Ubaid, c. 2400 B.C. Milk products appear to have become important from the fourth millennium B.C. As a symbol of procreation and fertility, images of cattle and calves as well as friezes of milking scenes and storage and processing of milk once decorated the façade of the temple of the Sumerian mother goddess Ninhursag. Images of calves and cattle continue a tradition in southern Mesopotamian art from the late fourth millennium B.C.

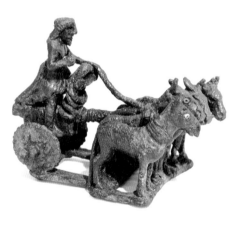

Fig. 15. Chariot and team, copper alloy, Ht. 7.2 cm, Tell Agrab, 2600 B.C. Among the revolutionary developments in ancient Iraq during the fourth millennium B.C. was the domestication of the donkey and the invention of wheeled vehicles. Heavier loads could now be transported over greater distances. By 2500 B.C. chariots pulled by donkeys had been transformed into both effective weapons of war and, as depicted by this remarkable cast sculpture dedicated in a temple at Tell Agrab in eastern Iraq, carriages for the elite.

One of the graves, the so-called Great Death pit, contained seventy-four attendants, six men and sixty-eight women. Four of the women lay against a wall close to four lyres. Among the most magnificent of these musical instruments is the so-called bullheaded lyre. It had been made largely of wood that had decayed in the soil, but the elaborate mosaic border of the sounding box and uprights lay in position and could be restored using modern wood. Decorating the front of the lyre was a glorious bull's head made of sheet gold over an original wooden core (fig. 2). The eyeballs, made of shell with the pupils of lapis lazuli, give the animal great vitality. The luxurious gold beard has a band running over the snout, perhaps reflecting the attachment of artificial beards to living animals as a way of enhancing their virility. Beneath the head, a series of inlay panels depict a combat scene between animals, animals nibbling at plants, and a mythological bull-man spearing a leopard.

A rich grave in the cemetery, apparently without attendants, belonged to King Meskalamdug (c. 2500 B.C.). Among the grave goods was a gold lamp and bowl inscribed with the name of the king. Beside his skull lay an extraordinary head covering of gold (fig. 17). It takes the form of an elaborate wig shaped in a hairstyle worn by rulers—an encircling braid holds the plaited hair in place with a distinctive chignon at the back. Rows of curls of hair fall from below the braid around his ear. Holes piercing the edge of the helmet may

have been used to tie a soft cap inside. Meskalamdug ruled at a time when the city-states of Sumer were expanding their political and economic power. This is clearly reflected in the exotic materials found in the graves, acquired from distant lands, such as lapis lazuli from Afghanistan, carnelian from the Indus Valley, and gold from Anatolia or even Egypt (fig.16).

North of Sumer, control of the alluvial plain seems to have been centered around the great city of Kish, whose rulers may at times have also exerted a degree of authority in the south. For the Sumerians, the city of Kish represented kingship and a number of rulers held the title "King of Kish" to indicate control of extensive territory. The importance of the city was emphasized by a tradition that claimed the city as the place where kingship was lowered from heaven after the Great Flood. One of the best preserved buildings of the Early Dynastic period is a palace at Kish where a majestic staircase led into one section of the building while a columned portico formed the façade of another. It was decorated with fragments of friezes showing a triumphant army and bound prisoners. These inlays are now divided between the Ashmolean Museum in Oxford and the Iraq Museum.

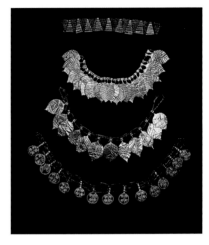

Fig. 16. Jewelry from Ur (Royal Cemetery), gold, lapis lazuli, carnelian, c. 2500 B.C. The female attendants who were buried with their dead king or queen in the royal graves were supplied with remarkable jewelry. The Sumerian jewelers exploited organic forms, such as leaves, or simple geometric shapes, such as spirals. The elaborate necklaces and headdresses may have been intended as gifts for the underworld gods.

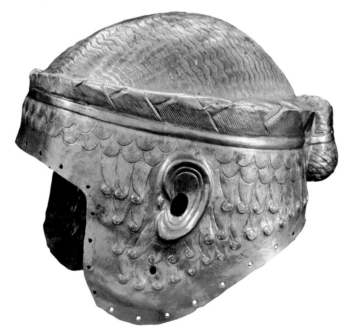

Fig. 17. Helmet of Meskalamdug, gold, Ht. 22 cm, Ur (Royal Cemetery), c. 2500 B.C. This magnificent headdress is formed from a sheet of gold hammered into the shape of an elaborate plaited hairstyle worn by kings. It possibly belonged to a significant early ruler of the city-state of Ur called Meskalamdug. The helmet was excavated from a richly furnished grave where it lay alongside the head of a powerfully built young man about 2 m. in height. Among the grave goods was a gold lamp and bowl inscribed with the name of the king.

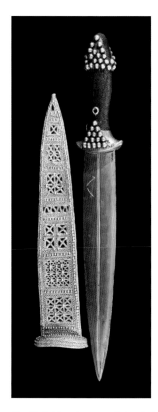

Fig. 18. Golden dagger and sheath, from Ur (Royal Cemetery), c. 2500 B.C. In a badly disturbed grave, an exceptional group of objects was uncovered, including this dagger and sheath. The hilt of the dagger is made of lapis lazuli set with gold studs and the blade is of gold. The sheath is also of gold, plain on the back except two lines of beading, but of rich filigree in front. Along with a cylinder seal, the dagger and sheath was attached to the remains of a belt of leather plated in silver with a square buckle.

Powerful rulers expanded the territory of their city-states and by around 2350 B.C. King Lugalzagezi of Uruk had unified much of Sumer. A rival to this southern kingdom emerged in the region of Kish in the shape of a man who called himself Sargon, "the king is legitimate." Sargon belonged to the Semitic population of southern Mesopotamia and established the Akkadian Dynasty, named after his capital city of Agade. The site of Agade has yet to be identified but probably lay not far from Baghdad. Under this new dynasty the cuneiform script was adapted to write the Semitic Akkadian language (related to modern Arabic and Hebrew). Sargon campaigned north into Syria and south, defeating Lugalzagezi and incorporating Sumer into an Akkadian Empire. At its greatest extent under later kings, the empire stretched to Anatolia in the north, Iran in the east, Arabia in the south, and toward the Mediterranean in the west. Commercial links included trade with the Gulf and the Indus Valley.

Under Sargon's grandson, Naram-Sin (c. 2210–2170 B.C.), who was the first Mesopotamian ruler to claim divine status, the empire reached its apogee. The ideology and power of the empire were reflected in art that is characterized by a profound new creativity that marks one of the peaks of artistic achievement in the history of the ancient world (fig. 19). A new emphasis on naturalism, expressed by vigor and sensitive modeling, is manifested in masterpieces of stone-relief carving, metalwork, and cylinder seals (fig. 20). The Iraq Museum contains two hollow-cast copper objects of outstanding quality from this period. The first is an almost life-size male head from Nineveh, possibly that of Naram-Sin, with a long beard and elaborate hairstyle held in place by a headband (fig. 21). Although intentionally disfigured in antiquity, this head still retains its original majesty. The earlier royal hairstyle of Sumer found on Meskalamdug's helmet is incorporated into the design. The second masterpiece is the lower part of a nude male figure squatting on a large circular drum, found near the town of Bassetki in northeast Iraq, that is from the northern

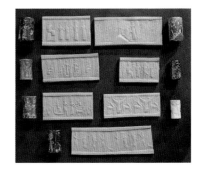

Fig. 19. Fragment of a victory stela, alabaster, from the region of Nasiriyah, c. 2250 B.C. The parade of bound and nude prisoners escorted by warriors before their king was a common theme in the art of Sumer. Under the Akkadian kings the scene was transformed by setting the soldiers apart from the prisoners, who are provided with distinctive hairstyles so that a knowledgeable viewer would be able to identify from which part of the empire they originated. This fragment of a stela is made from a beautiful translucent alabaster. (See page 100.)

Fig. 20. Akkadian Cylinder seals. Cylinder seals of the Akkadian period represent some of the finest works of art produced in ancient Iraq—miniature masterpieces in a variety of stones demonstrate the extraordinary skill of craftsmen. By the time of Naram-Sin (c. 2250 B.C.), a superb, naturalistically modeled style had developed exemplified by seals that depict balanced combats between heroes, bull-men and wild animals.

part of the Akkadian Empire (fig. 22). The sensitive shaping of the lower body, legs, and toes is the work of a master sculptor. The text inscribed on the drum tells us that the sculpture was created for Naram-Sin, who had a temple dedicated to him in Agade, and that he was thus accepted into the world of the gods. These large copper castings, probably done in multiple piece-moulds, represent a considerable technical achievement and suggest what art has been lost to us or has perhaps yet to be discovered. The Akkadian achievements and traditions they represent were so impressive that later peoples in Mesopotamia were inspired to emulate them.

Ultimately the Akkadian Empire was overwhelmed by internal disputes and external forces such as climatic change resulting in dryer conditions in the north, and the movements of foreign peoples such as the Amorites, tribal groups from Syria. Tradition credits the final blow to a little-known eastern mountain people called the Guti. Some city-states regained their independence at this time, for instance Lagash, under the rule of Gudea. Statues of this ruler survive in an unparalleled number. The majority of statues are in the Louvre Museum in Paris, but the Iraq Museum has a fine example (fig. 23). They show Gudea with muscular arms, symbolizing the strength of kingship. His hands are elegantly folded, and the ruler either

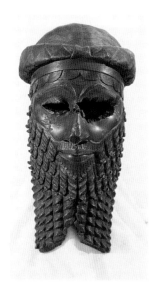

Fig. 21. Head of King Naram-Sin, copper alloy, from Nineveh, c. 2250 B.C. One of the greatest masterpieces to have survived from ancient Iraq is this majestic image of a king. Despite the damage, the head retains an impression of power and majesty befitting a ruler of the world's first empire. (See page 102.)

Fig. 22. Fragment of a male statue with an inscription of Naram-Sin, copper alloy, from near Bassetki, c. 2250 B.C. This almost life-size cast sculpture of a male figure is a triumph of artistry and technology. Although only the lower half of the figure was preserved when the sculpture was discovered in northern Iraq, it is likely that he was nude apart from his belt with tassels. Three columns of text inscribed beside the hero's marvelously modeled legs record the building of a temple to the Akkadian King Naram-Sin in his capital of Agade.

stands or sits in the tradition of earlier votive figures. He is either depicted bald or wearing a straight-sided fur hat, his beardless face radiating a calm, otherworldly expression. Inscriptions in Sumerian on the statues indicate that they were set up in temples that the ruler had refurbished. The sense of piety resonating in the sculpture is emphasized by the stark diorite from which the statues were carved. This incredibly hard stone was imported from the region of modern Oman. The considerable expense required to obtain and transport such stones, as well as the difficulty of sculpting such hard, durable minerals, presumably added to their prestige value.

Possibly contemporary with Gudea was Ur-Nammu (c. 2120– 2110 B.C.), who established his rule over the city of Ur and founded the Third Dynasty of Ur (also termed the Ur III period), which came to dominate Sumer and Akkad (c. 2100– 2000 B.C.) (fig.24). The Ur III rulers presided over a prosperous kingdom, with an ambitious program of building in most of the major cities. The most spectacular religious monuments are the great ziggurats, or staged towers, formed from increasingly smaller mud brick platforms built on top of each other.

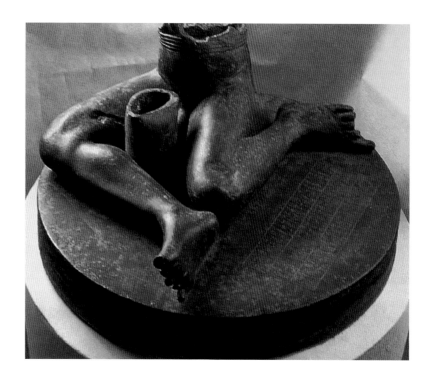

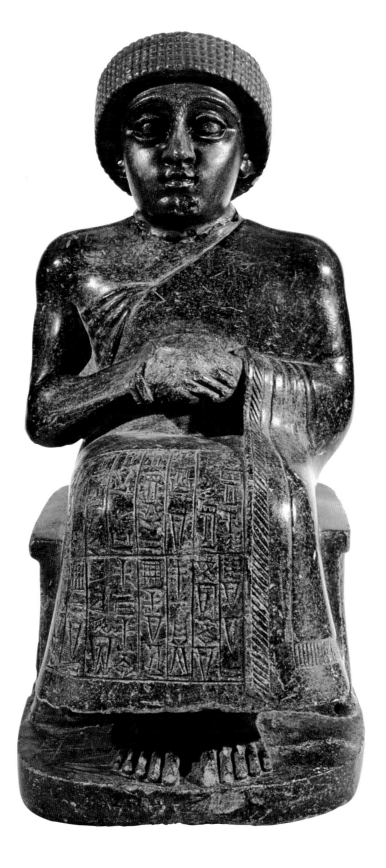

Fig. 23. Statue of Gudea, diorite, from Girsu (modern Tello). This image of Gudea, the ruler of the state of Lagash in southern Iraq, is pervaded with a sense of piety. Indeed the statue was probably set up in a temple in the tradition of earlier votive figures. The Sumerian cuneiform inscription on the front records Gudea's construction of a temple called E-ninnu for Ningirsu, the patron god of Lagash. The head is a plaster cast of the original that is housed in the University of Pennsylvania Museum of Archaeology and Anthropology.

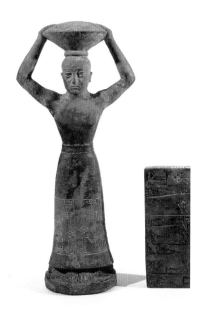

Fig. 24. Foundation figure of King Ur-Nammu, Ht. 35.6 cm, from Nippur. Since the mid-third millennium B.C., metal pegs with the upper end in the form of men wearing a god's horned headdress were deposited in the foundations of temple buildings along with a tablet giving the name of the king who had the building restored or refurbished. This foundation figure represents King Ur-Nammu. On his head he holds a basket that symbolically contained mortar for the first bricks of the temple. The inscription on the figure and on the accompanying stone tablet records Ur-Nammu's construction of the temple of the god Enlil in Nippur.

Fig. 25. Ziggurat of Ur, c. 2100 B.C., restored under Nabopolassar 626–605 B.C. By the late-third millennium B.C. huge stepped platforms were constructed, called ziggurats in cuneiform texts. While the actual significance of these structures is unknown, Mesopotamian gods were often linked with the eastern mountains, and ziggurats may have represented their lofty homes. Around 2100 B.C., Ur-Nammu, ruler of the city of Ur, built ziggurats at the sites of Eridu, Uruk, and Nippur, but his ziggurat at Ur is the best preserved.

The best surviving example is the ziggurat of Ur-Nammu at Ur (fig. 25). The exterior is decorated with buttresses and recesses to break the monotony of the flat surfaces and to give a play of light and shade. The Ur III period is often described as a Sumerian renaissance, following the Semitic Akkadian Empire. However, although Sumerian was used as the written language of administration, many motifs developed in the Akkadian period continued, including, under Ur-Nammu's son and successor Shulgi, the royal assumption of divine status. Shulgi initiated many administrative, legal, and organizational reforms, including establishing a curriculum for the schooling of scribes. A new literature was created with hymns to the gods and stories of heroic kings such as Gilgamesh and Enmerkar (both of whom lived in the early third millennium B.C.), while at the same time mathematical, medical, and legal exercises were also committed to writing. Such themes were copied and developed over the coming millennia within the cities of ancient Iraq, creating a rich legacy at the root of our own civilization.

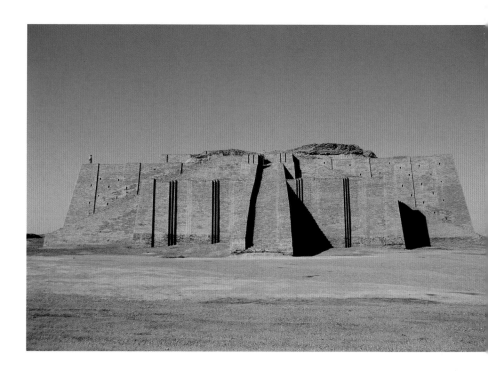

Akkadian Victory Stela

Diana McDonald

This alabaster relief from the Iraq Museum is one of three fragments from a single stela that dates to the time of the Akkadian Empire in Mesopotamia (c. 2334–2154 B.C.). This and another fragment are in Baghdad, while a third fragment is in the Boston Museum of Fine Arts. They were supposedly found in the region of Nasiriyeh in southern Iraq. When pieced together they portray a narrative of a military campaign waged by the Akkadian King Naram-Sin, the grandson of King Sargon the Great. Sargon established the Semitic Akkadian Dynasty and the first true empire in Mesopotamia. This relief is a finely skilled example of stone carving, using a beautiful imported translucent greenish alabaster to depict the victorious aftermath of a war.

The Baghdad segment shown here consists primarily of one register of the stela, with a row of six nude prisoners, some quite fragmentary now, who are walking forward with all their heads constrained within a long wooden stock. Their muscular upper arms are tightly bound behind their backs by ropes. They are shown fully in profile, with the shoulders foreshortened—a new development in Mesopotamian art—and unlike their captors, who are shown with frontal torsos. The prisoners' naked bodies are naturalistically detailed and subtly modeled, with two curved lines indicating their slightly bulging abdomens, below which are bare genitals. The artist also carefully delineated the knee muscles and details of the feet and toes. Furthermore, the two heads of the prisoners that are still extant show very different hairstyles:

scrupulously indicated beard curls and partly shaven head with braids on one, and a mustache and short hair on the other, perhaps indicating that they come from different regions. The six muscular bodies are less differentiated from one another, but serve to show that these young men, although captives, are individuals at the peak of their physical powers.

The other fragments portray the victorious Akkadian warriors, fully clothed and with grooved helmets. These soldiers carry battle-axes and daggers. The one currently in Boston probably would have had a warrior's now broken-off right arm around the neck of the last of the nude prisoners, controlling them as he marched them about. Another warrior would have appeared on the register below, bearing what is apparently war booty—a metal vessel which has a shape and style characteristic of Anatolia (modern Turkey). It is this vessel that provides the clue that the military victory may have taken place in Anatolia.

The Akkadian Dynasty established by Sargon marked the first time that Mesopotamia was united under one ruler rather than being a group of warring city-states. The Akkadians spoke a Semitic language, unlike the Sumerians who came before them, but the Akkadians adopted many Sumerian traditions. The artists, however, using many of the same Sumerian conventions and subject matter, lavished greater attention on details of human and animal physiognomy, and made the bodies more sculptural in nature. The theme of war and conquest is one that goes back to some of the very earliest representations

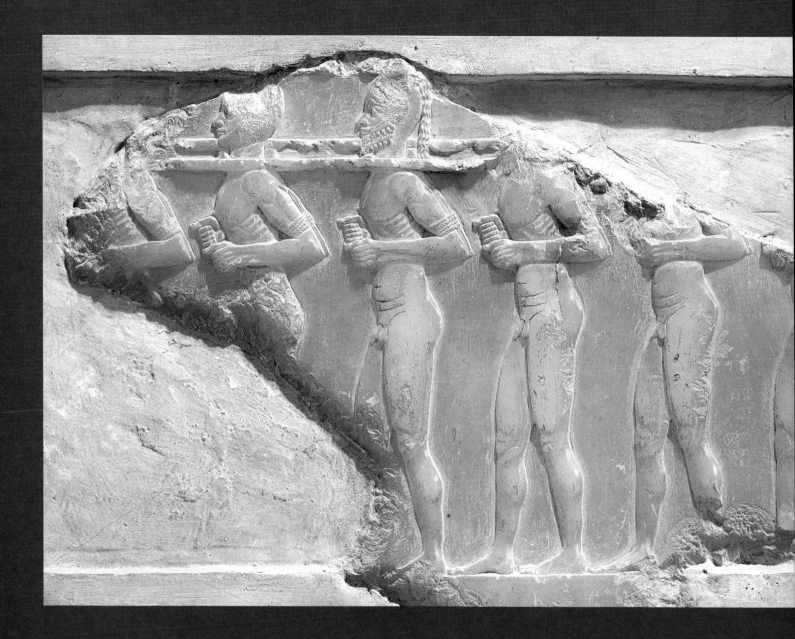

shown on cylinder seals of bound nude captives (c. 3200 B.C. at Uruk) and a similar scene, of the parading of nude bound prisoners of war, is shown on one of the registers of the famous "Standard of Ur" (now in the British Museum), which was found at the Royal Cemetery there and dates to about 2500 B.C. The counting of severed enemy heads or parading of war booty is shown as well in the much later Assyrian reliefs of the first half of the first millennium B.C.

Undoubtedly, the nudity of the prisoners symbolized their helplessness and humiliation in the face of the military might of their victorious conquerors, who in contrast remain fully clothed and armed. The exhibition of these humiliated enemies, in reality or in art, served as visual propaganda to support the military might of the state, which in the Akkadian Dynasty rose to its zenith under the great conqueror Naram-Sin, grandson of Sargon.

Akkadian Head of a King

Diana McDonald

One of the most arresting faces portrayed early in history is that of a king from the Akkadian period (c. 2300–2159 B.C.). Cast in a copper alloy, this life-size hollow sculpture is not only a tour de force of skill in metal working, but a sensitive artistic portrayal of the qualities of a ruler as set forth in his physiognomy. Whether it is a true portrait we will never know, but it embodies both the symbolic characteristics of kingship and the moral authority and nobility of character which a king must possess in order to hold sway over his subjects.

The head was cast using the lost wax method, and consists primarily of copper, with traces— less than one percent—of arsenic and nickel, which serve to strengthen the copper and was used at that period as a sort of proto-bronze. Real bronze would be harder and would use a larger percentage of tin as the alloy to harden the copper. The lost wax method involved considerable complexity and skill: the sculptor first had to model the head entirely in wax over a core, then cover it with clay and fire it so that the wax melted out of small channels. This created a mold into which the molten metal was poured. Casting flaws and problems were almost inevitable in such a process, and the cast sculpture's surface was worked on afterward to remove them. Surface details, such as the wavy lines indicating the texture of the hair, were created by chasing, which is essentially a form of scratching with tools.

The Akkadian period, though short-lived, produced some of the finest works of art from Mesopotamia. In this example, the smooth skin and fleshy lips of the ruler, whom many scholars believe to be Naram-Sin, is contrasted with the very elaborately textured beard and head hair which has been plaited and rolled above a fillet. The beard consists of carefully indicated ringlets of different sizes. A complex plaited chignon on the back of the head completes the coiffure, which is a duplication of that shown on the gold helmet of Meskalamdug, found at the Royal Cemetery of Ur and dating back more than a century to the Early Dynastic period. Thus the Akkadians were reaching back to the Sumerian period for these symbols of kingship in dress and coiffure.

Interestingly, the eyes of this sculpture have been gouged out and the ears damaged as well, perhaps in antiquity. The head was found in Nineveh, in northern Iraq. Most likely the eyes had originally been inlaid with shell or lapis lazuli. The damage, if indeed ancient, might well have been intended to render the image less potent. The noble visage of the king, so heroic and majestically serene, could be reduced to less of a magical presence by rendering it unable to see or hear. Enemies of the king or his realm could thus ritually eliminate the presence he had sought to impose, perhaps on the far corners of his empire, by means of these types of sculptures.

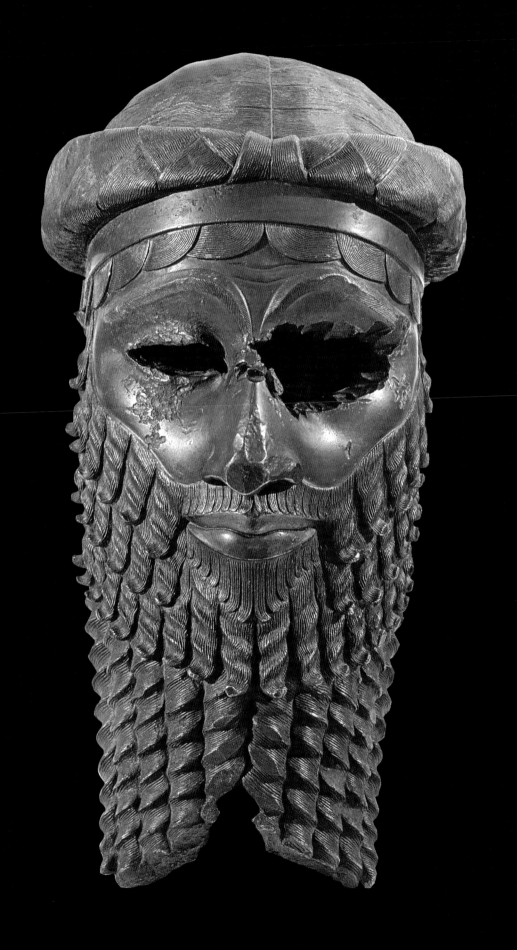

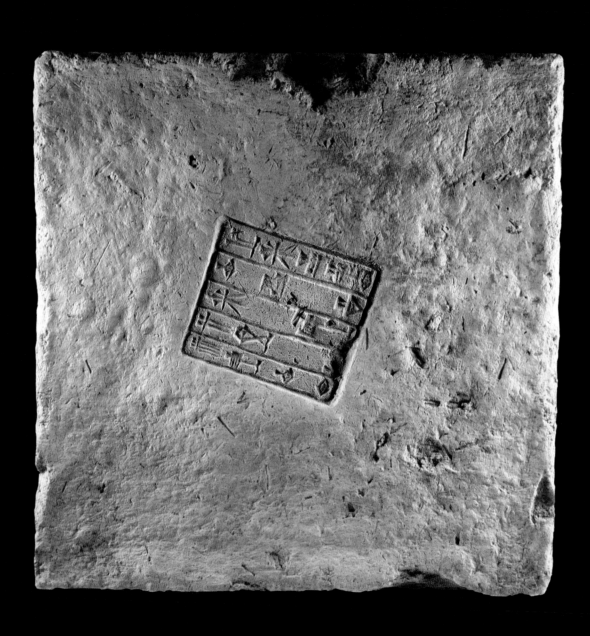

THE BIRTH OF WRITING, THE DAWN OF LITERATURE

Robert D. Biggs

When I first visited the Iraq Museum in the fall of 1962, it was still located on the east side of the Tigris. Although the space was far too small to accommodate the ever-growing collection of artifacts that came to light as a result of numerous archaeological campaigns (both Iraqi and foreign), it was filled with wonderful objects—a bull lyre and other fantastic works in gold from Ur, monumental Assyrian reliefs from Assyrian royal palaces of the first millennium B.C., and such well-known finds as the so-called Warka Head and the Warka Vase, both looted from the Iraq Museum but later recovered (the vase in damaged condition, however).

Most important of all, at least as far as I was concerned, was the museum's extraordinary and vast collection of inscribed clay tablets—among them the earliest examples of writing ever found. Collectively, these documents encompass the entire history of writing and literature in the cradle of civilization.

Having received my Ph.D. from Johns Hopkins University in ancient Near Eastern studies in the spring of 1962, I had come to the museum for a year to study cuneiform texts, specifically Sumerian magical texts. There was little space for visiting scholars, yet the then-director of the museum, Faraj Basmachi, set up a small table for me in his office where I would have abundant natural light coming in from a window by which I could read the cuneiform tablets. It was the type of hospitality

Fig. 1. An inscribed brick.

and generosity I would continue to enjoy from colleagues at the Iraq Museum from that very first visit until my most recent in 1985.

Around the time of my initial visit, a vacant lot on the west side of the river had been chosen as the site for a new museum, the design of which was still very much in the planning stages. Nevertheless, a diminutive replica of the famed Ishtar Gate from Babylon had been set up on the site where the new museum was to be built. (The original gate, faced with beautiful glazed bricks, was excavated by a German expedition and reassembled and restored in Berlin.)

Upon its completion, the new museum seemed spacious, airy, and light compared to its predecessor, with convenient space for scholars both from Iraq and abroad to study. Over the years, I have sat there side-by-side with my Iraqi colleagues for months at a time working on texts from various archaeological expeditions, mainly those I have been involved with— at Abu Salabikh (mid-third millennium B.C.), Nippur (ranging from mid-third millennium to late first millennium), Umm al-Hafriyat (Akkadian period, approximately 2350 B.C.), and al-Hiba (last third of the third millennium, early second millennium B.C.).

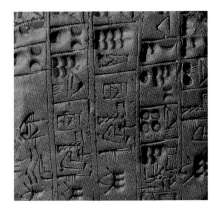

Fig. 2. Detail of an early third millennium B.C. text, clay.

It has long been held that the world's first writing was invented in Mesopotamia sometime around 3300 or 3200 B.C.—although recent carbon–14 dates have placed its origins between 3400 and 3300 B.C.—an art that, many believe, was born of a simple need for accounting and record-keeping. We are fortunate that the inventors of writing chose to capture their thoughts and communiqués and keep their records in clay, a material both plentiful and cheap. When shaped into a convenient size, marks could easily be made on the damp clay with reeds, another material also both abundant and inexpensive.

Because of the inherent durability of these documents, vast numbers have survived. The museum's holdings include an extensive collection of documents from this early period.

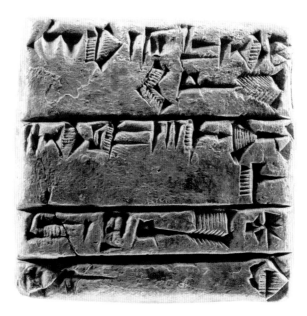

Fig. 3. Receipt for a quantity of gold for use on a figurine of a dragon, clay.

It has been through their study that we have been able to unravel and elucidate the history of written communication from its earliest beginnings.

The greatest number of archaic texts in the museum's collection came from the very ancient city of Uruk in southern Iraq (Erech of the Old Testament, known today as Warka), though other sites also have produced texts of the early third millennium. See fig. 3 for such an early text on stone from the Oriental Institute's excavations at Khafajeh in the Diyala region of Iraq. Recent years have seen considerable progress in understanding these early texts, and the complex numerical system has been worked out.

The earliest examples of writing from the late fourth millennium B.C. are pictographic—that is, composed of signs incised on clay with a reed stylus. Most signs clearly resemble the object they were meant to depict, thus a drawing of a pig's head represents a pig; a drawing of a donkey's head represents a donkey; a drawing of a shaft of barley represents barley. For an illustration of the development from pictograph to cuneiform, see fig. 4.

		Archaic Uruk c. 3000	Presargonic Lagash, c. 2400	Neo-Assyrian c. 700
SAG	"head"			
KA	"mouth"			
GU	"to eat"			
EME	"tongue"			
DU	"to go"			
UDU	"sheep"			
UD	"goat"			
GUD	"bull"			
GEME	"female slave"			
GI	"reed, to render"			
SAR	"plant, to write"			

Fig. 4. Illustration of the evolution of a few cuneiform signs from pictograph to Assyrian cuneiform.

Over time, however, the drawings developed into cuneiform (from the Latin word for "wedge"), with signs made with short strokes. It is clear that the original orientation of the pictographic signs was ninety degrees clockwise from the orientation used in later periods, perhaps occasioned by a change in the way the tablet was held in the hand or the way the reed stylus was held (fig. 4).

From early in the third millennium B.C., signs were arranged in a sort of ruled rectangular box system, which cuneiform scholars refer to as "cases," and only later toward the end of the third millennium B.C. were the signs arranged on a line in the sequence in which they were to be read. These cases were arranged top to bottom in columns, whose sequence on the obverse was left to right. If the writing continued on the back

(the reverse), the tablet was normally turned top to bottom, and the columns continued in the right to left sequence (though there are exceptions).

Eventually, cuneiform, invented to write Sumerian (a language with no known relatives), was adopted to write the Semitic language now known as Akkadian, a term used to include both the Assyrian dialect (spoken and written in northern Iraq) and the Babylonian dialect (spoken and written in southern Iraq), though certain accommodations had to be made because a number of sounds in Semitic Akkadian do not occur in Sumerian. Although we believe Sumerian died out as a spoken language, perhaps as early as 2000 B.C., we know from numerous collections of prayers and lamentations that Sumerian continued to be used for liturgical purposes in the temples. In fact, Sumerian texts continued to be composed for hundreds of years for use in the cult, though they are usually recognizable for their not adhering to classical Sumerian grammar. Kings, as well, continued to have some of their votive texts written in Sumerian, so obviously Sumerian was considered a prestigious language; in fact, a sacred language that could be understood by the gods. We also have many examples of bilingual texts, with two versions appearing side by side, the Sumerian on the left and the Akkadian on the right. Perhaps the Sumerian was intended to be understood by the gods and the translation that was provided was understandable to ordinary humans. In other cases, especially in incantations against demons, we have interlinear bilinguals with the Akkadian translations being given just below the Sumerian for each line. We do not know whether only the Sumerian was recited, with the Akkadian translation intended for the officiant to understand.

Attributed to the Early Dynastic I period (early third millennium B.C.) are the Archaic Texts from Ur, the ancient city near present-day Nasiriyah, excavated principally by a joint expedition from the British Museum and the University of Pennsylvania.

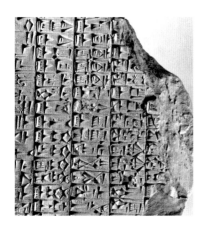

Fig. 5. Lexical text, listing occupations or professions, clay, baked in antiquity, from Abu Salabikh.

From the first phase of the Early Dynastic III period (conventionally known as ED IIIA, c. 2600 B.C.), we have numerous tablets from Fara (ancient Shuruppak, home of Ziusudra, the Mesopotamian Noah, who survived the Great Flood), excavated principally by a German expedition under Robert Koldewey early in the twentieth century, and from Abu Salabikh (ancient name uncertain), excavated in 1963 and 1965 by the Oriental Institute of the University of Chicago under the directorship of Donald P. Hansen and whose epigraphic finds I published in 1974. Abu Salabikh was subsequently excavated by the British School of Archaeology in Iraq under the directorship of J. N. Postgate. All finds registered by both expeditions at Abu Salabikh were in the Iraq Museum.

A low mound about nineteen kilometers from the ancient Sumerian religious center of Nippur is called Abu Salabikh (whose name means "father of the flints," from the numerous flint tools found littering the surface). Here, numerous pottery fragments dating to the middle of the third millennium B.C. were found lying on the surface. This same time period can be seen at the archaeological site of Nippur, just meters below the present surface of the mound. Donald Hansen, then at the

Fig. 6. Design on the reverse of the Abu Salabikh tablet shown in fig. 5.

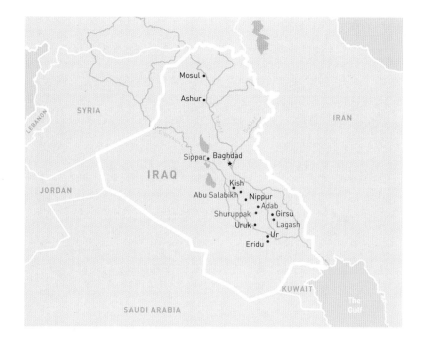

Fig. 7. Administrative tablet, clay, baked in antiquity, from Abu Salabikh.

Fig. 8. Reverse of the tablet shown in Fig. 7. The left column gives the total quantity of barley.

Oriental Institute in Chicago, had long had an interest in the site. An opportunity presented itself in the spring of 1963 when, having driven the Nippur Land Rover to the site of Choga Mish in Iranian Khuzestan for use by another Oriental Institute expedition (for which a sum of money had to be deposited in an Iraqi bank as security—and which could not be taken out of the country once the Land Rover had been returned to Iraqi territory), the director of the Oriental Institute, Robert McCormick Adams, granted permission to use this very modest sum for a brief sounding at Abu Salabikh. Although there was no expectation of finding any written materials, I was named as the epigrapher responsible for any written finds. Quite unexpectedly, within the first few days two well preserved tablets were found (both baked in antiquity by a fire so intense that the unbaked bricks of the walls were turned to red bricks). These are illustrated in figs. 5, 6, 7, and 8. Soon small, unbaked, badly broken fragments began to be found. Following the brief spring season in 1963, we had an opportunity to return in December 1965. Almost immediately, we came upon a heap of cuneiform tablets in an ancient rubbish pit, along with discarded animal and fish bones and broken pottery.

One of the remarkable aspects of these cuneiform tablets from Abu Salabikh (c. 2600 B.C.) was that there were a number of literary texts. Literary texts from this period were so unexpected that a Chicago colleague complained that I had embarrassed the Oriental Institute by making such a claim in an interview with the press officer at the American Embassy that resulted in newspaper articles in Europe and America. Later, after I had identified one text as being a version of the "Instructions of Shuruppak," previously known from copies from hundreds of years later (mainly from Nippur, c. 1800 B.C.), and such other texts as the "Kesh Temple Hymn" (likewise known from copies from hundreds of years later), he apologized, recognizing the importance of the Abu Salabikh finds for the history of Sumerian literature. An example of one of the literary texts is

the introductory section to a collection of short hymns to a number of Sumerian deities that can be translated as follows: "Nippur, city grown together with heaven, embracing heaven, city of Enlil, bond between heaven and earth, Enlil, the Great Mountain," emphasizing the belief that Nippur, the center of Sumerian religious life, was a bond linking earth and the heavens (figs. 9, 10, and 11).

Among the literary texts is one of the earliest written in a Semitic language (fig. 13). With the help of another, approximately contemporary version of this text discovered some years later at Ebla, a famous old city near Aleppo in Syria (whose third-millennium archives were found in the remains of the royal palace by an Italian expedition), a good bit of it can be understood (the Ebla text was written in the Semitic language called Eblaite, though we do not know what they called their own language).

Sumerian literary texts of the mid-third millennium still pose formidable challenges to being understood, partly due to their very sparse use of the prefixes, infixes, and suffixes (roughly comparable to our tense markers and prepositions) that render Sumerian of later periods understandable to us. An additional challenge is that signs are normally arranged in each "case" as they fit best, rather than on a line in the sequence in which they are to be read. Nevertheless, in the thirty years since the publication of the Abu Salabikh tablets and with the vast new material from Ebla, considerable progress has been made. Sumerian texts of the mid-third millennium B.C. are generally written in a very succinct manner and appear to be memory aids to a reader who could supply the grammatical elements corresponding to our prepositions and tense markers. The orthography was still quite fluid and did not conform to the standardized conventions of, say, 1800 B.C., though variants can sometimes remove ambiguity and help to elucidate the meanings.

Fig. 9. Illustrated here is a tale about the god Lugal-banda (father of Gilgamesh, according to Sumerian tradition) and his wife, the goddess Nin-Sun, from Abu Salabikh.

Fig. 10. Another literary text. The three round holes in the upper left represent the Sumerian word for "mountain," from Abu Salabikh.

Fig. 11. Large literary text, clay, unbaked and uncleaned, as it came out of the ground.

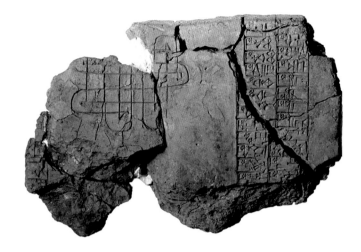

Fig. 12. Reverse of an Abu Salabikh tablet.

Fig. 13. Abu Salabikh tablet, the earliest known literary text in a Semitic language.

Among other finds at Abu Salabikh were many texts of the genre Assyriologists call lexical texts; in effect, lists of words (such as kinds of fish, names of plants, names of occupations, geographical names, and names of deities). One such text illustrated here is a list of occupations (fig. 5). This text has forerunners going back to almost the beginning of writing and, in fact, by 2600 B.C. some of the cuneiform signs in the Abu Salabikh copy were already so archaic that they occur nowhere but in copies of this list.

A few of the Abu Salabikh literary and lexical tablets have designs drawn on the backs, consisting of somewhat geometric shapes made of cuneiform wedges continued by some graceful curves, possibly to fill empty space decoratively (figs. 6 and 12).

Another surprising feature of the Abu Salabikh texts was found in the colophons, which list the scribes' names and that of the scribal master. Approximately half the names are not Sumerian but Semitic. And this only nineteen kilometers from the Sumerian heartland city of Nippur! Nippur, the religious center of Sumer, was home of the god Enlil, chief deity of the Sumerian pantheon. Previously the impression had been that a few nomadic, Semitic-speaking people gradually infiltrated the Sumerian south. But here they were, not living in tents

and herding sheep and goats, but active in a center of Sumerian learning and scholarship and contributing to what I have called "the first great flowering of Sumerian literature and the culmination of the archaic Sumerian tradition of scholarship." Such a colophon is shown in fig. 14, the column on the far left beginning with a personal name followed by "copied the tablet." The far right has words for wooden objects.

Compared to the quantity of literary and lexical texts, the number of administrative texts is relatively small. A well-preserved example with an account of barley rations is shown in figs. 7 and 8. Of interest is one (fig. 15) that clearly was intended to be read in the local Semitic language, since it has the Semitic preposition "in." We also have a few school exercises showing the efforts of beginning students to form wedges and to write signs. A typical example is shown in fig. 16, where one can readily see that some signs have been partially rubbed out and a new attempt was made.

From the third millennium, we have a number of documents concerning transfer of ownership of land. Many are on clay tablets, but there are a number on stone as well. In fig. 17 we have an example from Nippur inscribed on the back of a statue, the front of which is illustrated in fig. 18. It was discovered in the North Temple (called thus because no evidence was found to identify the name of the temple or to identify the name of the deity to whom it was dedicated).

The largest portion of tablets known from the Early Dynastic IIIB period, c. 2400 B.C., come from southern Iraq, principally the ancient city Girsu, many excavated by clandestine diggers in the late nineteenth and early twentieth centuries, but others by French expeditions. A smaller number were excavated at al-Hiba (ancient Lagash) in the late 1960s and early 1970s by a joint expedition from the Metropolitan Museum of Art and the Institute of Fine Arts, New York University, under Donald Hansen and Vaughn Crawford. Among the finds of the latter were several Sumerian literary texts such as incantations, but

Fig. 14. Reverse side of a tablet, Abu Salabikh, with a colophon at the left.

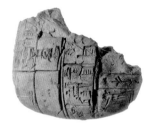

Fig. 15. Reverse of a small administrative tablet with Semitic proposition "in," from Abu Salabikh.

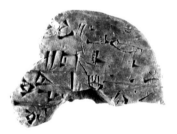

Fig. 16. School exercise tablet from Abu Salabikh..

Fig. 17. Land sale contract inscribed on the back of a statue, from Nippur.

also buried in the foundation of a temple oval were found a number of inscribed foundation stones of the ruler of the city-state Lagash, Enannatum. Each such stone was accompanied by a bronze figurine of a deity in the shape of a peg, the shaft of which was inscribed with a brief version of the foundation inscription. The full text reads, "For Inanna, goddess of all the lands, Enannatum, the governor of Lagash, the one who was chosen in the heart of (the goddess) Nanshe, the great governor for the god Ningirsu, the one given a good name by Inanna, the son begotten by the god Lugal..., the son of Akurgal, the governor of Lagash, the beloved brother of Eannatum, the governor of Lagash—for Inanna he constructed the temple oval (Ibgal); for her he made (the temple precinct) Eanna better (than any other) in all the lands; he furnished it with gold and silver; he put (this) in place so that his personal god, Shulutula, might pray forever to Inanna in the Ibgal for the well-being of Enannatum, the one with whom Inanna communicates, the governor of Lagash. The governor who keeps it permanently in good condition will be my friend." The final phrase refers to future rulers, who are implored to maintain the pious work this commemorates (fig. 19a–b). From this period there are also numerous votive cones, as well as a remarkable silver vessel with a votive inscription on it (fig. 20).

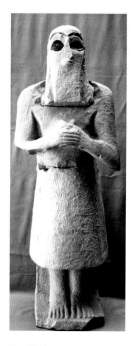

Fig. 18. Front view of the statue at top.

Fig. 19a–b. An inscribed foundation stone and accompanying copper peg in situ, and one such peg figurine shown in its entirety.

From the dynasty of Akkad (see Chapter V) we have a number of administrative texts and letters, but also votive texts, including the spectacular bronze statue base with an inscription of King Naram-Sin, fourth king of the Akkadian Dynasty, known from his own inscriptions recording his military conquests and pious deeds, but also as the hero of later legends (fig. 21). This is one of the treasures looted from the Iraq Museum but subsequently recovered (it had reportedly been hidden in a cesspool). See fig. 22 for an administrative document from Ur and fig. 23 for a cylinder seal excavated by the University of Chicago early in the twentieth century at Bismaya (ancient Adab). Adab was one of the famous, very old cities of Sumer, whose ancient remains have reportedly been largely looted and destroyed following the invasion of Iraq in 2003. The seal itself has the inscription carved in reverse so when it is rolled out, the inscription and the image are seen as positive.

The largest corpus of third-millennium texts comes from the Third Dynasty of Ur (generally known as Ur III), named for the dynasty of kings who ruled from the city of Ur, famous as Ur of the Chaldees, home of the biblical patriarch Abraham. Its bureaucracies produced hundreds of thousands of documents that have been recovered and of which many thousands are now published. The texts from this period are overwhelmingly administrative, though there are some letters and legal documents, as well as a few literary texts and incantations. Most administrative tablets are small enough to hold comfortably in one's hand. Many have three to ten lines of text plus a date, but some large account tablets can have up to twenty columns of writing, consisting of hundreds of lines. Ur III tablets were plentiful enough that as late as the 1960s, the department store Marshall Field's in Chicago had a supply of them for sale for $10 each.

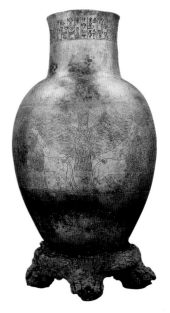

Fig. 20. Silver vase from Girsu with dedication to the god Ningisu.

Fig. 21. Statue base with inscription of the Akkadian king, Naram-Sin. (This is one of the pieces that were looted from the museum but subsequently recovered.)

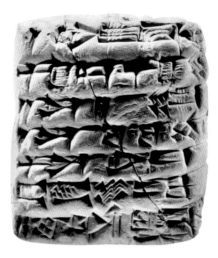

Fig. 22. Small administrative tablet from the Third Dynasty of Ur.

Fig. 23. Cylinder seal and modern impression, from Bismaya, ancient Adab.

The Second Millennium B.C.

The second millennium includes the Old Babylonian period, famous for the dynasty that included Hammurabi and his famous law code that was carried off several centuries later by Elamite raiders from western Iran and recovered by a French expedition in the ancient Iranian city of Susa. From this period we have many administrative documents and contracts, often bearing a rolling of a seal of the participants. We have a relatively small number of literary texts in Babylonian, but a much larger number of literary texts in Sumerian, principally from Nippur and Ur. The scribal schools of Nippur and Ur, ever mindful of their Sumerian origins and traditions, apparently strove to preserve the Sumerian literary heritage. We also have a number of texts giving omens based on unusual births (such as an animal with an extra leg or two heads), the "reading" of sheep livers, or the behavior of birds. An example: "If the malformed lamb already has teeth when it is born, the kings' days are at an end; someone else will sit on his throne." There are a few medical texts as well.

Rulers sometimes had bricks inscribed with dedicatory inscriptions and then had them baked for use in special situations (see fig. 1 on page 104).

From the Middle Babylonian period (also called the Kassite period), we have a great many administrative documents, principally from Nippur (excavated by American expeditions), Ur (excavated by the British Museum—University of Pennsylvania expedition), and Dur Kurigalzu (excavated by an Iraqi expedition). There are also some literary texts, school exercises, medical texts, and omen texts.

THE FIRST MILLENNIUM B.C.

There are vast numbers of texts dating to the first millennium, many of them excavated in the nineteenth century. This includes the library of King Ashurbanipal of Assyria (reigned 668–627 B.C.) who prided himself on being able to read and write, and even to read "stone tablets from before the Flood." The remnants of this library are primarily in the British Museum, where scholars have been laboring for well over a century to piece together the many thousands of fragments. Illustrated here (fig. 24) is an example of Tablet XI, the "Flood Tablet," from the Epic of Gilgamesh from Ashurbanipal's library. This is the text that caused such excitement in the nineteenth century when it was discovered, for it had an account of the Great Flood with the many details (such as the ark, the rains, and sending out birds to seek for dry land) familiar to readers of the Bible from the story of Noah and the ark. Many texts have come from Babylon, Uruk, and Sippar. In fact, a few years ago Iraqi archaeologists made a remarkable discovery at Sippar—a very old city near Babylon and home of the sun god Shamash and his temple, Ebabbar, which still flourished in the time of the Babylonian kings Nebuchadnezzar and Nabonidus and the Persian rulers who followed him—a library with cuneiform tablets still on the shelves. These tablets are all in the Iraq Museum.

In 1989, Iraqi archaeologists excavating at Nimrud, the ancient Assyrian capital city of Kalhu came upon the unplundered tombs of several Assyrian queens. These tombs contained gold

Fig. 24. Tablet XI, the "Flood Tablet" of the Epic of Gilgamesh.

Fig. 25. Gold bowl inscribed in Assyrian cuneiform, from the tomb of Yabâ, an Assyrian queen, Nimrud.

Fig. 26. Inscribed prism of the Assyrian King Sennacherib.

Fig. 27. Incantation bowl, inscribed in Aramaic, with a bound demon drawn in the center, from Nippur.

jewelry of extraordinarily fine workmanship, as well as gold bowls and vessels inscribed with the names of the queens. One of these illustrated here (fig. 25) is inscribed in Assyrian cuneiform saying, "Belonging to Yabâ, the queen, wife of Tiglath-pileser, king of Assyria."

Assyrian kings recorded their building activities and their military exploits in a series of inscriptions referred to as annals. Shown here is an example from the reign of Sennacherib (704–681 B.C.) inscribed on a baked clay prism from the Oriental Institute Museum (fig. 26).

Even when, as a result of ethnic movements, Babylonian and Assyrian had been replaced by Aramaic as the spoken language, certain documents continued to be written in cuneiform on clay (everything written on parchment or papyrus has perished without a trace). This is notably true of astronomical texts. In fact, the latest known dated text is an astronomical text from A.D. 75. The Babylonians, famed in antiquity for their astrology, were also advanced in astronomy and were able, based on hundreds of years of careful daily observations of the heavens, to predict accurately the occurrence of eclipses, but they were also aware of the cyclical movement of the planets.

In addition to its substantial collection of cuneiform inscriptions, the Iraq Museum also holds examples of writing in other ancient scripts. Although writings in Aramaic on parchment and papyrus have not survived in Mesopotamia, we have numerous examples of the genre usually designated by Aramaic

incantation bowls. These are small terra-cotta bowls with Aramaic incantations inscribed inside. Sometimes there is a drawing of a demon in the center, typically bound by chains. These are often found upside down in doorways, presumably to deter the entrance of malevolent beings. (See fig. 27 for an example from Nippur.)

The Roman period site of Hatra is famous for its stone monumental architecture and the many statues that adorned its temples, many of which were moved from the site to the Iraq Museum by the Iraqi Department of Antiquities. (Some of those statues had their heads knocked off and stolen in the looting of the Iraq Museum.) Many of these are inscribed with dedications in Aramaic. There are also some Aramaic inscriptions engraved on walls (fig. 28).

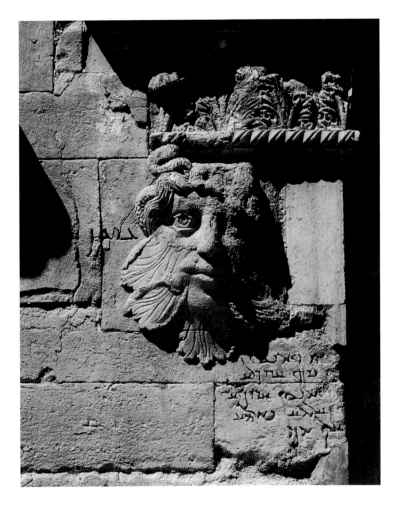

Fig. 28. Aramaic inscription on a decorative wall, Hatra.

Fig. 29. Sumerian-Akkadian incantation transcribed in Greek letters.

Another genre is ancient Mesopotamian texts transcribed in Greek letters (that is, not translated into Greek, but the pronunciation given phonetically in Greek letters). Among these (and this example is not from the Iraq Museum) is a remarkable text, only recently deciphered, which turns out to be a bilingual Sumerian-Akkadian incantation, with both the Sumerian and Akkadian transcribed in Greek letters (fig. 29). Most Babylonian texts in Greek letters are lexical (word lists), but this particular text represents in Greek letters the pronunciation of both the Babylonian and the Sumerian, important for giving us insight into the pronunciation of Sumerian almost 2,000 years after it died out as a living language.

The best preserved part of this incantation can be translated as:

May it be as pure as heaven!
May it be cleansed like the earth!
May it be as bright as the midst of the heavens!
May the evil tongue stand aside!

With the end of cuneiform writing in the early first millennium A.D. and the use of new writing materials such as paper, all knowledge of the writing system that had served ancient Mesopotamia so well for thousands of years—and which has preserved for us the knowledge and achievements of one of the great ancient cultures—was completely lost until the great decipherments of the nineteenth century, a work which many of us have been proud to continue in the Iraq Museum. We mourn the tragic losses the museum has suffered and the frightful destruction of ancient sites, but we look forward to the day when the museum can again open its doors to the Iraqi people and to the foreign visitors who care deeply for it.

Cylinder Seal Impression

Diana McDonald

Cylinder seals are a form of artwork developed in Mesopotamia and characteristic of the region and its culture. Small cylinders approximately the size of a finger were crafted of stone, shell, or other hard substances and carved in reverse with designs and sometimes also inscriptions in cuneiform. The seal was used by rolling it, with some pressure, over wet clay in order to leave its imprint. This form of art first appeared in Mesopotamia around 3500 B.C. and was used continuously until ceasing to be widely produced after about 300 B.C., after Alexander the Great. The seals are closely associated with cuneiform writing, whose wedge-shaped forms were most often impressed with a stylus or reed onto clay tablets, and which could be made official by the impression of a seal. Cuneiform writing was invented at about the same time and existed contemporaneously with seals for 3,000 years. Both cuneiform and cylinder seals are a defining characteristic of Mesopotamian civilization.

Cuneiform writing and seals are integrally related and are coexistent because of this use of clay tablets. Originally, stamp seals were developed as early as the sixth and fifth millennium as a means of imprinting designs, sometimes of rectilinear patterns and later, usually of animals. The first known "documents" from Mesopotamia were shaped clay tokens and bullae (generally ball-shaped lumps of clay), which were impressed with markings that represented animal or agricultural goods. The first attempts at writing were really signs that were targeted toward visually accounting for commodities

or, essentially, record-keeping in the service of the trade of such goods. Cylinders were an innovation at the time writing became more common and tablets were starting to be used, because the cylinder, when rolled over the clay, covered far more area than a stamp seal. Thus both could deliver more information and in some cases, keep goods more secure from tampering, for instance by rolling wet clay sealings on jars.

Seals were much more than devices that provided administrative certification or authentication of documents by officials: they testified to ownership; they served as amulets of luck, power, and healing; and the rare and semiprecious stones such as lapis lazuli, out of which they were often made, and gold, with which they were sometimes capped, provided visual indicators of an individual's status in society. Seals were worn on pins, or on the arm or neck. In the Bible, the *Song of Songs* refers to seals when the bridegroom beseeches his beloved:

Wear me as a seal upon thine heart
As a seal upon thine arm
For love is as strong as death…

The modern impression of a cylinder seal from the Iraq Museum, shown here, is a beautiful and fairly representative example of the type of cylinder seals that were produced in the Sumerian Early Dynastic period, c. 2600–2300 B.C. This one was found at the site of Ur and includes a Sumerian inscription in the upper half of a register, which also depicts crossed animals and mythical creatures (a human-headed bull). The

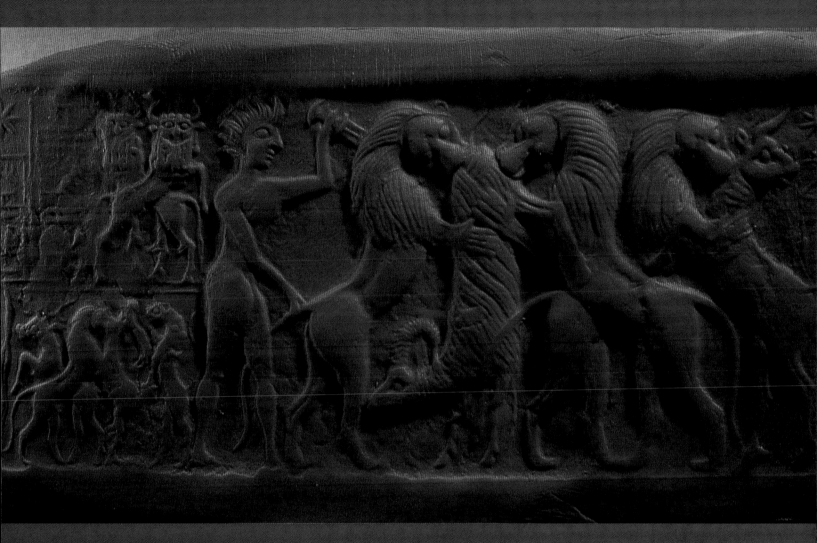

inscription reads "Shara-bar-a, scribe of the lady." The main scene consists of the characteristically Mesopotamian combat scene of a mythical hero protecting animals. A nude hero plunges a dagger into the neck of a lion attacking an upended sheep, whose hind end is also being bitten by a symmetrically placed lion. Crossed behind this lion is another full-maned lion that bites a bull looking back over its shoulder at the inscription. In the divided register under the inscription, we see a leopard attacking a long-horned caprid from one side while a lion attacks it from the other. The inverted and crossed bodies and different textures of the mane, the lions' bodies and the sheep's wool, as well as the horns of the animals, provide for a dynamic and dramatic composition. This metaphorical struggle for survival in nature is captured by the theme of combat, so commonly used in Mesopotamian art. Life at this early stage of civilization was undoubtedly difficult, and a constant test of physical endurance, well expressed by the image of fighting off the predators who also sought to devour the domestic animals possessed by humans.

Chapter VII

BABYLONIANS AND ASSYRIANS

Julian Reade

THE EARLY SECOND MILLENNIUM

With the collapse of the Third Dynasty of Ur (scholars disagree whether this happened about 2000 or 1900 B.C.), southern Iraq reverted to its previous condition as a land of independent city-states and tribes. The process of political unification began again, with individual leaders fighting for influence and recognition. The next four centuries are sometimes called the Old Babylonian period, because Babylon emerged as the most resilient state in the area, but other cities, especially Isin, Larsa, and Eshnunna, had been dominant beforehand. There were many more competing states, however, in both southern and northern Iraq, while the ancient kingdom of Elam and the mountain tribes of southwestern Iran, together with the city-states of eastern Syria, sometimes had a powerful role.

Our knowledge of this period in southern Iraq comes largely from excavations conducted between 1930 and 1990, and much of what was found is (or was) in the Iraq Museum. Archaeologists from other countries have cooperated in the work, and only a few can be mentioned here. A German expedition dug at Isin, for instance, locating the temple of Gula, goddess of healing; her symbol was the dog, amply attested in her temples both at Isin and at nearby Nippur. French expeditions excavated the royal palace and the sun temple at Larsa. Archaeologists from Chicago began the exploration of the kingdom of Eshnunna in the 1930s, and

Fig. 1. Inscribed foundation document: terra-cotta, from Dur Sharrukin (Khorsabad), late 8th century B.C., Length 23.5 cm. The Assyrian and Babylonian kings, very conscious of their place in history, regularly wrote the achievements of their reigns on stone and terra-cotta documents which were buried in the foundations of the temples, palaces, and city-walls.

Fig. 2. Woman's head, known as the Mona Lisa of Nimrud: stained ivory, from Kalah (Nimrud), Ht. 16.1 cm, 9th–8th century B.C. The head had been thrown down a well by enemies when the citadel of Nimrud was attacked in 612 B.C.; this was a traditional way of destroying enemy goods in antiquity, but it sometimes led paradoxically to their survival in relatively good condition. The head suffered severely, however, when the storeroom housing it was flooded during the sack of Baghdad in 2003.

124

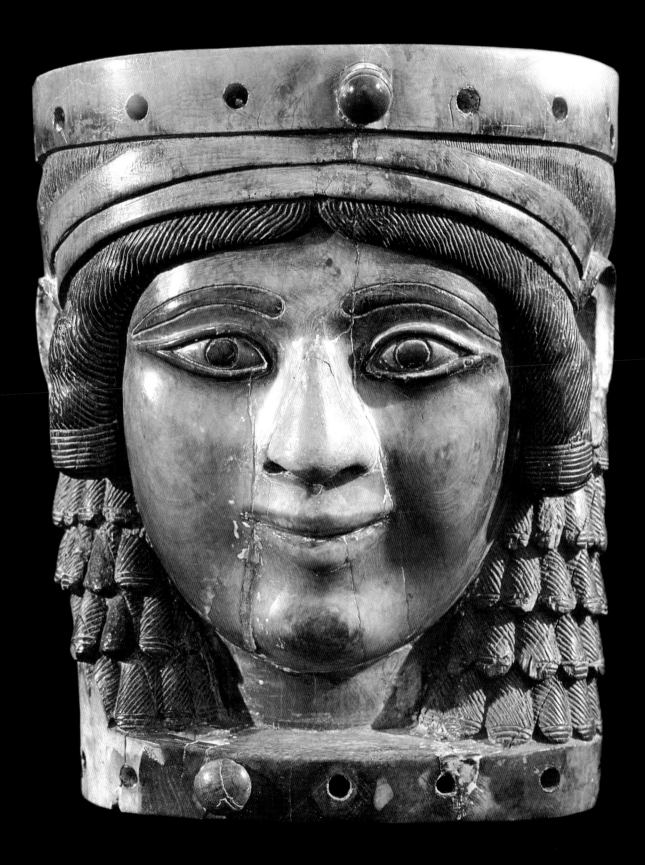

their work was continued by Iraqi teams in the 1950s, notably at the town of Tell Harmal, now famous for its written records. A vast archive dealing with the politics of southern Iraq was found across the border in Syria, at the city of Mari captured by Hammurabi, king of Babylon. Babylon itself is poorly known, however, since remains of this period are deeply buried. In northern Iraq the most productive excavations have been those of the British at Tell al-Rimah, with more archives and a wonderfully preserved temple.

The basic conditions of life had not changed since the third millennium. Few urban communities could survive for long unless their natural resources were managed efficiently. In southern Iraq this involved intelligent maintenance of the fragile canal systems, through which the fields and palm orchards were irrigated by water from the Euphrates, Tigris, and Diyala Rivers. These canals, which evolved in prehistory, had become increasingly complex, and people with local experience and expertise were better than distant imperial bureaucrats at organizing practical work of this kind. Meanwhile, in northern Iraq, whose history in this period is closely interwoven with that of the south, agriculture continued to depend on rainfall. Equally important, in both areas, stock was pastured in the surrounding steppe and, between harvests, on the farms themselves.

At the same time, the structure and composition of society had changed. The great temple institutions that had developed in the third millennium still existed. They were maintained in the traditional fashion, but they did not dominate the economy or people's spiritual lives. Many of the new rulers had been Amorite-speaking tribal chiefs from the south or west, but it was the local Akkadian rather than Amorite that survived and flourished as the written language of the country, superseding Sumerian. Generally, the material evidence recovered from excavations, while as usual it represents only a small proportion of what remains to be found, suggests that more diverse political conditions created an atmosphere that allowed for more

Fig. 3. Armed warrior, terra-cotta statuette, from Girsu (Tello), Ht. 18 cm, early second millennium B.C. This bearded, heavily cloaked figure, clasping his axe, wears a wide diadem on his head and can probably be identified as a king. This is surely one of the Amorite chiefs who established their own small kingdoms all across southern Iraq after 2000 B.C., in the years that followed the collapse of the central authority of the last Sumerian dynasty.

individual initiative and creativity. The remarkable cultural achievements of the third millennium provided a secure base of urban civilization, within which new types of enterprise had been developing, and in the second millennium they emerged into the light.

Long-distance trade had always flourished since Iraq had few raw materials, and the archives of some of the private families controlling trade in this period have been recovered. The most abundant, actually excavated near Kayseri in central Turkey, record the activities of a colony of Akkadian-speaking merchants from Ashur (or Assur, hence Assyria), then a city of moderate size, about 0.6 square kilometers, in northern Iraq. The documents offer a remarkable picture of the workings of the colony. Sometimes, for instance, the husbands stayed abroad on business for years, while the wives were their agents at home in Ashur. The colony was the most important of several Assyrian colonies that operated caravans, exporting tin and textiles to Turkey and importing silver in return. The tin itself, however, must have come from merchants operating in Iran, and some of the textiles were Babylonian. The Assyrians, while they tried to maintain a monopoly over their own

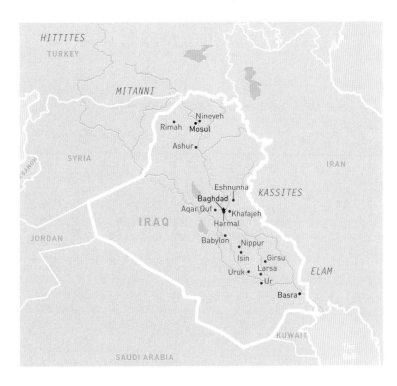

Turkish trade routes, were interacting with other trading networks too. One of the most important traded items was copper, since this was needed for tools and weapons of many kinds. A major source of copper was the Gulf, and a document of this period from Ur records a complaint about the quality of some copper ingots that had been sent there from a Gulf agent.

The Babylonians are best known for a code of laws, or rather a list of legal judgments, which had been once erected in Iraq but actually excavated in Iran where it had been taken as loot in antiquity. This was written during the reign of Hammurabi, but was a traditional kind of compilation, since kings had always liked to emphasize their interest in justice. Many other documents, however, are the earliest of their kind that are known. Examples of some had existed earlier, but it is as though there were more literate intellectuals in this period, and some of them were systematically collecting all the knowledge they could find. Much of this knowledge must have previously been passed down by word of mouth, but now it was being committed to writing. Copies of traditional Sumerian stories and hymns were accompanied by translations into Akkadian: among them are the first written accounts of the ancient hero Gilgamesh, whose futile search for immortality reflects a society which had many questions about the role of the gods and the purpose of life. One way of foretelling the future was thought to be by omens, of which there were numerous varieties; a common method, which lasted into the Roman Empire, concerned the markings on the liver of a sacrificed sheep. It was hoped that omens would in some way reveal the will of god, and there are many documents dealing with their interpretation, but one king advised another not to take them too seriously.

More remarkable are the medical and mathematical manuscripts. Lists were made of symptoms and remedies; they embody folk wisdom concerning the healing properties of plants, straightforwardly recorded without any magical incantations.

Fig. 4. Geometrical problem: clay tablets, from Tell Harmal, Ht. 9.5 cm, early second millennium B.C. One tablet gives the dimensions and area of the large triangle in the drawing and the areas of the smaller triangles within it, and then explains how to calculate the dimensions of the smaller triangles. It shows a familiarity with the characteristics of similar triangles and right-angled triangles, which reappear 1500 years later in the work of the Greek mathematician, Euclid.

Fig. 5. God killing a one-eyed demon, terra-cotta plaque, from Tutub (Khafajah), Ht. 11 cm, early second millennium B.C. The god can be recognized by his horned helmet, and may be Ninurta, whose name still survives in the form of Nimrud. The demon may be called Asag, a possible ancestor of the Cyclops.

Fig. 6. Lion guarding temple door, terracotta, from Shaduppum/Tell Harmal, Ht. 60 cm, early second millennium B.C. The worldwide tradition of placing a pair of ferocious animals on either side of important entrances probably appears in Iraq about 3000 B.C. Lions in ancient Iraq symbolized the power of the savage world which surrounded urban civilization and threatened its security, so that one of the duties of a ruler was to protect his people against them, but their power was also harnessed by the gods. The last lions in Iraq were killed early in the twentieth century. This terra-cotta lion was smashed during the looting of the Iraq Museum.

Mathematics was a vital part of the curriculum, and records often appear to be school exercises. The pupils learned how to manipulate numbers and how to calculate volume, so they would be able to work out practical problems such as the number of bricks required for a building. A very important skill, especially for surveyors who had to deal with landowners and farmers, was the ability to calculate area. Sometimes the explanations were illustrated with geometrical figures. One well-preserved manuscript presents what is essentially a proof of a theorem that is now named after Pythagoras, the Greek scientist who actually lived some 1,000 years later.

The minor arts continued to flourish, as they always did, for those who could afford them. Many of the most popular artistic themes were much the same as those of the late third millennium, but some artists seem to have been experimenting with the potential of cheap local materials—unfired clay

and terra-cotta. There are large painted images of gods and worshippers of naturalistic appearance. The less important temples, which could not afford bronze, might have a pair of life-size terra-cotta lions guarding their doors. The most impressive monuments of this period, however, were architectural. The finest known is the temple at Rimah, located in northern Iraq but based on southern models and evidently built by an architect trained in the south. It was neatly proportioned and built with mathematical precision; some of its roofs were vaulted, and it was decorated on the exterior with elaborate designs of giant columns in the form of palm tree trunks. Many other temples were made on the same principles, and some of them continued to be rebuilt on much the same lines for a thousand years or more. All of them, however, were built of mud brick (adobe) and eventually collapsed into the form of shapeless mounds. They can be excavated and planned, but no satisfactory method of conserving mud brick has yet been devised.

This period ended with a notable phase of environmental warfare, which has sad modern echoes. The kings of Babylon, once they had gained control over nearly all southern Iraq, were faced with rebellions. Since Babylon was upstream of the

Fig. 7. Temple facade: moulded bricks, from Uruk (Warka), Ht. 165 cm, about 1415 B.C. This panel decorated the temple of the goddess Inanna, and was built by the Kassite King Karaindash soon after the Kassite Dynasty established itself in southern Iraq. Figures with flowing vases symbolize the supernatural powers providing the water on which life and prosperity depended. The creation of elaborate decorative schemes from brick were an ancient Mesopotamian tradition, but the technique of using bricks as sculpture was a Kassite innovation. (See page 144.)

rebellious cities, it was possible to subdue them by diverting canals and cutting the supplies of water necessary for their crops. It proved less easy, however, to undo the damage, and Babylon eventually became the capital of a greatly diminished area. Elsewhere, for reasons not yet known, international trade and contacts declined. There was a dark age of which we know little, lasting perhaps a century, around 1500 B.C. The world that emerged from it was very different.

THE LATE SECOND MILLENNIUM

By the later fifteenth century, southern Iraq was part of the Kassite Empire, which included Babylon and sometimes extended overseas into the Gulf. The Kassite rulers themselves probably had their ancestral home in Iran, but one of their most successful kings, Kurigalzu, built himself near Baghdad a capital city which has been excavated by Iraqi archaeologists. Its principal monument, a temple tower of solid mud brick, still dominates the landscape for miles around. The Kassite language was seldom written down, and most of the people of the south probably still spoke Akkadian. Northern Iraq at the same time belonged to the Mitannian Empire, with its capital in Syria; it had yet another language, Hurrian. The city of Ashur retained some of its independence as the center of a small kingdom. Both Kassite and Mitannian empires corresponded on equal terms with the rulers of Egypt and the Hittites, so that much of the Middle East was divided among four Great Kings. In times of peace they exchanged gifts and embassies, and the different cultures cross-fertilized one another. The idea of a supreme male god, created in the image of an active Great King, began to establish itself beside the more diffuse religious beliefs inherited from prehistory, when a female goddess of fertility had a greater role. The Mitannian Empire eventually disintegrated, and its place in Iraq was taken by the kingdom of Ashur. One enterprising king, Ashur-uballit I, extended his territory northward to include the

Fig. 8. Cylinder seals: stone, from Assyrian sites, about 1300–700 B.C. Strange animals are included in the designs carved in low relief on these seals. The cylinders, usually about 3 or 4 cm high, were rolled across the clay of inscribed tablets before they dried; sometimes stamp seals were used too. The resultant impressions acted like modern signatures, validating contracts and other agreements. Some of the finest works of art of ancient Iraq were created on this miniature scale. Many seals belonged to individuals, and some were inscribed with their names. Officials on government business often had standard seals, like rubber stamps. Many of the seals once in the Iraq Museum have been stolen.

ancient city of Nineveh, and nearly all the lands beside the Tigris in northern Iraq soon came under Assyrian control. Ashur was excavated by a German team before 1914; theirs was the earliest scientific archaeological work in Iraq and their finds went to Berlin or Istanbul, but Iraqi teams have made important discoveries since.

The major artistic productions of this period to survive from southern Iraq are once again made of terra-cotta. Experiments were made in the difficult technique of glazing terra-cotta, and glazed faience became a popular material. The most important innovation, however, was the use of glass, which had hardly been known previously. Both glazed terra-cotta and glass had the huge advantage of being brightly colored, like precious stones, and the colors were less vulnerable than paint. We have to envisage Kassite and Assyrian palaces and temples of this time as brilliant, gaudy monuments, with magnificent textiles and wall paintings as well as furnishings of silver and gold. Some of the smaller objects were decorated with intricate scenes of animals, far more lively and imaginative than those created previously (fig. 10). In this period of long-distance communications, naturalism became an international style, from Crete to the Gulf. One of Iraq's major contributions was its long-established cuneiform script, which was adapted for use in Syria and Turkey by people speaking other languages. Within Iraq itself, the traditional writings continued to be valued, and some of them became known in other cultures too.

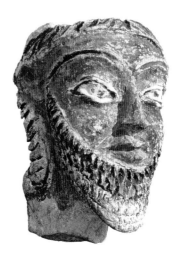

Fig 9. Head of bearded man, painted terra-cotta, from Dur Kurigalzu (Aqar Quf), about 1400–1300 B.C., Ht. 4.3 cm. This is a rare example of a miniature sculpture which still retains its paint. The sculptors of Babylonia were highly respected, and one of the Hittite kings in Turkey specifically asked a Kassite king to lend him one.

THE FIRST MILLENNIUM

During about 1200–900 B.C. there is another relatively dark age. The empires based in Iraq did not entirely disintegrate, but their spheres of influence shrank. Tribes speaking the Aramaic language, like the Amorites before them, came from the south and west and occupied much of the countryside. The kings of Ashur or Assyria were the people who finally

transformed the situation. They created an empire which, at its greatest extent, reached into both western Iran and central Egypt and had a lasting effect on the populations of the Middle East. Even the name Assyria survives today, since it was sometimes shortened to "Syria." The modern state of this name occupies what were once the western provinces of the empire.

Ashur was not only the name of a city, but the name of a mountain god, the personification of the range of hills on which the city stood. He was the principal god of Assyria; Ishtar, goddess of Nineveh, eventually became his partner. The king of Ashur was the god's agent on earth, responsible for the protection and prosperity of the god's land. Because the rolling farmlands of Assyria were vulnerable to raids from mountain tribes to the east and tribes of the steppe to the west, there developed a tradition of vigorous campaigning, and assertion of Assyrian authority along the borders. The most effective way of doing this was to extend the borders, turning potentially troublesome neighbors into taxpayers and mercenaries. It was this process of annexation that eventually led to many of the more distant conquests.

Fig. 10. Carnivore, painted terra-cotta, from Dur Kurigalzu (Aqar Quf), about 1400–1300 B.C., Ht. 7 cm. A little red paint survives on this beautifully made statuette. It is usually described as a lioness, but looks more like a cheetah, an animal used in hunting, or even some kind of dog. The lively style is typical of this period, when flourishing trade relations existed between the royal courts of Iraq, Egypt, and other great powers, which led to imaginative artistic developments.

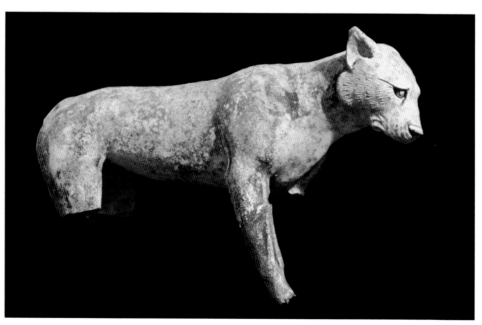

Between the ninth and seventh centuries, the Assyrians faced the challenges of administrating a growing empire of unprecedented size, and the kings became increasingly imperial figures, surrounded by ritual, remote from their subjects (fig.11). From the beginning the empire was divided into provinces that were allocated to senior members of the king's household, usually eunuchs. Newly conquered populations were often deported from one side of the empire to another, to isolate them and ensure their loyalty. During the eighth century, the provincial governors became so powerful that some of them overshadowed the king, yet they were not always able to ensure the security of their territories. The provincial system survived this crisis, but after that the kings tried to keep much closer control of their subordinates. A network of staging posts was created, and scores of government agents sent continual political reports back to the capital. Centralization of the state, around the person of the king, was accompanied by artistic achievements of which the most notable are the Assyrian sculptures, carved-stone wall panels that decorated successive palaces and glorified the king.

The city of Ashur was situated on the edge of the most fertile Assyrian land, and Nineveh was more conveniently placed as an administrative and military center. While Ashur always remained the great cult center of the national god, the king Ashurnasirpal decided in the early ninth century to move his base farther north, closer to Nineveh. He chose the old city of

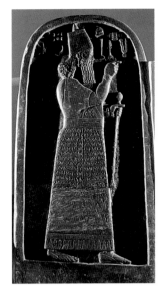

Fig. 11. Assyrian royal stela, alabaster, from Tell al Rimah, about 800 B.C., Ht. 130 cm. This shows the Assyrian King, Adad-Nirari III (811–782 B.C.), wearing a fez with a pointed top which was the royal hat, and carrying a mace as a symbol of his authority. His right hand is raised in a special gesture of worship, as if he has just snapped his fingers. Around him are the symbols of eight great gods.

Fig. 12. Tribute-bearers, yellow limestone, from Kalah (Nimrud), about 845 B.C., Ht. 25 cm, detail. Shalmaneser III, king of Assyria, recorded some of his achievements on a stone dais, on which his throne rested when he was in the arsenal at Nimrud. Its sides showed processions of people from southern Iraq and the northeastern corner of the Mediterranean, who brought him tribute, including trays of jewelry, ivory tusks, timber, and horses.

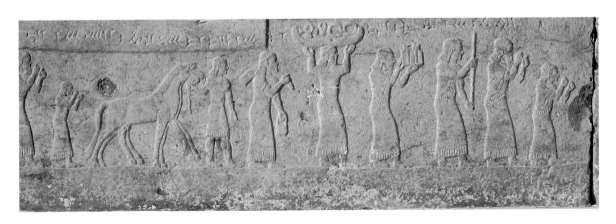

Kalah, or Nimrud, which he rebuilt on a grander scale. Major building at Nimrud continued for generations. Due to extensive British excavations, it is now the best known of all Assyrian cities, but others followed much the same model. We can envisage how it may have appeared to a visitor in the late eighth century, shortly before another king, Sargon, moved his base elsewhere.

Approaching the city from the east, there was first, on the left, a huge canal that brought water from a tributary of the Tigris, to water the fields and parkland outside the city, where the king grew exotic plants from the empire and bred wild animals to exhibit and hunt. Beyond, the main course of the Tigris ran through Nimrud's floodplain, at a slightly lower level than that on which the city itself was built. Directly in front of him, the visitor saw the mud brick city wall spreading away to either side, enclosing a huge area. The wall was altogether some twenty meters wide and twenty-five meters high, and was stepped inward, in two tiers, so that an attacker who had captured the outer part of the wall still had another obstacle to face. The wall was crowned by crenellations sheltering the defenders, and near the top a row of blue-glazed bricks with flower patterns helped provide magical protection. Then, passing through a heavily defended city gate, the visitor found on his left another imposing wall that surrounded a military camp, the headquarters of the standing army.

Excavations have revealed that this was much more than a camp and military base; in it were found some of the Iraq Museum's most attractive objects. Fort Shalmaneser, as it is sometimes called, named after the king responsible for it, incorporated a palace in which the king could occasionally reside, and it also contained stores in which much of the booty collected by Assyrian kings on their campaigns was kept. Among the features of the principal wing of the palace were a carved stone base for the royal throne (fig. 12), and a high panel of bricks once glazed in brilliant colors that was

Fig. 13. Decoration over a palace door, glazed bricks, from Kalah (Nimrud), about 845 B.C., Ht. 407 cm. This panel shows the Assyrian king twice, raising his hand in worship. Above him there is a winged disc, a sun symbol widely used in the Near East; the supreme god, here identified with Ashur or Ninurva, rides in the disc. The background color of this panel was originally a rich pale blue. At this time the Assyrian were still developing techniques of glazing brick, which they used for the exterior decoration of several palaces and temples.

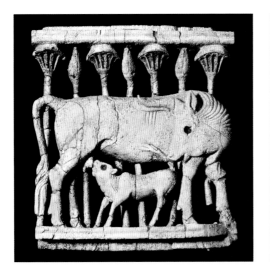
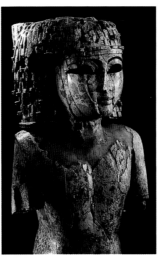

placed above an outer door (fig. 13). The most striking finds from this building, however, were thousands of small exquisitely carved ivories (fig. 14, 15). These were mostly made in the cities of Syria, Lebanon, and Palestine, and had been attached to articles of furniture as decorative facing. The Assyrians apparently collected so much of this ornate furniture that they did not know what to do with most of it, and it remained in store until Nimrud was destroyed.

Following a broad street past grand mansions, our visitor will have reached the main citadel of Nimrud, a high fortified platform, the access to which was carefully controlled. He entered through a gate between a pair of large stone lions, and saw to his left the façade of the complex of the temple of Nabu. Nabu was in origin a Babylonian god, associated especially with the art of writing, but had attained international status. Many people in Assyria and Babylonia were given names that honored him. The temple had its own magical figures in front of the main entrance and inside its internal courtyards. Some documents from the temple are the remains of a library of cultic and traditional literature, but others show that the temple also functioned as a bank, where farmers could borrow seeds which they could repay, with interest, after the harvest.

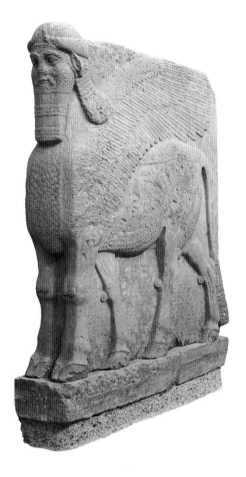

Fig. 16. Human-headed winged bull, yellow limestone, from Kalah (Nimrud), about 865 B.C., Ht. 240 cm. Monstrous figures like these are said to have the intelligence of a man, the speed of a bird, and the strength of a bull. They were used as guardian figures in Assyrian palaces and temples. A characteristic of figures of this date is that they have five legs, so that they looked equally well balanced whether seen from directly in front or from the side.

Fig. 17. Lioness killing a Nubian, inlaid ivory, from Kalah (Nimrud), Ht. 10.2 cm, 8th century B.C. The surviving inlay consists of carnelian and lapis lazuli; details are embellished with gold overlay. This is one of a pair of ivory plaques found in a well in the palace of Ashurnasirpal (883–859 B.C.). (See page 142.)

Beyond the temple, to the right, was the plainer palace of the governor of Nimrud, responsible for the city and the province, and beyond this an open space in which monuments commemorated the achievements of Assyrian kings. Two of them were the Assyrian variety of obelisk, with their tops not pointed but stepped, like the great temple towers that had stood beside the most important temples since the third millennium. The sides of the obelisks were carved with scenes of foreigners bringing tribute to the Assyrian king, a message that was reinforced in the main royal palace, originally built by Ashurnasirpal. It was about 200 meters long, divided into public and private areas, with the state apartments between them. The façade of the throne room was dominated by massive human-headed winged bulls and lions, made of gleaming whitish-grey alabaster but probably once painted: these were magical guardians (fig.16). Above the doors were bright panels of glazed brick. The interior of the throne room was lined with stone panels about two meters high, carved with more magical figures and lively scenes of the king's triumphs in war and the hunt. One can see details of the patterns and embroidery. Every stone panel also had a record of the king's achievements written across it in cuneiform. Wall paintings higher on the walls displayed similar themes. There were comparable carved stone wall panels throughout the state apartments. This was the first widespread use of such panels in Iraq, facilitated by the local availability of easily carved gypsum alabaster. The rooms were provided with elaborate bronze tableware and

stone jars of scented oil. The furniture was covered with carvings of ivory, wood, and gold leaf (figs. 2, 17). The whole complex was carefully planned as an architectural unit proclaiming the magnificence of the king.

In the private area, where the royal women lived in harem conditions, the rooms are more casual and practical in appearance, but beneath some of them Iraqi archaeologists have found the graves of queens and courtiers, with lavish gold jewelry and other treasures. Much of this dates from the late eighth century, when Assyrian armies reached the Mediterranean and western luxuries were becoming popular in the Assyrian court (figs. 18, 19).

Near the royal palace were the principal temples with their own ritual furnishings, including divine statues made of many different materials. Over the temples loomed the temple tower, some forty or forty-five meters above ground level in the town, still visible as a distant landmark.

Two later Assyrian kings built new capital cities. Sargon used Nimrud as the model for his own city of Khorsabad; this was the first Assyrian city discovered and excavated by the French in 1843. Winged bulls from Khorsabad dominate one of the

Fig. 18. Jewelry ornaments with tassels, gold with glass inlay, from Kalah (Nimrud), late 8th century B.C., Ht. about 10 cm. One of the trees represented by the inlays is a palm-tree, with clusters of dates hanging from it. This was the principal tree of Babylonia, hugely productive and significant. The other is a schematic tree of a special Assyrian type.

Fig. 19. Royal headdress, gold with glass inlays, from Kalah (Nimrud), late 8th century B.C., Ht 16 cm. From a queen's grave, it is perhaps the most elaborate piece of jewelry ever found in the ancient Near East. At the top there is a decoration of vine-leaves. In the middle there is a row of goddesses, versions of Ishtar, the goddess of fertility. The lower part of the headdress was decorated with globes, each decorated on the outside with an inlaid flower. Bunches of glass grapes hang underneath.

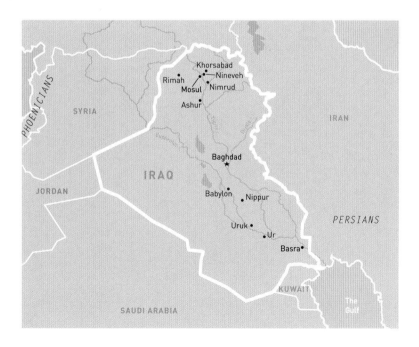

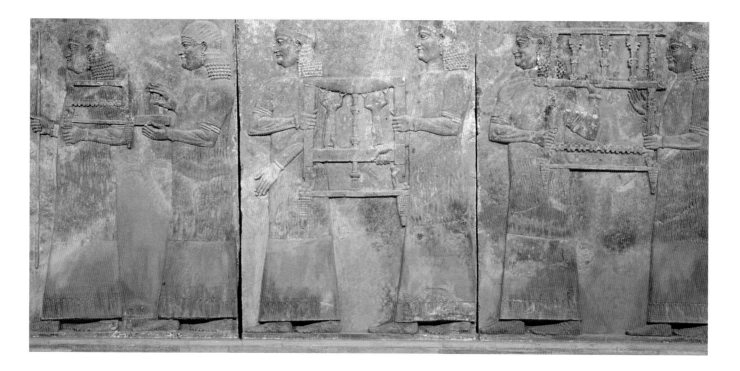

Fig. 20. Royal servants carrying furniture, alabaster wall-paneling, from Dur Sharrukin (Khorsabad), Ht. 287 cm, about 710 B.C. These wall-panels were part of the facade of the state apartments of the palace of Sargon, king of Assyria (721–705 B.C.). The figures carrying the furniture are beardless, and can be identified as eunuchs. Eunuchs dominated the courts and civil service of several empires in the ancient Near East. Having no families of their own, and being dependent on royal friendship, they could be treated as relatively reliable courtiers, officials, and servants.

entrances to the Iraq Museum. Sennacherib built on a still larger scale at Nineveh, a city excavated by British and Iraqi archaeologists. Sennacherib was an innovative thinker, and his records mention among much else the unusual techniques employed by his workmen for casting bronze and raising water. His engineers cut through rock outcrops and constructed stone aqueducts to irrigate the environs of the city. The king observed with pleasure that migratory birds nested in his artificial park. He shows, however, little interest in astronomy, a science that had made considerable progress. Experts in Babylonia had created a calendar which reconciled the solar and lunar cycles, and they could sometimes predict eclipses. Sennacherib intended Nineveh to be a universal metropolis. The language commonly spoken in its streets, and through most of Assyria and Babylonia, was by now Aramaic, which was to remain the main language of the Middle East for centuries. Although Sennacherib's vision failed and Nineveh was destroyed by enemies in 612 B.C., it was for a time the finest and most cosmopolitan city in the world.

Ashurbanipal, grandson of Sennacherib, presided over two of the greatest Assyrian achievements. One was the creation of a central library that was meant to contain all the classical cuneiform literature of the previous 2,000 years. The other was a palace decorated with carved wall panels of outstanding quality, anticipating the evolution of Greek art in the centuries that followed. The subject matter, as usual, is power and glory, but the narrative compositions embody an unparalleled range of artistic devices. The naturalism of the carved lions and other animals contrasts with the solemn dignity of the king.

During the period when Assyria was at its most powerful, Babylon was struggling and often failing to retain its independence. It eventually succeeded, and inherited a large portion of the Assyrian Empire. Nebuchadnezzar, inspired by Nineveh, set about rebuilding his own city on comparably grandiose lines. Instead of stone, which was scarce in Babylonia, he used baked brick; a remarkable invention was a type of glaze for the colored bricks, which has lasted far longer than the glazes used in earlier and later periods (figs. 22 and 23). The Greeks learned about the walls of Babylon and the Hanging Gardens in the royal palace, and these entered literature as two of the Seven Great Wonders of the World.

Fig. 21. Magical guardian, alabaster wall-panel, from Dur Sharrukin (Khorsabad), Ht. about 290 cm, about 710 B.C. This is one of the numerous winged spirits which inhabited the Assyrian universe, and which were carved in the royal palaces. Their purpose was to provide protection against human enemies and, more particularly, against the evil spirits that might bring sickness and misfortune.

Fig. 22. Striding lion, glazed bricks, from Babylon, Ht. about 100 cm, early 6th century B.C. Many lions were represented on Nebuchadnezzar's great Processional Way at Babylon. The association between gods, kings, and lions went back before 3000 B.C. This was the king of beasts, which only royalty was allowed to hunt, and the king presented himself as many modern rulers have done, with a personality that combined benevolence with ferocity.

Fig. 23. Striding dragon: glazed bricks, from Babylon, Ht. about 100 cm, early 6th century B.C. The dragon, or mushhushu, was the symbol of Marduk, god of Babylon. The Assyrians and Babylonians at different times recognized a series of gods as supreme manifestations of an underlying divine unity. When Babylon was the supreme power in the physical world, Marduk was the supreme god. Dragons and bulls alternated on the glazed facade of the Ishtar Gate, which was the principal entrance to the city.

In 539 B.C., Cyrus, king of the Persian Empire, occupied Babylon, and it remained in Persian hands until the arrival of Alexander the Great in 331 B.C. The Persian Empire was an updated version of the Assyrian, by which it was influenced in many ways, but was far more extensive. So Babylon became a major provincial capital rather than the center of power, and there are few fine works or buildings to commemorate this period. There are, however, great numbers of documents, including the archives of merchant families with interests as far-flung as those of the early Assyrians. Meanwhile the ancient literature of Iraq was still being copied and conserved. A document in which Cyrus boasts of his tolerant treatment of the different peoples of his empire is based in principle on the announcements made by Sumerian kings about their love of justice. While Ashur and Nineveh took centuries to recover, Babylon survived as a city of culture long after it had lost all pretensions to political leadership.

Assyrian Ivory Lioness from Nimrud

Diana McDonald

One of the most delicate and spectacular objects from the Iraq Museum is this small ivory plaque, one of a pair, depicting a lioness attacking a Nubian boy. The ivory plaques were found at the bottom of a well in the palace of Ashurnasirpal II (reigned 883–859 B.C.) during Max Mallowan's excavations at ancient Kalah (Nimrud), in northern Iraq, and they date to the eighth century B.C. One is now in the British Museum, the other in Iraq. Most likely they were used to adorn furniture, as inlays, and both were set with carnelian and lapis lazuli and gilded. The style of the ivory indicates manufacture in a Phoenician workshop, ending up through trade or as war booty at the Assyrian court. The theme and the details, however, are Egyptian in origin.

The subject matter of a lion attacking an animal is widespread in Mesopotamian art, and the kingly lion hunt is well established as a theme for several millennia. It is rare in Mesopotamia, however, to see a human succumbing to a wild animal. The Phoenician style of the carving indicates that the piece was most likely made in a Phoenician workshop on the Mediterranean coast, where Egyptian motifs were freely utilized. The triumph of the wild beast over man was probably palatable when a foreigner was the victim, as is the case here. The motif is known in Egypt, and the intricate background of lilies and papyrus come from Egyptian flora and art.

One interesting aspect of the ivory is the naturalism and the very close observation of the hunting behavior of the lioness as demonstrated here. The lioness, whose head was inlaid with a lapis lazuli diadem, is shown at the final moment of her kill. Lions usually take down their prey by grasping their haunches after running them down. They will then kill the prey by clamping down on the windpipe and suffocating them. This is precisely the behavior that we see reproduced here. Yet this fatal action is shown as an almost lyrical embrace, and the fallen Nubian boy arches his back in the final throes of suffocation, as if in counterpoint to the sleek curves of the lioness.

We know the boy is Nubian because of the style of his (gilded) curls, and his bejeweled arms and kilt with gold leaf seem to imply some special status as well as being decorative. The preciousness of the stone inlays and gilding give us a clue to the richness of the furniture and trappings of the Assyrian court in the first millennium B.C., and also hint at the love of foreign crafts and luxury objects which glorified the ruler and the elite.

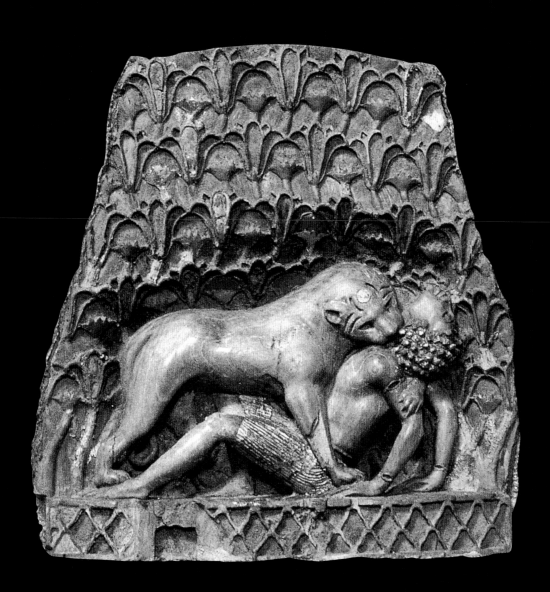

From the Kassite Temple of Karaindash

Diana McDonald

A new group of people rose to power in southern Mesopotamia in the second millennium—the Kassites. They ruled over Babylonia for a significantly long time—from about 1530–1155 B.C.—and adopted many of the existing gods and art forms of the region. Knowledge of their origins and rule is unfortunately still sparse. In this wall decoration from a temple built by the Kassite King Karaindash (c. 1415 B.C.) for the goddess Inanna, erected in the city of Uruk (Warka), one can see the melding of Kassite style with traditional Mesopotamian subject matter.

The fragment of the temple façade in the Iraq Museum depicts alternating male and female figures set in niches. The entire work is composed of individually molded terra-cotta baked bricks forming figures, an artistic and architectural innovation that reaches its zenith a thousand years later with the molded, glazed bricks of the spectacular Neo-Babylonian Ishtar Gate, and other structures in Babylon. Another large fragment of this temple's façade is on view in Berlin.

The recesses or niches in the exterior walls, a traditional aspect of early Mesopotamian temple architecture, shelter the divinities shown there and produce a rhythmic pattern which would have been accentuated by the strong sunlight of southern Mesopotamia. We know these male and female figures are divine because they all wear the horns on their caps that are an essential characteristic of Mesopotamian divinity. All the figures hold overflowing vases, whose streams of water continue across the niche horizontally and decorate the buttresses with an undulating parallel set of streams descending upon what may be mountaintops, as indicated by the curved tops of the bricks below.

The male divinity is bearded and his robe bears the scale pattern that is used to indicate mountains. Thus he may be a chthonic (earth) deity who actually arises out of the mountain, the traditional dwelling place for many Mesopotamian gods. The female deity wears a flowing robe that is incised with undulating parallel lines symbolizing water. These two divinities embody natural forces—earth and water—which underlie those of the fertility goddess Inanna, to whom the temple is dedicated. Both male and female divinities stand upon semicircles, which again symbolize mountains, the chthonic realm of these gods.

The very traditional Mesopotamian subject matter and dress are modified by a stylistic element characteristic of the Kassites, however. The figures are slender and more elongated than those produced earlier in the Mesopotamian tradition. These proportions, and the use of molded bricks, are the most striking Kassite contributions to the artistic tradition. One can speculate that by building a temple at the already ancient and storied city of Uruk, to a goddess whose importance stretches back for more than a millennium, the Kassite king was attempting to not only exploit the important natural powers of such gods but to also demonstrate his legitimacy in the eyes of the local population.

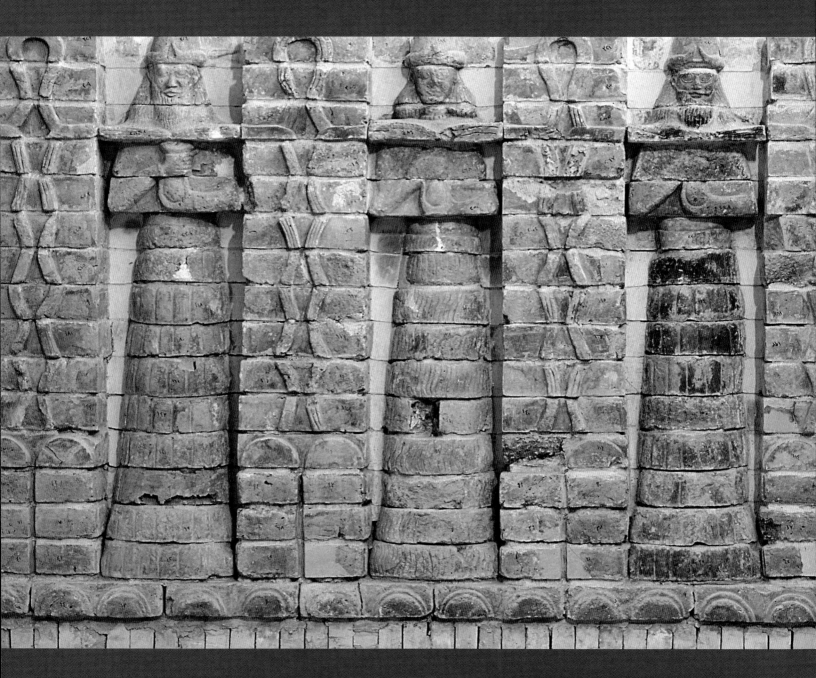

IN THE WAKE OF ALEXANDER THE GREAT

Elisabetta Valtz Fino

"Continuity is essential to an understanding of historical development, whether in the field of arts, or politics, or philosophy. Lacunae in history lead to misunderstanding and incorrect attribution of new ideas and new patterns. In the history of the Near East [...] two serious obstacles have long blocked attempts to provide a continuous narrative of man's development in that part of the world. These are our lack of knowledge of the Parthian and Sasanian periods [...] the dark ages of the Near East."

—Neilson C. Debevoise. Preface to *Parthian Pottery from Seleucia on the Tigris*, Ann Arbor, University of Michigan Press, 1934.

Fig. 1. Male head from Hatra, limestone, 1st–2nd century A.D. The noble and severe profile of this head epitomizes the best quality of the Hatraean sculpture. The schematic rendering of hair, beard, and mustache belonging to the Assyrian and Achaemenid tradition, becomes here an element of an idealized portrait. A number of Hatra statues are reported as severely damaged or totally smashed in the looting of the Iraq Museum. Hatra has been listed since 1985 in the UNESCO world heritage sites.

Iraq Museum, Baghdad, Gallery XVI: The statuette of a woman (fig. 2) is poised as if she were about to stride in noble attitude. Her beautiful, pale face is surrounded by a rich headdress, and her hand and foot appear delicately from beneath a mantle draped over her tunic. In this elegant figure, marble, limestone, stucco, and gold combine to give this enchanting lady a unique glamour among the other Mesopotamian sculptures in the galleries of the Iraq Museum.

A short distance away, a statue of Heracles (fig. 3) stands in the Lysippean pose in classic heroic nudity, a powerful bronze body whose left leg is bent and whose arm was once leaning on a club, his bearded face brightened by white inlaid eyes. An inscription written in Greek and Aramaic tells us that the statue was looted in A.D. 150 from Charax, the great harbor city on the Gulf, by the Parthian King Vologases IV, who brought it to Seleucia on the Tigris, in Mesopotamia, "to be exhibited in front of Apollo's temple, by the bronze gate..." These are new names in the millenary geography of the land

between two rivers, and both these statues represent a new art, a new world. In this gallery of the museum, the dark ages of Mesopotamian history are unveiled in front of us, with its astonishing achievements. It is a period in time that had remained relatively unknown until the beginning of the twentieth century, when a series of archaeological campaigns began to yield extraordinary finds that would illuminate this once little-known chapter in Mesopotamian history.

In the fall of 1927, Leroy Waterman of the University of Michigan decided to make a preliminary excavation in a site on the western bank of the Tigris River, some twenty-nine kilometers downstream from Baghdad. He was looking for a lost city dating from the third millennium B.C., but, as the excavation would later reveal, the huge fields of mounds in the dusty plain along the west bank of the Tigris turned out to be the remains of Seleucia, the city founded around 306 B.C. by Seleucus Nikator, one of Alexander the Great's successors, to be the Asian capital of his empire.

Seleucia is crucial to the understanding of the last 900 years of the history of the Near East before the Islamic conquest: from Alexander the Great (300 B.C.) to Mohammed (A.D. 600), three dynasties rose and fell, ruling over the vast territories stretching from the eastern Mediterranean to western Central Asia—the Hellenistic Seleucids, the nomadic Parthians, and the Iranian Sasanians, all of whom ruled from the royal complex of Seleucia/Ctesiphon.

THE FIRST DYNASTY:
THE HELLENISTIC SELEUCIDS

As a result of the extraordinary military campaign that Alexander conducted in the heart of Asia from 334–326 B.C., having defeated the most powerful empire of the time—the Persian Achaemenid—the young Macedonian general gained control of a huge territory, where cultures very different than his own had been flourishing for millennia. At his death in 323 B.C., Alexander's great empire extended from the

Fig. 2. Statue of a draped lady, from American excavations at Seleucia, marble, limestone, and stucco, with traces of gold foil, Ht. 56 cm, Parthian period, A.D. 70–120. This can be considered the masterpiece of the Hellenized sculpture of Parthian Seleucia. Found in a wall niche in a private house, it belongs to the Hellenistic typology of the draped women. It is a composite statue, made of different materials, cleverly scaled in their weight: the heavy body, with its rich draped mantle over the tunic according to the Greek prototype, is in limestone; the pale, smooth face is in marble; the eyes are inlaid, according to an old Mesopotamian tradition; and the elaborate headdress is made of stucco with a golden filet and diadem.

Mediterranean Sea to the Indus Valley. It was inherited by two of his generals: Ptolemy, who ruled Egypt, and Alexander's close friend Seleucus Nikator, who took possession of the eastern provinces of the vast empire where he founded the Seleucid Dynasty. The establishment of new cities, filled with Greek colonists, became the main instrument for the diffusion of Greek culture into vast stretches of Asia now under Seleucid rule. The most important colonial cities in the Near East were Antioch and Dura Europos in Syria, Ai Khanoum in Afghanistan, and above all the "royal city" of Seleucia on the Tigris in the heart of Mesopotamia, where Seleucus Nikator established the seat of his dynasty. This empire was in truth a continuation of empires that had come before—Persia, Babylonia, and Assyria—but now had a powerful Greek influence placed upon it. The colonists brought with them new ways of life, language, religion, artistic expression, and architecture —a new Hellenic culture that began to merge with local ancient traditions.

THE SECOND DYNASTY: THE PARTHIANS

After 150 years of rule, the descendants of Seleucus Nikator were overthrown by the Parthians, an Iranian seminomadic tribe roaming the Central Asian steppes, who in 250 B.C. invaded the eastern Seleucid provinces. Through a series of conquests over the following years, the Parthians grew to become a prominent power, founding an imperial dynasty and eventually conquering all of Mesopotamia including Seleucia on the Tigris around 150 B.C. They established their royal residence, Ctesiphon, opposite Seleucia on the eastern bank of the Tigris.

The Parthians ruled from there for nearly half a millennium, and their influence extended from Asia Minor to western Central Asia. Taking advantage of their territorial imperative over the main trading route connecting the Mediterranean coast to the Far East—what became known as the Silk Route—they controlled the international trade linking China with Rome.

Fig. 3. Statue of Heracles, Iraqi finding at Seleucia, bronze, Ht. 85.5 cm, Parthian period, 1st century B.C.–2nd century A.D. The only great statue in bronze from Seleucia holds an extraordinary importance in the history of ancient art. The pose is very similar to that of the bronze Heracles by Lysippus (4th century B.C.), known from many copies made in Roman times. The hero is standing at rest, with his well-balanced body and his left arm leaning on the club (here missing). But he is not looking downward and his right arm is not behind the hip as in the prototype, witnessing an original interpretation of the classical scheme by the bronze workshops of Hellenistic Mesopotamia.

An eclectic, intermixed culture flourished in the Parthians' vast realm, where the Hellenistic heritage was still alive and had mingled with different local traditions. The meeting of the two cultures gave birth to original styles of art seen most notably in Seleucia, which under Parthian rule became one of the wealthiest and most cosmopolitan metropolises of the ancient world.

THE THIRD DYNASTY: THE SASANIANS

During the second century A.D., weakened both by wars with the expanding Roman Empire, and by struggles for independence breaking out in different provinces, the Parthian Empire eventually succumbed to the revolt of Ardashir in A.D. 224. Ardashir, a vassal prince from the province of Fars (Iran) became the first king of yet a new dynasty, the Sasanians, and confirmed Ctesiphon as a royal capital. The Sasanians were the last rulers of the area prior to the Islamic conquest. They established a strong and centralized empire that would endure for four centuries and control a vast area stretching from Mesopotamia to Iran to present-day Afghanistan, equal in power to the Roman and Byzantine empires in the West and to the Chinese Tang Empire in the East.

Claiming to be the inheritors of the Persian Achaemenid Empire that had been conquered by Alexander the Great, the Sasanians developed a unique form of dynastic art to glorify their kingship: gigantic palaces decorated with mosaics and stuccos, rock reliefs, precious metalwork in gold and silver, gems, glassware, luxurious silk textiles. Their national religion—Zoroastrianism—helped to unify the different regions of their realm. Goods and raw materials as well as religious beliefs (such as Christianity and Buddhism), artistic styles, and technological innovations were transmitted along the Silk Route, producing as the enduring outcome a cross-fertilization of artistic expressions.

The Sasanian Empire was the swan song of the ancient Iranian dynasties; the Sasanian rule in fact collapsed under the new, growing power of Islam. At Qadisiya, Iraq, in A.D. 636, the army of the caliph Omar defeated the Iranian army and conquered Ctesiphon, the royal Sasanian capital.

With the advent of Islam a chapter in the history of the Near East drew to a close, and a new era for the world began. However, Sasanian heritage, which had disseminated far and wide into Central Asia, China, and Japan through the international trading routes, was to deeply influence Islamic and medieval European cultures in such matters as kingship, court procedures, administrative systems, warfare, and chivalry, as well as architecture and art iconography.

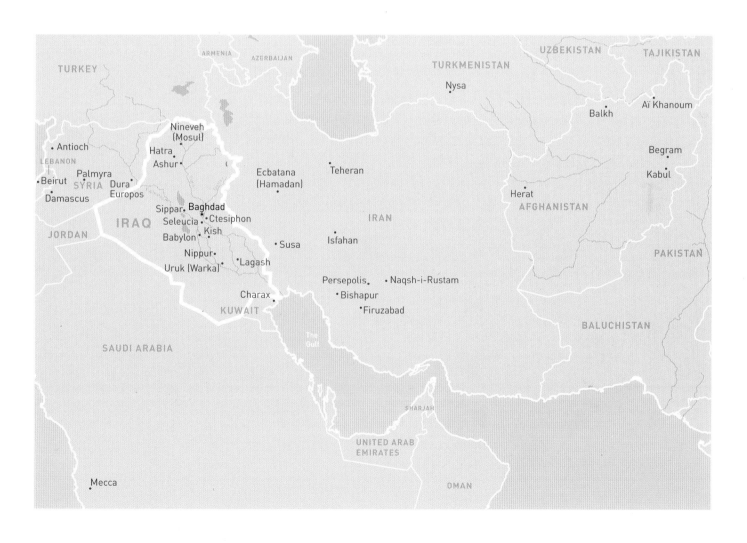

SELEUCIA ON THE RIVER TIGRIS

Seleucia on the Tigris, together with the new capital Ctesiphon, bore witness to a great part of these dramatic events that changed world history. Founded by Seleucus Nikator, Seleucia became one of the largest and greatest cities of the ancient world. Sixty-four kilometers north of Babylon, in the most strategic spot of Mesopotamia at the crossroads of the Tigris and Euphrates waterways, it was centrally located to dominate the inland caravan route connecting Central Asia to the Mediterranean.

Historians of the past, such as Pliny the Elder writing in the first century A.D., left vivid descriptions of the riches and the power of the city whose population had grown to 600,000 inhabitants, which minted its own coins, and rivaled Antioch and Alexandria in wealth it derived from controlling the major trade routes.

The Roman wars against the Parthian Empire in the second century A.D. severely affected the city, and the expedition of the Roman Avidius Cassius's army in A.D. 165 was particularly devastating. The city went into such a decline that when the

Fig. 4. American excavations at Seleucia, season 1930–31 and 1931–32. View of the Block B, Level III (142 B.C.–A.D. 43). The block excavated by the American mission was a pivotal point in the archaeology of the "dark age" of Mesopotamia. The dwellings were built in mud brick, with a porticoed entrance of two columns, according to a Greek layout. The main new feature was the introduction in the 1st century A.D. of the Parthian typology of the *iwan*, a vaulted room opening on one side into the courtyard.

Sasanians overthrew the Parthians in A.D. 226, King Ardashir decided to build "a new Seleucia" (the so-called Veh Ardashir, which means "the beautiful city of Ardashir") to continue the life of Seleucia on the opposite bank of the river, close to its capital, Ctesiphon. That area developed to become the magnificent center of imperial power, especially in the final years of the Sasanian Dynasty.

After A.D. 226, no life survived in deserted old Seleucia, where only a watchtower, erected by the last Sasanian king, remained. No settlements were established in the following centuries, and only shepherds with their flocks of goats and sheep crossed the dusty mounds, covered by a carpet of pottery shards.

The enterprise of digging Seleucia was enormous, due to the vastness of the ancient city (5.5 square kilometers, though the entire archaeological area, including the Sasanian settlements, is a hundred square kilometers). Thanks to the American excavations from 1928 to 1937, an entire dwelling block of 150 by 75 meters was brought to light, with its four superimposed levels of habitation, dating from the third century B.C. to A.D. 226 (fig. 4).

Hundreds of rooms; courtyards with columns; graves with their precious furnishings of gold, bronze, and glass objects; 3,000 terra-cotta figurines; 4,000 pottery objects and lamps; more than 3,000 beads; 450 objects in bone and ivory; and many thousands of coins were found in one season of digging.

The American excavations stopped before World War II. The digging was resumed by the Italians in 1964 and continued until 1989, the eve of the first Gulf War. The Centro di Ricerche Archeologiche e di Scavi di Torino (Turin Excavations and Archaeological Research Center) started its project in Iraq with the scientific aim to investigate the relationship between East and West in Mesopotamia. And Seleucia on the Tigris was chosen as the key site to study the impact of Hellenism on the ancient Mesopotamian culturehe American excavations

We built an expedition compound on the spot, with a house and a storage/conservation room, and in 1969 the Iraqi/Italian Institute was settled in Baghdad to cooperate with the State Organization of the Antiquities in surveys, restoration of monuments, and training courses for local personnel.

I was part of the archaeological missions from that year on at Seleucia as well as many other sites, beginning as an undergraduate and eventually becoming director of the excavations during the last seasons of digging. This was a period of uninterrupted, extensive, and rewarding series of digs and studies that culminated in the landmark exhibition "The Land Between the Two Rivers," which in 1985 brought to Italy 500 objects from the Iraq Museum, including treasures from Ur and ivories from Nimrud.

When I went to Seleucia the first time, the peasants who had originally worked with Professor Waterman had grown older but still retained vivid memories of the days when *Ameriki* were digging. Their extended families—sons, grandchildren, and cousins—were happy to resume the work with our mission and, to our great surprise, the enchantment of the site was still the same as in the Ann Arbor days. Nothing had changed, neither electricity nor running water, nor paved road had reached the spot, and until 1980 only a few mud brick houses belonging to the peasants dotted the dusty site, surrounded by cultivated fields and orchards facing the Tigris River and the ruins of the Sasanian palace of Ctesiphon.

Our life was cheered by dust storms, torrid hot days, and freezing nights, drawing and writing by candlelight, flooded tracks, mud-trapped Land Rovers, but also by Gypsy dancing, Arab coffees, parties with the workmen, wedding picnics, babies being born in the villages, hare-hunting, date harvests, and the continuous thrill of archaeological discovery: our research and digs were completing the picture sketched by the earlier American excavations, and the forgotten city began to live again little by little.

Fig. 5. Italian excavations at Seleucia, 1969–1975. View of Tell 'Umar complex from the west. The most prominent feature of the Seleucia archaeological site is a high mound, known as Tell 'Umar by the local peasants. It stands at the northern edge of the ancient city, facing on its south side a large square, lined by the city archives and the shops of the Stoa (the greek market place). The huge amount of mud brick structures that were superimposed one above the others are paradigmatic of the Mesopotamian way of building. The original building in the Seleucid period was a theater, whose cavea (seating area) was sustained by a 13 meter-high structure. In the Parthian period, the monument was transformed into a religious complex, which was abandoned when the city's life ended in A.D. 226. The tall mound of its ruins was reused during the reign of the Sasanian King Khosrau II in 6th century A.D., to build a powerful watchtower as an outpost for the defense of the capital city Ctesiphon in the last days of the Sasanian empire.

With each passing year we came to better understand the strategic importance of Seleucia. The city layout was based on Hellenistic principles that produced a functional plan: a regular grid of blocks (150 by 75 meters) was crossed longitudinally by a canal running west-east, leading to the harbor on the Tigris River. The canal acted as the main waterway for the import/export business, and moreover divided the city into two different areas. South of it, a sort of "downtown," was centered on a bursting arcade street, opening into shopping areas. North of the canal, residential areas and public buildings were found. The main complex was centered on a large public square, where the city theater was built (fig. 5). A row of private buildings and shops lined the east side of the square, while the city's archive building stood on the west side.

There, scattered on the floor among the ashes of the burnt shelves, we found the most unexpected and astonishing treasure: some 36,000 bullae (fig. 6), the small lumps of clay that sealed the documents stored in the archives. Many of them were baked by the fire that destroyed the building and its

contents when the Parthians conquered the city in 141 B.C.; others, because of the fragility of the crude clay, were found smashed or broken. They bear inscriptions in Greek and the impression of portraits of the Seleucid rulers of the city. Their miniature quality is exceptional: they are considered absolute masterpieces of Hellenistic art and form the world's greatest corpus of seal impressions ever found in an excavated single building (fig. 7).

The bullae were used to seal documents related to salt and other taxes. We could imagine the caravans coming from Central Asia and across the Iranian plateau converging into the city and traversing it along the main street, unloading and exchanging merchandise to be then carried to the Syrian coast and the great cities of Asia Minor. We might picture the traffic of seagoing boats from India, Africa, and Arabia coming up-stream along the Tigris, mooring at the city's docks, or sailing away along the Euphrates to carry the merchandise up to the Mediterranean Sea.

The light that the American and the Italian excavations throws into the dark age of late Mesopotamian history is invaluable, because Seleucia is the ideal place to understand the new world born in the wake of Alexander the Great. He reached the frontier of the then-known world, crossed it, and founded

Fig. 6. Bullae from Italian excavations at Seleucia, clay, average size 1.8 x 2.5 cm, Seleucid period, 225–154 B.C. The bullae had different shapes and sizes: sometimes the lump of clay was small and squeezed around the strings of the document, like our lead seals; sometimes, like a napkin-ring, it wrapped both the rolled document and its strings. The documents are not preserved, but we know that they were economic transactions. The Greek inscriptions on the bullae read: "Tax on salt" on the first line; on the second "Seleucia"; on the third was indicated the year. The bottom line reads "Tax exempted" or "Tax due." The portraits may represent officials in the service, but some of them are clearly related to the highest ranks of the administration, probably of the Seleucid court, due to the quality and the typology of the portraits.

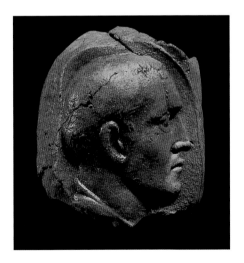 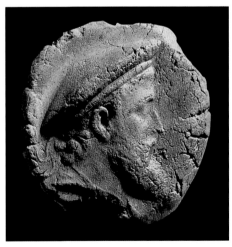 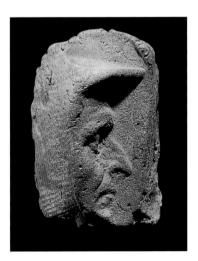

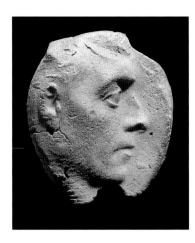

Fig. 7. Bulla from Italian excavations at Seleucia, clay, 1.8 x 1.6 cm, Seleucid period, 225–154 B.C. This extraordinary miniaturized portrait represents a male profile with a noble face marked by an aquiline nose. It testifies to the excellency of manufacture during the Seleucid period. Each of the 36,000 bullae found during three seasons of excavations, was cleaned by brush using a magnifier, then mended if broken, consolidated, and numbered. Photographed, filed, and inventoried, they were accessioned by the Iraq Museum, where they were carefully kept in cabinets. They are unique documents of official art of Seleucid Mesopotamia. Since the looting of the Iraq Museum, their destiny is unknown to us.

new cities bearing his name. For the first time soldiers and merchants from Greece came to settle permanently in a huge territory in the East. This land was characterized by a millenary history of highly developed civilizations, such as Iran and Mesopotamia, but was also marked by wide stretches of steppes where unknown nomadic tribes roamed on horseback. Alexander the Great had dreamt of a new world, where Greek and Asian civilizations could melt together, and that dream came true.

The most important aspect of the historical significance of Seleucia is exactly the meeting between East and West. In the heart of Mesopotamia we find a city of Greek layout, filled with Greek public buildings such as a gymnasium and a theater, but instead of stone and marble, they are built of mud bricks, which was the ancestral construction technique used in Mesopotamia since prehistory.

A mixed population of Greeks and Semites lived in the city. The native elite was involved in the city's public administration, which used both Greek and cuneiform writing. The ripe heritage of this mixed culture would also appear in the Parthian period, when the city adopted oriental architecture such as the vaulted hall (*iwan*). The statues of Heracles and the draped lady are the best symbols of this complex twofold culture.

Other artifacts from the American and Italian excavations give us clues into the enduring Hellenistic heritage in Parthian Mesopotamia. In the popular art of terra-cotta figurines, for instance, we find two styles: beside a continuation of the old Babylonian schematized figurines, a naturalistic form was also developed, which emphasizes bodies (fig. 8) and flowing garments. They portray Greek deities, theatrical masks (fig. 9), music players, draped nurses, and heads with elaborate hairdressing. Most widespread are the reclining female figurines,

which probably are related to the funerary banquets (a custom known also at Palmyra and Hatra). On the other side, alabaster statuettes of naked women reclining voluptuously could be interpreted as fertility goddesses or amulets (fig. 10). In any case, terra-cotta figurines were a cheap and very popular form of art. It could satisfy different tastes and faiths of the population, who adopted the most worshipped Greek deities and heroes such as Venus and Heracles, but also retained characters of the old Babylonian religion. These figurines provide a glimpse into everyday life and the funerary customs of a wealthy city with a mixed culture.

Besides these and other precious objects made of glass, bronze, and ivory, jewelry (fig. 11) was perhaps most instrumental in helping us form the picture of the lavish standard of life in Seleucia: jewelry from the Parthian period is clearly drawn from the Hellenistic-Roman tradition, highlighted by a sophisticated and baroque combination of gold, pearl, and colored stones such as turquoise and malachite.

It is evident from all the objects excavated that Seleucia on the Tigris played a crucial role in the cultural exchange between East and West. New ideas brought from the West exploded in the area, such as drastically new urban planning; different iconography and styles of artistic expression; a burgeoning economy; large-scale production of pottery and terra-cotta figurines; new religious beliefs; new customs and ways of life, and political systems. When the West met the East at Seleucia it heralded a new world in human history.

One by one the thousands of objects that I and the other archaeologists from the American and Italian missions brought to light from the dusty and barren mounds of Seleucia during thirty excavation campaigns found their way at the end of each season into the Iraq Museum. In all, hundreds of people worked together to achieve this most precious of collections:

Fig. 8. Male torso, from Italian excavations at Seleucia, terra-cotta, 12 x 4.5 cm, Parthian period, 1st century B.C.–1st century A.D. The impressive quality of this terra-cotta is even more astonishing when compared to its size: the torso is a few centimeters high, and yet it attains the monumentality of a great sculpture. In the Parthian period, the workshops of the city went on producing the same Hellenized types together with a more "local" trend, rooted in the old Babylonian tradition. However, the mass production and the non-religious value of the figurines are concepts deriving from the western world. They were produced in the thousands, and were present in every house in Seleucia, according to the excavations' evidence. We can infer that they probably had multiple uses: toys, amulets, offerings, gifts.

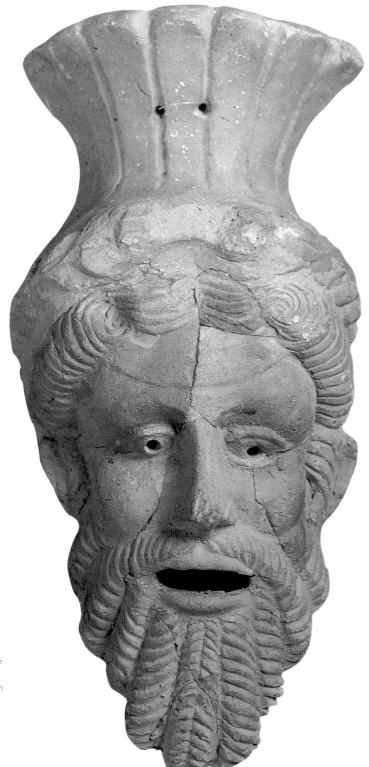

Fig. 9. Mask, from Italian excavations at Seleucia, terra-cotta, 30.5 x 12 cm, early Parthian period, 1st century B.C. The theatrical masks are among the most typical products of the Hellenistic culture of the city. A number of them were found in the workshop excavated by the Italian mission in the Archives Square, in front of the city theater. They are mold-made, and bear holes on the top or at the sides, to be hung from the walls. They mostly represent Sylenus faces, sometimes modeled in a very realistic and plastic style.

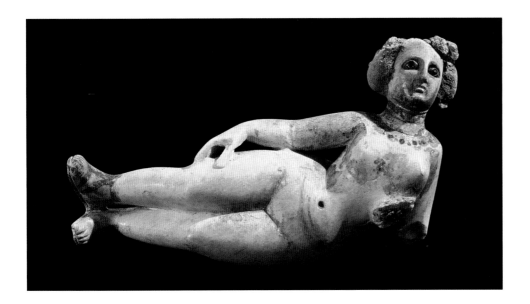

Fig. 10. Reclining female figure from American excavations at Seleucia, marble, stucco, color painting, 31 x 15 cm, Parthian period, 2nd century A.D. This example is a composite statuette made of marble and stucco, with pink and reddish touches underlining certain parts of the body. Sandals, jewelry, and an elaborate head-dress are emphasized and contrast with the naked body, enhancing its erotic value. Some of the most exquisite figurines from Seleucia are reported as looted from the Iraq Museum.

Fig. 11. Earring from American excavations at Seleucia, gold, pearls, grenade, crysoprase, Parthian period, 1st–2nd century A.D. As in Rome, pendant earrings were popular in Mesopotamia. Parthian examples show a predilection for colored stones, pearls, and gold granules forming a kind of pomegranate, like in this exquisite earring. Jewelry is reported as looted from the Iraq Museum.

museum representatives, local workmen, drivers, cooks, guards, American and Italian archaeologists, conservators, restorers, architects, photographers, professors, and students. Year by year, a support network was built to sustain our efforts that included the purchasing of cars, housing, supplies, and money devoted to the projects, as well as hours and hours of pain-staking work. Cleaned, photographed, drawn, filed, registered, numbered, inventoried, and packed, these treasures were meant to be preserved and kept for the studies of scholars, public display, exhibits in the galleries, archiving in the store-rooms of the Iraq Museum, and inclusion in publications that would tell the world a new and important chapter in the history of Mesopotamia.

My last season at Seleucia was in 1989 (fig. 12), and regular excavations never took place after the first Gulf War, but thanks to our exhibit, "The Land Between the Two Rivers," Heracles and the draped lady were standing side by side to be admired by a wide public in Rome, Florence, and Turin, from 1985 to 1987, together with hundreds of other masterpieces that the Iraq Museum generously lent to Italy.

HATRA, THE CITY OF THE SUN GOD

Far away from the palm groves of Seleucia and Ctesiphon, in the northern steppes stretching between the Tigris and the Euphrates known as Jazirah, the imposing ruins of Hatra (fig. 13), the most astonishing and dramatic of all the ancient monuments of Mesopotamia, stand like a mirage in honey-colored stone.

If compared to the two other contemporary caravan cities in the desert, Palmyra and Petra, rediscovered in the eighteenth and nineteenth centuries by European explorers, Hatra remained relatively unknown until recent days. The magic silence of its ruins was broken only by horseback travelers and a preliminary survey in 1907 by the great German archaeologist Walter Andrae. The first real excavations started in 1951, led by the Iraqi Antiquity Service under the direction of the great Iraqi archaeologist Fuad Safar. Since then the unveiling of the mystery surrounding the origin and the character of Hatra's culture is still in progress, thanks to restorations and uninterrupted archaeological excavations both by Iraqi and by Italian archaeological missions, stopped only by the 2003 war.

Fig. 12. Excavations at Seleucia, the last season of work of the Italian Archaeological Mission, June 1989. Against the backdrop of Tell 'Umar, in the foreground the work in progress at the eastern side of the Archives Square, with Iraqi workmen and some members of the Italian team. A continuous porticoed façade with shops opened onto the Square, while a wealthy private house during Seleucid's period was in the rear. Our project was to entirely detect the layout of what was emerging as the main open public space of the city during the Seleucid period, but the events of the Gulf War and the following sanctions against Iraq have prevented us from carrying on further campaigns. This picture is the last one showing an official archaeological excavation at the Seleucia site.

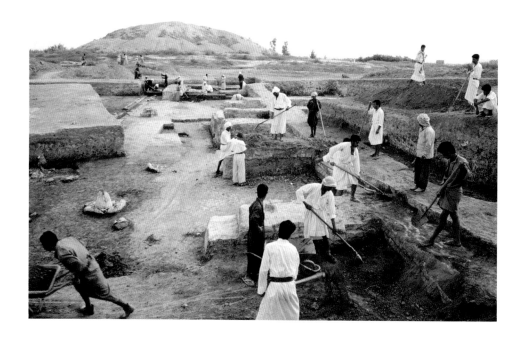

Fig.13. Aerial view of the site of Hatra. The aerial photo shows with impressive crispness the remains of the city and its plan. The ruins were extensive and very well preserved because of the isolation that surrounded Hatra for centuries. No settlement which could have spoiled the monuments arose nearby. These facts allowed the Iraqi Antiquity Service to carry on a reconstruction of the main temples using mostly the stone elements scattered on the ground.

Neither a Hellenistic capital such as Seleucia, nor a Roman-Oriental city such as Palmyra, Hatra was independent yet linked to both the Parthian and Roman empires. It was both a holy and trading city, lost in the desert, that has left an impressive number of temples and halls, statues and reliefs, frescoes, and inscriptions, showing a very complex culture.

Most likely the origin of Hatra is to be found in a small settlement from the fifth century B.C.—a simple watering hole near Wadi Thartar and a temple—located 115 kilometers southwest of Mosul, not far from the caravan route that connected Mesopotamia with Syria and Anatolia.

By the end of the first century A.D., Hatra was fortified, encompassing 3 square kilometers, and flourishing as an independent trading and sacred city within the Parthian Empire. Completely different from Seleucia, Hatra's round plan derives from an ancient Iranian tradition, and its urbanism does not follow a Hellenistic layout. Its fortification system was extraordinary: a huge wall with 160 towers and 4 gates encircled the round city. Its walls resisted the attacks of the Roman emperors Trajan (A.D. 117) and Septimius Severus (A.D. 197),

who failed to take the city during their campaigns in Mesopotamia. Notwithstanding an alliance with Rome in A.D. 230 against the new common enemy, the Sasanians, the city was captured by the Sasanian emperor Shapur I in A.D. 240. Finally deserted, it fell into ruin probably around A.D. 300.

Hatra's remains are so imposing that entering the city through the gate is still breathtaking. In the very center, a precinct of 437 by 322 meters (hatra in Aramaic means "enclosure") contains the main buildings. In a huge square space, probably reserved for the gathering of pilgrims, stands the graceful profile of a columned temple, and in an inner court of 140 by 322 meters, the gigantic temple complex dedicated to the Hatraean gods (fig. 14).

Columns, capitals, architectural decoration, statues, all realized in limestone and in great scale, make Hatra's temples some of the most spectacular complexes of the ancient world, unique in the land of the two rivers. And also unique are the buildings: the façade of the Great Temples, 115 meters long, is a sequence of eight vaulted halls—the *iwans*—with their annex rooms. The *iwan* is a huge, rectangular hall, covered by a vault and completely opened on the façade. It is the main feature of the architecture of the Iranian Parthians, who probably transferred into a monumental structure the concept of the nomadic tent, which had an open side: to the north in summer, to the south in winter.

Fig. 14. The "Great Iwans," Hatra, 2nd century A.D. Stepping into the second courtyard, the pilgrims at the holy city of Hatra were struck by the view of the eight *iwans*. The monumental façade, extending for 115 meters, opens eastward; its shady vaults and cool caves seem carved from the sunny surface of worked stone. Smaller vaults on two stories flank the great *iwans*, acting as buttresses. The archivolts are lined by sculptured heads of deities and horses, each probably bearing an astral significance.

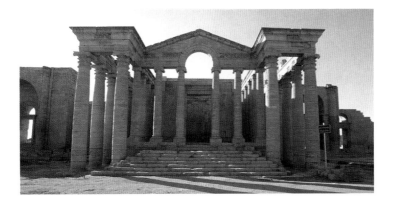

Fig. 15. The "Hellenistic temple," Hatra. Probably end of 1st century A.D. This wonderful temple appears to visitors as a monumental frame of the great courtyard, marking the entrance to the great *iwans'* enclosure. It is dedicated to Maran, the Aramaic name for the Old Mesopotamian Sun-god, Shamash. It shows a great mastery of architectural and stylistic elements. The temple is unique in Mesopotamia both for its material, the pink limestone, and its typology, an original creation of Hatraean architecture.

In the Parthian and Sasanian royal palaces, the *iwan* was the main hall, and acted as a "stage" for the performance of a royal ritual—the king's audience. In the religious complex, the Hatraeans adopted the *iwan* as a space for ceremonial purposes and sacred banquets, and the benches on which the attendees sat still stand. These oriental architectural features are dressed with opulent Roman decorations. The *iwans*, the largest of which has a covered surface of 500 square meters, display an imposing architectural decoration on the façade: columns twenty-five meters high with monumental Ionic capitals, archivolts decorated with sculptures of human and animal heads, while inside there were niches for altars and statues.

But Hatra's temples seem to rival each other in richness and variety of decoration: columns and arcades are used in a temple in front of the *iwans*, another vaulted temple is lavishly decorated with friezes depicting musicians, while the so-called Hellenistic temple, with its two rows of columns and Syrian pediment, has a Mediterranean flair, unusual in the Mesopotamian desert (fig. 15).

Who were the rulers who erected these monuments? Who were the inhabitants of this extraordinary city? Which deities did they worship? The Hatra inscriptions, in Aramaic, tell us that the population was Semitic, and the title of the rulers of Hatra was King of the Arabs. These rulers were probably a sort of sheikh from the nomadic tribes who were spreading into the northern steppes of Mesopotamia with their flocks of sheep

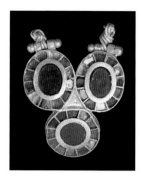

Fig. 16. Pendant from Iraqi excavations at Hatra, gold, spinel, late Parthian period, 2nd–3rd century A.D. Thanks to Seleucia statuettes and to the Palmyra and Hatra sculptures, we know that the Parthian ladies wore earrings, necklaces, and belts made of golden chains. A typical feature of Parthian jewelry is the use of colored stone in a special kind of inlay technique, such as this Hatra pendant.

Fig. 17. Dionysus head, from the great temple of Hatra, bronze, 24.5 x 22 cm, 1st–2nd century A.D. Much as the Seleucia Heracles, this magnificent mask represents a rare example of a bronze work of Parthian Mesopotamia. It is a fascinating blend of Hellenistic iconography and style with an oriental taste. Heads of deities in fact were used to decorate the arches of the Parthian *iwans*, and form the main decoration of the great *iwans* of Hatra. The head was dedicated to Bar Maran, the Aramaic god worshipped in Hatraean pantheon, son of "our Lord" and "our Lady." He is identifiable with both Dionysus and Mithra as god of the resurrection of the life and vegetation in spring.

and camels. In the last centuries B.C., they settled in the Jazirah, at the borders of the Roman and Parthian empires, and Hatra grew both as a religious and possibly trading center. It soon became a wealthy (fig.16) and cosmopolitan city, open to various cultural influences: Mesopotamian from the local tradition, Iranian from the Parthian world of which it was also a part, and Roman from neighboring Syria.

Religion was a very important unifying element: we must imagine the gathering of the pilgrims in the great precinct, where temples were erected to several deities. Under the desert's crisp, starry sky, the Arab peoples of Hatra worshiped a complex pantheon: ancient Mesopotamian and Greek gods merged together with local astral cults into a syncretic religion, very similar to that of Palmyra and Petra.

The astral triad was represented by "Our Lord," the Sumerian Sun-god Shamash (Aramaic Maran), "Our Lady," probably the goddess Nanai/Moon (Aramaic Martan), and their son, Bar Maran, identifiable with Dionysus (fig. 17). Many other syncretic deities were worshipped, such as the Babylonian god of the underworld, Nergal/Greek Hades, the Arabic great goddess Allat/Mesopotamian Ishtar/Greek Athena, and the Syrian Atargatis and Balshamin.

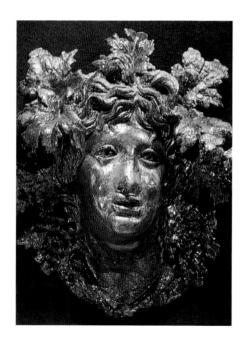

What kinds of ceremonies were performed in the temples of Hatra? There seemed to have been at least two distinct traditions. The first was the Mesopotamian ceremonial tradition reflected in the small temples, scattered within the city among private houses, whose small sacred space was not visible from the exterior and where the priests performed the rituals. The second tradition was that of the great *iwans*, where public sacred ceremonies were attended by large crowds of devotees. They probably culminated in ritual banquets, as we know from Palmyra and Petra. In a square building devoted to the sun god, the worshippers circled the shrine walking along corridors that wrapped the temple. This seems to testify to the existence, in pre-Islamic time, of an Arabian ritual similar to the circling of the Ka'aba at Mecca.

Thanks to contact with neighboring Syria, the Roman pantheon was also well represented: the Hellenistic temple contained marble statues representing deities such as Aphrodite, Apollo (fig.18a–b), Hermes, and Poseidon. They

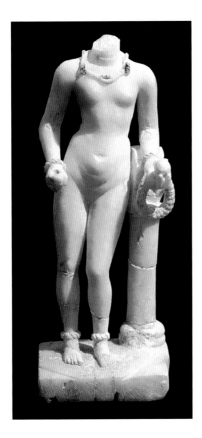

Fig. 18a–b. Aphrodite and Apollo statues from the Hellenistic temple, Hatra, marble, A.D. 160. These classical statues representing Olympic deities Apollo, Aphrodite, Poseidon, and Hermes were found within the Hellenistic temple in Hatra. They were set in niches opened into the cellar wall, when the exterior row of columns was added, probably during the short "Roman" interlude around A.D. 230. In this period Hatra experienced an alliance with the traditional enemy, Rome, in order to prevent attacks from the threat coming from the new Sasanian power.

Fig. 19. Votive incense altar from Hatra, local alabaster, 2nd century A.D. All the temples of Hatra, including the small shrines out of the sacred enclosure, were filled with cult objects: statues of worshippers, small statues of deities, reliefs showing groups of gods and goddesses, made in local stone, Mosul alabaster. Quite widespread are the small votive incense altars such as this one. The attributes of the female figures are a globe and a cornucopia, the classical symbols of abundance connected with the Greek goddess of Tyche, the Roman Fortuna.

Fig. 20. Relief with a sacrifice scene, marble, 38 x 30 cm. The variety and the diversity of the artistic trends in Hatra are witnessed by this relief, which is a typical example of the representation of local deities. Here we are facing not a portrait but an idol which is not intended to be naturalistic, but to strike the viewer with the power of his symbolic meaning. No attention is paid to the body: all the interest is focused on his attributes, and on the ritual that he is performing. Here the sacred figure is killing a ram; in other reliefs we have the god of the underground world, Nergal, mastering the snakes.

are Roman copies of Greek statues, made in the pure classic style of the fourth century B.C., imported from a Roman workshop (maybe Antioch in Syria). A completely different style is shown in the sculptures representing local deities (fig. 20), who are portrayed frontally, with no physiognomic personal traits, in a rigid attitude, and with poorly proportioned bodies.

But the most moving documents from Hatra are related to its people, whom we know from the inscriptions and the many sculptures to have been very devoted to their religion and to have made many offerings to the temples (fig. 19). The most astonishing parade of sculptures representing sovereigns, dignitaries, and priests was displayed in the Gallery XVI of the Iraq Museum. Here we come face-to-face with the kings Uthal and Sanatruq (fig. 21), the queen Abbou, and the princess Shapry. These noble and majestic figures, standing with their right hands open in a gesture of greeting and respect, look straight into our eyes. Suddenly, a strange feeling strikes us: where we have seen these faces before? They look

familiar to our eyes that are used to admiring the Romanesque-Gothic sculptures, which decorate the churches of Europe built 800 years later. The statues of Hatra speak a new language, the language of spirituality, which is reflected in their open eyes. Although they stand in frozen postures, they seem to have inner, noble strength, and notwithstanding the opulence of their embroidered garments, they express a calm and simplicity that anticipates medieval sculpture (fig. 1).

THE SASANIAN EPILOGUE

Both Seleucia and Hatra were conquered by the Sasanians, the last dynasty to rule Mesopotamia before Islam. The first Sasanian emperor, Ardashir I, was crowned in A.D. 226 at the Parthian capital, Ctesiphon, which in the following centuries continued to flourish as the administrative capital and winter residence for the imperial court, while the summer residence was Hamadan, in Iran.

In the final phase of Sasanian rule, the royal complex centered on Ctesiphon and Veh Ardashir epitomized the splendor and glory of imperial power. King Khusrau I in the sixth century A.D. built another settlement there, called Asbanbur, which included royal stables and a game reserve (Persian "paradise") filled with ostrich, gazelles, boars, lions, and bears. Close to the park stood the royal palace, known as Taq i Kisra, the Throne of Khusrau (fig. 22). The palace was built in baked bricks and gypsum mortar, and its main feature is a gigantic *iwan*.

It is still preserved with a small part of its monumental niche-and-column façade, and forms one of the most prominent ruins in the Mesopotamian landscape. In fact, the enormous hall is forty-eight meters long, and its parabolic barrel vault is thirty-five meters high with a span of twenty-six meters, the largest in the world built without centering. Medieval Islamic writers vividly described the appearance of the king in majesty and the elaborate rituals taking place in the Taq i Kisra, which was considered one of the marvels of the world.

Fig. 21. Statue of King Sanatruq I from Hatra, limestone, 2nd century A.D. The life-size statue of the King Sanatruq belongs to a very homogenous group, which includes kings, princesses, warriors, priests, and nobles . Although the refusal of the classic style of Greco-Roman tradition is shared also by Palmyra and Petra sculptors, these are unmistakably Hatraean in style and details. Their dreaming stare, majestic frontal posture, and lavishly decorated dresses enhance their charisma.

The interior was decorated with marble and glass mosaics, and the floors were covered with silk carpets embroidered in rubies and emeralds representing gardens with flowers and trees. Evidence of the splendor of the Sasanian court is the luxurious production of works of art, such as the magnificent silverware, glassware, and textiles. Though we often lack the knowledge of the spot where they were found, they are now scattered in many museums around the world.

After the fall of Ctesiphon under the Muslim army in A.D. 636, the only remnants of the Sasanian imperial glory are the ruins of the Taq i Kisra and the stucco tiles that lavishly decorated the royal palace and residences of the nobility. The stuccos display a large variety of motifs and offer an extraordinary insight into the iconography and style of the Sasanian decoration that once completely covered the structures. Beside Ctesiphon, other Sasanian palaces in Mesopotamia have yielded stucco decoration, such as Kish, a royal site close to Babylon. Palaces and halls in fact were characterized by huge volumes and wide surfaces, which offered a great opportunity for decoration that covered the architectural features completely. As for the *iwan*, though stucco—as well as the *iwan*—was inherited from the Parthians, the Sasanians developed a new technique. Instead of working out the single piece,

Fig. 22. Taq i Kisra at Ctesiphon, modern Salmanpak, 5th–6th century A.D. The gigantic skeleton of the great throne hall of the Sasanian King Khusrau stands along the east bank of the Tigris in the sleepy village of Salmanpak, 30 kilometers downstream from Baghdad. The north wing of its imposing façade, decorated with arches and columns, collapsed because of a devastating flood in 1899. A joint archaeological mission of the German State Museum and the Metropolitan Museum of Art excavated the site in 1931–32, finding interesting stuccos. The site has always been one of the most visited monuments of Iraq: its survival, however is threatened by the 1991 and 2003 wars, which have compromised the fragile status of its brick structure, which remains a unique example of an astonishing building technique.

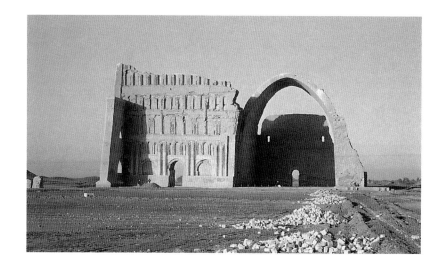

Fig. 23. Relief tiles from Ctesiphon, stucco, 102 x 103 cm, 6th century A.D. Floral motifs (such as pomegranates, rosettes, grapes, leaves, palmettes, lotuses, grapevine scrolls, undulating stems) and geometrical motifs (such as meanders, lozenges, and circles) are widely used in Sasanian stucco production. They are freely repeated and/or combined in many different interrelations to produce an almost endless variation in decoration. The typical procedure is to start from a single motif to create a more complex pattern, which became a kind of overall tapestry for the walls. Islam adopted this concept, transferring into glazed tiles used to cover all the surfaces of their mosques.

they used molds to produce a series of tiles with the same decoration, so that they could be put one beside the other to form an overall motif. This concept would become the basis for the beautiful glazed Islamic tiles.

The most widespread motifs were floral and geometrical elements, combined to produce an overall pattern that covered the entire surface of the walls (fig. 23). There were several origins for the motifs: Assyrian and Achaemenid palmettes and lotuses, Hellenistic and Roman acanthus and vine scrolls, Iranian pomegranates and wings. But all these motifs were unified into a new decorative structure that conveyed the symbolic meanings the Zoroastrian religion attached to floral and geometric elements.

Within the range of figural motifs, animals were quite widespread. They were related to royal imagery as well as Zoroastrian religion and astrology: figures from the zodiac, symbols of deities, and apothropaic values were all represented by animals such as boars, rams, lions, bulls, and birds. Small plaques depicting animals within a landscape or in combat scenes (fig. 24) were set in friezes running along the inner walls of the *iwans*. Others represented human figures and busts of

kings. Traces of color (blue and red) still present on some pieces give us a glimpse of what the global effect of these polychrome surfaces that once decorated the interior of the *iwans* was. Unfortunately, we are not yet able to fully understand the symbolic meaning of the stucco decoration, but we can appreciate its decorative value. Both Islamic and Christian ornamental art in fact would adopt and develop this ornamental value in later centuries, dismissing its original symbolic and religious significance.

Along the lush banks of the Tigris, the barren tells of Seleucia and the gigantic *iwan* of Ctesiphon show us the adventure of the last 900 years of the old Mesopotamian culture that underwent dramatic changes and transformations through the Hellenistic, Parthian, and Sasanian periods. In the vast solitude of the northern desert, Hatra stands as an astonishing revelation of an Arab city of pre-Islamic time where the meeting of oriental and western cultures intermingled with the Semitic background, creating a new and original art. In this way, the continuity from the old Mesopotamian cultures through the "dark ages" flowed into the new Islamic era, and this complex heritage, elaborated by Islam, was transmitted to medieval Europe and eventually to our modern world. This is the enduring heritage that Mesopotamia and Iraq have left to us. We have the imperative duty and moral responsibility to preserve and save it from the self-annihilation of violence and war.

Fig. 24. Tile from the palace of Kish, painted stucco, 29 x 37 cm, 5th century A.D. This is a quite rare example of a figured stucco, a lion attacking a bull. Animals were ubiquitous in Sasanian art. They had a symbolic significance, related to the Zoroastrian religion and to astrology. The lion attacking the bull has a very ancient origin, and has been extensively used in ancient Persian art. It is probably a representation of the spring equinox.

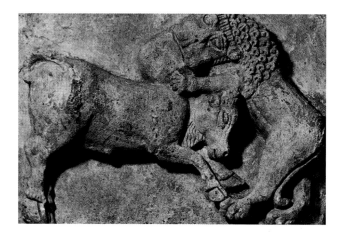

Alexander the Great Coin

Diana McDonald

Alexander the Great, King of Macedon, is one of the few historical figures whose life, with its many extraordinary accomplishments, marks both the beginning and end of an era. Alexander, born in 356 B.C., had conquered, by his death 33 years later in Babylon, almost all the world known to him, and had given birth to a legend of a semidivine hero with superlative military genius, blinding ambition, unparalleled diplomacy, and a brief but heroic life. He standardized the minting of coins in his reign and thus we see here a head of Heracles in a lion skin, depicted with the features of Alexander, imprinted on silver. The coin was minted in Babylon.

Alexander inherited his territory of Macedon upon the death of his father, King Phillip II, in 336 B.C., when he was only twenty years old. Tutored by Aristotle and already skilled in the arts of war, he was known both for his physical beauty, courage, and for his legendary taming of the spirited stallion Bucephalus, who accompanied him on his military campaigns for twenty years, and for whom he named a city. Alexander conquered the ancient Near Eastern world by besting the Great King of Persia in battle, not once but several times, and established Babylon and Persepolis as his eastern residences. This conquest of Persia marks the point at which, traditionally, the ancient Near Eastern or Mesopotamian civilization is thought to "end" and, with Alexander's death, at which point the Hellenistic era begins and Greece imports its culture and mores to the east.

Alexander captures our imagination, and that of many ancient historians, precisely because he combined the elements of youth, beauty, and uncommon valor with a superhuman drive to push the boundaries of his empire to its utmost limits. The battles he fought, including Issus and Gaugamela (in present-day Iraq), are still studied by military historians for his strategy. Neither the daunting passes of the Hindu Kush of present-day Afghanistan, nor the war elephants of the Indian King Porus at the battle of the Hydaspes seemed to dampen his ardor to conquer new lands. His marriage to Roxanne, the daughter of a Sogdian aristocrat and to other Achaemenid princesses, are variously portrayed as romantic or merely political and cunningly dynastic, while his emotional attachments to friends of his youth, and fellow warriors, was seen as often more substantial (and controversial to this day). His early death at Babylon, brought on by a fever which some have believed to be malaria, only parlayed his life into the mythical sphere, at the same time that his kingdom fell to pieces with the fighting of his successors, the general Ptolemy, who established the Ptolemaic Dynasty of Egypt, and the general Seleucus, who established the Seleucid Dynasty in the Near East. His own infant son by Roxanne, born posthumously, was murdered, as was she. His mother and his father had been murdered earlier in his life. The world had indeed changed with Alexander's life and death, and the influence of Greek culture and Greek political rule, combined with the many

elements of Persian culture that Alexander had chosen to adopt, were implanted in the civilization of Europe and the Middle East.

Alexander was famously depicted in a mosaic of the Battle of Issus, found at Pompeii, with enormous eyes, where his keen focus and intelligence are apparent. Alexander's colossal confidence was enough to rattle the Great King of the Achaemenids, Darius, in battle, in this Roman mosaic copy of a Greek painting. Alexander's triumphant entry into Babylon, after the Battle of Gaugamela, was a favorite motif for kings and nobles as late as the Renaissance in the paintings that they chose to display. In many of Alexander's coins, Alexander bears the horns of a ram. This symbol makes reference to the prophecy made at the oasis at Siwa, where Alexander was apparently told of his own divinity by the god Ammon and so was entitled to bear those horns. This motif is interesting to note because in Mesopotamia, for thousands of years, horns on human figures had been a sign of divinity. Similarly, in the coin shown here, the head of Heracles, with the skin of the Nemean lion, is assimilated to Alexander because of the use of his features. This usage of propagandistic imagery of the king's face, now so widespread on coins of his age, both served to propel the myth of his heroic nature and his divinity, much as the Assyrian kings and their earlier Mesopotamian counterparts had emphasized their heroic deeds, lion conquests, and moral authority through the distribution of their art, whether in sculpture, relief, or other media.

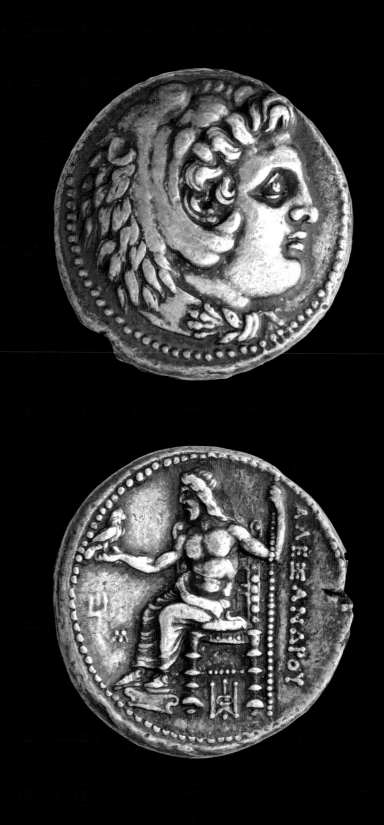

Chapter IX

THE COMING
OF ISLAM

Alastair E. Northedge

In A.D. 637 a shocking and unexpected event occurred: at the battle of Qadisiyya, near Najaf in south-central Iraq, the Sasanian army, one of the great powers of the world at the time, was defeated by Arab tribesmen under the banner of Islam. The Prophet Mohammed had died at Madina in what is now Saudi Arabia some five years before. Inspired by the revelation of the texts of the holy Qur'an, transmitted by the angel Gabriel from A.D. 610 onward, Mohammed had founded a community at Mecca and later at Madina. By the end of his life, Islam was recognized across much of the Arabian Peninsula. The new revelation created a great sense of unity among Arabs and led to the formation of a unified state where none had ever existed before.

The Sasanian Empire collapsed and disappeared entirely with the death of the last king in A.D. 652. Iraq had always been a colonial territory under Iranian rule, although the empire's capital was located at Ctesiphon south of Baghdad. The Semitic peoples of Mesopotamia came quite easily to speaking Arabic in the centuries that followed the conquest. Many Arab tribes already lived on the western border of Iraq and in the steppes of the Jazirah north of the Euphrates. Islam was tolerant, and permitted non-Muslim communities, mainly oriental Christians and Babylonian Jews, to survive. Mainly at first for financial reasons, they were declared "protected" peoples, and the principle, once established, was never revoked.

Fig. 1. Bowl with opaque white glaze and cobalt blue decorations, early 9th century A.D.

Fig. 2. Spiral minaret of the Abu Dulaf mosque, Samarra, A.D. 859–861.

In the sixth century and earlier, the Sasanians had reworked and greatly extended the irrigation system and made Iraq an extremely wealthy province. The Muslims benefited from this, and Iraq was a major power into medieval times. However, nobody in those days understood what we know today, that in a hot climate, extensive irrigation inevitably leads to salinization of the soil and the ruin of large areas of land. Iraq declined economically after the Mongol invasion of 1258, and reached a nadir under the Ottoman Turks from the sixteenth century onward.

THE UMAYYAD CALIPHATE (A.D. 661–750)

In the wake of the conquest, the Arab tribal armies were settled in A.D. 637 in two new cities at Kufa, close to Najaf, and Basra. These cities were composed of unfortified tribal settlements around the mosque and governor's palace (Dar al-Imara). These populations were opposed to the first dynasty of hereditary caliphs, the successors of the Prophet Mohammed, and the Umayyads, who settled at Damascus in Syria. Ali, the son-in-law of the Prophet, and last of the Orthodox caliphs, sought refuge in Kufa and was murdered there in A.D. 661. His son, al-Husayn, was killed in an abortive revolt at Karbala in A.D. 680. These iconic events were the foundation of the Shi'ite branch of Islam. The reaction of the Umayyads, however, was to suppress the Iraqis and build a third new city for a Syrian garrison in A.D. 705 at Wasit, south of Kut al-Amara.

The remains of this early period of Islam in Iraq are little known, by contrast with Syria and Jordan and the other countries of the Levant. There, the stone construction of the Umayyad mosque in Damascus, the Dome of the Rock in Jerusalem, and the castles of the desert have retained their splendor. In Iraq, the brick construction has been much overlaid by later additions and reworking. Nevertheless, there are many remains that can still be seen. The mosque of Kufa probably dates in its present form to A.D. 670, replacing a

primitive mosque of A.D. 637 (fig. 3a–b). Only the outer walls of the early mosque survive today, a high brick wall with semicircular buttresses. Inside there is only an open courtyard, with a descent into an underground space called al-Safina ("the ship"), and the nineteenth century golden dome to one side commemorating the spot where Ali was murdered in A.D. 661. In 1936, the Iraq General Directorate of Antiquities excavated the governor's palace (Dar al-Imara) on the southwest side. Today, untended with reeds growing on the site, the fragmentary brick walls are difficult to understand, but the double enclosure with a cruciform plan of four *iwans* (an openfronted vaulted hall) around a courtyard is fundamental for later Islamic architecture.

The Iraq General Directorate of Antiquities has also excavated the mosques at Wasit and Old Basra, modern al-Zubayr, but little is known for the moment about how much of the early mosques is preserved. Castles in the desert were also built, and two are known at Tulul al-Ukhaydir, close to the Abbasid castle of Ukhaydir, and Shu'ayba close to al-Zubayr, the latter unfortunately destroyed by the construction of an oil refinery.

Fig. 3a–b. **Right:** The mosque of Kufa in its present form. **Above:** The outer walls of the earlier mosque.

IMPERIAL ISLAM IN IRAQ: THE ABBASID CALIPHATE (A.D. 750–1258)

With the Abbasid revolution in A.D. 750, the resentment of
the Iraqis against the Syrians boiled over. It was a peculiarly
Islamic revolution against the too-secular government of the
Umayyads: many of the themes familiar today among Islamic
fundamentalists were already present. A conspiracy in Kufa
recruited an army among the frontier troops in eastern Iran,
and that army defeated the last Umayyad caliph in A.D. 750.
However, the result was a new dynasty of caliphs, descended
from 'Abbas, an uncle of the Prophet, and they settled in
Iraq. The outcome was a great flowering of Islamic civilization
over a period of two centuries, until the middle of the tenth
century. However, the wider Islamic world, which by now
spread from southern Spain (Andalusia) to Pakistan and
Uzbekistan, proved uncontrollable by the methods of commu-
nication known at the time, and the problems in the outer
provinces eventually came home to roost in Iraq. The Islamic
world split into a great number of minor states, no different
from medieval Europe. The Abbasid Dynasty nevertheless
survived, as the source of legitimacy and even regained power
over the territory of modern Iraq in the twelfth and early
thirteenth centuries, until the Mongol conquest in 1258.

It is a sad fact that the achievements of the Abbasid caliphs
have been little appreciated, and even today academic confer-
ences are sparsely attended by specialists on the theology and
literature of the period. Nevertheless it was a splendid period,
when Iraq was one of the great powers of the world, with an
empire that stretched from Tunisia to central Asia. Under the
caliph al-Ma'mun (A.D. 811–833), a school (Dar al-Hikma)
was founded in Baghdad, which undertook the translation of
Greek scientific and philosophical texts into Arabic, later to
be transmitted to Europe through Spain. The Arabic poetry of
the Abbasid period is, even today, thought to be the finest
ever composed. Trading ships from Basra and the Gulf spread

out over the Indian Ocean to bring the products of the Far East and India to the West. It was the first world culture where you can see elements from Europe, India, and China all combined together.

IMPERIAL ARCHITECTURE AND URBANISM

After a period in Kufa and surrounding areas, the second Abbasid caliph, Abu Ja'far al-Mansur (A.D. 754–776), founded a new capital in Baghdad in A.D. 762–766, called the City of Peace (Madinat al-Salam). The new site was located some thirty kilometers north of Seleucia-Ctesiphon, the former Hellenistic, Parthian, and Sasanian capital on the Tigris, perfectly placed for communication with the Gulf, Syria, and Iran. However, its placement on the map attracted the eye of invaders, from the Buyids in A.D. 945, to the Mongols in 1258, the British in 1917, and finally the recent war of 2003. As a result, the old city has suffered terribly, and nothing at all is left of the early city of the eighth and ninth centuries. Its plan has had to be reconstructed from texts, for there are many descriptions. In its time, it was one of the largest cities in the world, covering about seventy square kilometers. It is true also that the construction in fired and unfired mud brick, drawn from the heritage of ancient Mesopotamia, does not conserve well, but even the street plan of the ancient city cannot be identified.

At its heart, al-Mansur built a fortified circular city on the west bank, which is usually called the Round City, or the City of Abu Ja'far (fig. 4). The site is not certain but was probably near the Iraq Museum. The diameter was perhaps 2,500 meters, but may have been less. At its center was placed the palace of the caliph, adjacent to the mosque. There were four gates, leading through arcaded streets to the central circular courtyard. Around the central space were placed the houses of Mansur's sons, the buildings of the administration, the arsenal, and the public kitchen. In forty-five radial streets were the houses of the military officers and their troops. It was not a public city;

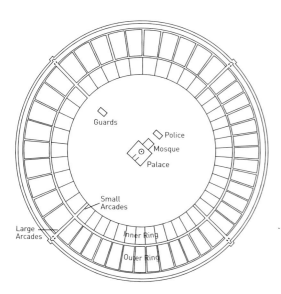

Fig. 4. The Round City of Baghdad, A.D. 762–766.

rather, the private domain of the caliph and his administration. The remains of a similar caliphal city, built in A.D. 936, can be seen today at Madinat al-Zahra, outside Cordoba in Spain, although the plan there is rectangular. The circular plan in Baghdad has attracted many interpretations of its symbolism as the "navel" of the universe, but in fact it goes back to earlier Mesopotamian and Iranian circular structures.

Outside the walls, a vast, sprawling city developed, based on four avenues leading from the gates, with markets placed at al-Karkh, today the name for the older part of west Baghdad. The establishment of the heir apparent, al-Mahdi, was sited on the east bank at Rusafa, and over the centuries the city became more concentrated on the east bank, connected with the west by three bridges of boats. At the end of the ninth century, a new caliphal palace complex, called the House of the Caliphate (Dar al-Khilafa), was built on the east side, and this remained the royal residence until the Mongol conquest. As lost as the Round City, it was described in A.D. 917 as composed of

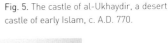

Fig. 5. The castle of al-Ukhaydir, a desert castle of early Islam, c. A.D. 770.

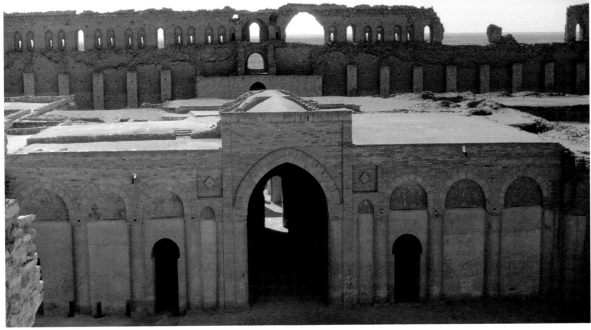

many richly decorated pavilions and three main palaces—al-Taj, al-Hasani, and al-Thurayya—with a park for wild animals and a polo ground. One small detail has been preserved: the description of A.D. 917 refers to a golden tree with birds that sang. A miniature of such a tree was sold on the art market in Paris recently, though the birds do not sing.

The best idea of the architecture from the beginning of the Abbasid caliphate can be gained from the castle of al-Ukhaydir, about fifty kilometers west of Karbala, and perhaps the last of the desert castles of early Islam, built about A.D. 770 by 'Isa ibn Ali, one of the uncles of the caliph al-Mansur (fig. 5). Even when first identified at the beginning of the twentieth century, it was preserved in nearly complete condition—a rather austere building with little decoration, with high, forbidding buttressed walls of stone rubble, and a reception *iwan* and family apartments around a courtyard. As the most famous representation of early Abbasid architecture, under the pressures of Saddam Hussein's rule, the building was restored up to the battlements, though it is not thought that the restoration fundamentally changed the building.

While castles, palaces, and mosques are the best known architectural remains of Islam, the particularly Muslim character of the state was emphasized by the building of the pilgrim road to Mecca, the road known as Darb Zubayda, after the wife of the famous caliph Harun al-Rashid (A.D. 786–809), who is known for his appearances in the stories of the *Thousand and One Nights*. At the end of the eighth century, the road from Baghdad to Kufa and Mecca across the central Arabian desert was developed like a Roman road, partly paved, with stations equipped with cisterns and caravansaries to receive the annual pilgrimage. While most of the stations studied are located in Saudi Arabia, the line of forts within the western desert of Iraq can still be visited.

The Second Capital: Samarra (a.d. 836–892)

When they were wealthy, the caliphs often sought new sites for residences. One popular area was the region of Samarra, 125 kilometers north of Baghdad on the Tigris, and a well-known hunting ground in the steppe. In the 790s, Harun al-Rashid founded an octagonal city south of modern Samarra, today called the Octagon of Qadisiyya. It was left unfinished in A.D. 796, but the site has remained untouched on the banks of the Tigris, a building site 1,500 meters across, abandoned with the octagonal walls of earth surrounding the trace of avenues leading to the site for the central mosque. Evidently based on the Round City, it remains the best witness we have of what that city was like.

Forty years later in A.D. 836, Harun's son al-Mutasim looked for a new site for his court and army, which was recruited from Turkish slaves from the steppes of central Asia, and even Chinese Sinkiang. He chose Samarra, today a town of 200,000 with a Shi'ite sanctuary over the tombs of two of the Imams, but with a strongly Sunni population. Unlike the Octagon, Samarra, called officially Surra Man Ra'a ("He who sees it is delighted"), proved to be durable and lasted through the reigns of eight caliphs, until A.D. 892 (fig. 6). However, it was built on poor steppe land, and when it was abandoned, nobody came to reoccupy the land, apart from the small town sited over the city center. A tenth century traveler describes riding up the avenue, with houses intact, lacking only the doors and roofs. Until the 1950s, nearly all of the site remained untouched, but the pressure of modern activities, and the need for land, has now severely reduced the site.

In the sixty years of its occupation, Samarra grew rapidly until it reached the size of Baghdad. Indeed, one can count fifty-eight square kilometers of buildings, extending forty-five kilometers along the banks of the Tigris, the size of a western capital city of the early twentieth century like Paris or Berlin.

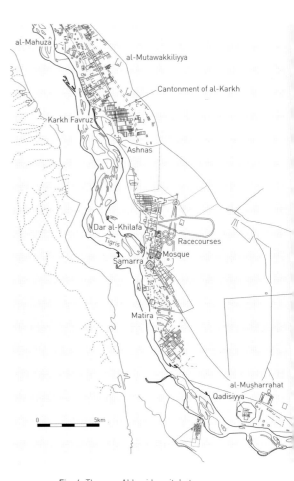

Fig. 6. The new Abbasid capital at Samarra, A.D. 836–892.

It is the largest ancient city in the world about which we know anything in detail, and remains the iconic symbol of the glories of the Abbasid caliphate.

Unlike Baghdad, there was no fortification; the first city was laid out from the caliphal palace along both sides of a central avenue seven kilometers long. Most of the area was occupied by the cantonments of the army for whom family houses were built, all in cheap earth construction, while a hunting reserve was laid out to the east. More military cantonments and palaces were laid out farther north and south, in particular, in A.D. 859–61, a second caliphal city, called al-Mutawakkiliyya, after the third caliph of Samarra, al-Mutawakkil. But this was abandoned in 861, after the assassination of the caliph. Even today you can drive up the 100-meter-wide central avenue of al-Mutawakkiliyya and believe you are in a city that was only abandoned a few years ago (fig. 2), though the earth buildings are reduced to mounds.

The mosque, 239 by 156 meters, with its famous spiral minaret fifty-two meters high, was built in A.D. 849–51 and was for a long time the largest mosque in the Islamic world. It was constructed on a grand scale by al-Mutawakkil (A.D. 847– 861), with plates of glass lining the inside walls, additional porticoes outside the main building to accommodate all the faithful on Fridays, and three broad approaches cut through the existing housing from the main avenue (fig. 7).

Fig. 7. The congregational mosque of al-Mutawakkiliyya at Samarra, with its spiral minaret, A.D. 849–852.

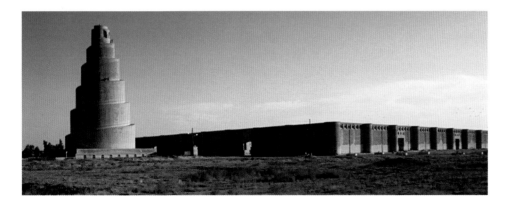

The caliphal palace, again, at 1.25 square kilometers, one of the largest imperial palaces preserved from ancient times, is best preserved in its underground elements, the only part surviving above ground being the Bab al-'Amma (the Public Gate), a triple *iwan* overlooking the Tigris. Nevertheless it was a magnificent imperial structure, a tripartite garden on the riverfront leading up a monumental staircase to the Bab al-'Amma and the throne halls, which were decorated with carved stucco and marble dadoes, and in one dome chamber, frescoes on the ceiling (figs. 8, 9). The scale of the construction can be seen today in the Circular Basin, on the north side of the great Esplanade, a circular pool sixty-five meters in diameter cut down fifteen meters into the subsoil. In the walls of the pool, amphorae were found containing fish bones, evidently refuges for the exotic fish that lived in the pool (fig. 10). In an adjacent building, some of the earliest glazed tiles were found, commonplace today but at the time, decorated with metallic luster, a royal rarity.

Not surprisingly, at the beginning of the twentieth century, when western scholars first became interested in the archaeology of Islam, there was great interest in excavating at Samarra. It was the Germans who won the race: Ernst Herzfeld and Friedrich Sarre first went to the site in 1903, and excavated from 1911 to 1913 with hundreds of workmen, like other German expeditions in Iraq. It was not an entirely happy experience; Herzfeld did not have much money and quarrelled with the Ottoman governor and the workmen. In the end, how do you excavate forty-five kilometers of buildings? It is even more impossible today with modern techniques, which require much more care than those of a century ago. Nevertheless it was a great effort, cut short by World War I. With the postwar weakness of Germany, the publications came out slowly, ending with the textual history of the city (*Geschichte der Stadt Samarra*), published thirty years later in 1948, after Herzfeld's death. Even then the architecture of the excavations

Fig. 8. Stucco revetment from an Abbasid house preserved in the museum of Samarra, 9th century A.D.

Fig. 9. Carved wooden panel from the Caliphal palace in Samarra, preserved in the Islamisches Museum, Berlin.

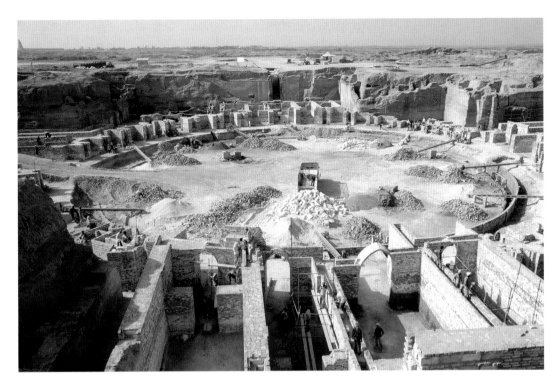

Fig. 10. The Caliphal Palace at Samarra, circular basin, c. A.D. 836.

was not published; only now has a first volume of a new series just been published by Thomas Leisten of Princeton University. However, the 1920s volumes on the architectural decoration, paintings, and ceramics have proved to be fundamental to the understanding of how Islamic art developed.

From the 1930s onward, the Iraq General Directorate of Antiquities has continued to excavate, culminating in a grand project of excavation and restoration initiated in 1980 at the instructions of Saddam Hussein, on which millions of dollars were spent and hundreds of workmen employed. It was intended to be the equivalent of the Islamic period of the rebuilding of Babylon, but it did not work out in the same way, for much less is known about Samarra. The main effect was the excavation of new buildings and restoration of known buildings such as the mosque, the Caliphal Palace, and the Palace al-'Ashiq, the home of the last caliph of Samarra, al-Mu'tamid (fig. 11).

Fig. 11. The Qasr al-'Ashiq at Samarra, A.D. 870–883.

At about the same time, in 1983, authorization was given to the present author to make a detailed survey of the city area, as it had never been properly studied. Evidently, in view of the Iraq-Iran war at the time, only a survey from air photography could be expected to be completed; photographs were cadged together from different sources, and surface pottery was collected on the ground. The basic dimensions were measured with a laser theodolite on site, traveling by vehicle from one point to another, and taking sights over two kilometers at a time, with the calculations requiring the introduction of a variable for the curvature of the earth! At any rate, 7,000 buildings were identified, of which 2,000 are blocks of ten to twenty small houses.

International Trade and Iraqi Craftsmanship: The Origins of Islamic Art

In spite of the impression given by Samarra, Iraq under the Abbasid caliphate was by no means state dominated. There was another side of free commercial enterprise and international trade, led by merchants from Baghdad, Basra, and the Gulf. The best known archaeological site of a trading city is Siraf on the Gulf coast of Iran, a site on inhospitable terrain, with bazaar merchants' houses, and mosques of the ninth century, where shards of Chinese porcelain litter the foreshore. When we can excavate again at the site of old Basra we will find the same, more so as Basra was a more important city.

From the late eighth century, ships went out from Basra to India and then to China. They sold glass and other products such as date honey (*dibs*), and brought back teakwood and spices from India and ceramics from China. Nearly all the types of porcelain and stoneware produced in southern China were exported to the Middle East. In the ninth century, Chinese wares are only found in small quantities, such as in

Fig. 12. Bowl with green and blue motifs from Samarra, mid-9th century A.D.

Fig. 13. Polychrome lustre bowl, mid-9th century A.D

the Caliphal Palace in Samarra, but over the centuries the proportion of Chinese wares goes up. The impact of the pure white porcelains, grey-green celadons, and three-color ware (San-Tsai) on Iraqi potters was extraordinary, and created the revolution that brought us the art of Islamic ceramics as we know it today. This revolution is now attributed to Basra at the beginning of the ninth century, but is still called Samarra ware, as it was first found there.

Open bowls covered in an opaque white glaze to imitate Chinese porcelain were painted in cobalt blue, and later with green and brown (fig. 12). In a second phase metallic luster was introduced, with different effects of red, brown, and yellow (fig. 13). In the tenth century this was reduced to a monochrome metallic copper, with abstract or primitive human figures. Other wares were introduced with splashes of green and brown, added to incised sgraffiato patterns. Large turquoise-glazed amphorae with barbotine decorations were used for the export of liquid products, and these wares have been found all around the Indian Ocean, from East Africa to Malaysia. Their styles influenced ceramics in the Mediterranean, from Egypt to Tunisia and Andalusia, and, after a delay of some centuries, Christian Spain and Italy.

MEDIEVAL IRAQ

With the retrenchment of the Abbasid caliphate in the middle of the tenth century, the centers of Islam moved to Iran and Egypt; Iraq was no longer a power to influence the world but developed its own individual styles. At the same time, architecture transitioned from the unfired mud brick and earth construction inherited from ancient Mesopotamia to a universal use of fired brick. As a result, many buildings are preserved, nearly always, as in medieval Europe, the religious architecture—mosques, mausoleums, and madrasas, the theological schools that developed from the eleventh century. One of the earliest is the mausoleum of Imam al-Dur, from the late eleventh century, a square building with a conical dome and

Fig. 14. The minaret of al-Hadba, in the mosque of al-Nuri, Mosul, A.D. 1170.

Fig. 15. Imam al-Dur, 11th century A.D.

Fig. 16. Detail, the Abbasid Palace, Baghdad, c. A.D. 1242.

brick patterns on the exterior (figs. 14, 15), but this style was repeated later at the Baghdad mausoleums of Sitti Zubayda (fig. 18) and al-Suhrawardi.

In particular, in the last years of the Abbasid caliphate, in the early thirteenth century, a fine and delicate style of brick patterns and terra-cotta geometric plaques was developed in Baghdad, to be seen today in the Madrasa Mustansiriyyah of 1232 and the so-called Abbasid Palace, probably in fact a madrasa of 1242 (fig. 16). The Mustansiriyyah accommodated all four schools of Islamic law and corresponded to the medieval notion of a university, founded at the same time as the European medieval universities of the Sorbonne and Oxford.

Baghdad and Mosul also developed one of the first schools of Islamic miniature painting, which is known from many manuscripts starting with scientific treatises based on Byzantine models, and continuing with literary works that

illustrate medieval life in Iraq, such as those of the Maqamat of al-Hariri. Production continued into the seventeenth century.

In Mosul, a fine school of metalwork developed—vessels of brass inlaid with copper, silver, and gold, and decorated with inscriptions, human figures, and astrological imagery (fig. 17). The court scenes represent music, banqueting, the hunt, mounted combats, and enthronements. The bowls, ewers, and candlesticks often identify the craftsmen and date back to the first half of the thirteenth century.

Fig. 17. Candelabra, inlaid with silver, scenes of court life, zodiac, and horsemen. Signed al-Hajj Isma'il and Mohammed ibn Futtuh al-Mawsili, probably Mosul, c. A.D. 1230.

Fig. 18. Mausoleum of Zumurrud Khatun, Baghdad, otherwise known as the Tomb of Zubayda.

OTTOMAN IRAQ

A frontier province between the Ottoman Turks and Iran, Iraq did not recover well from the Mongol invasions. Nevertheless the period did lead to an indigenous development: that of the Shi'ite holy places. The Shi'ite sect of Islam has always been interested in the personalities of the Imams, descended from the family of the Prophet Mohammed. The tombs of the Imams were first built up in the tenth century, at the time of the first Shi'ite dynasties, but developed over the centuries with finance from Shi'ite communities in other areas of the Islamic world, notably Iran and India. The golden domes seen everywhere in Iraq were financed by the Qajar dynasty of Iran in the nineteenth century (fig. 19).

The first tomb was that of Ali, the son-in-law of the Prophet, buried at Najaf in A.D. 661, but the most important is that of his son al-Husayn at Karbala, killed by the Umayyads in A.D. 680. In Baghdad two Imams are buried at Al-Kadhumain and two at Samarra. All these sanctuaries attracted large numbers of pilgrims and continue to do so. The dead were transported from far away to be buried in the vast cemeteries surrounding the shrines at Najaf and Karbala.

The Ottoman period was not a successful one in Iraq; little interest was paid to the country, and much land was abandoned. Part of the problem was that Iraq was a frontier province against Iran, situated far from Istanbul. Another part was the difficulty that the small-scale medieval states in the Middle East, no different from those of Europe, had in restoring the large-scale irrigation works necessary to make the agriculture of Iraq work well. The unfortunate history of Iraq in the twentieth century has much to do with the failures of the last five centuries, and bears no relationship to the economic, cultural, and intellectual achievements of earlier Islam.

Fig. 19. The Shi'ite shrine at Al-Kadhumain, outside Baghdad.

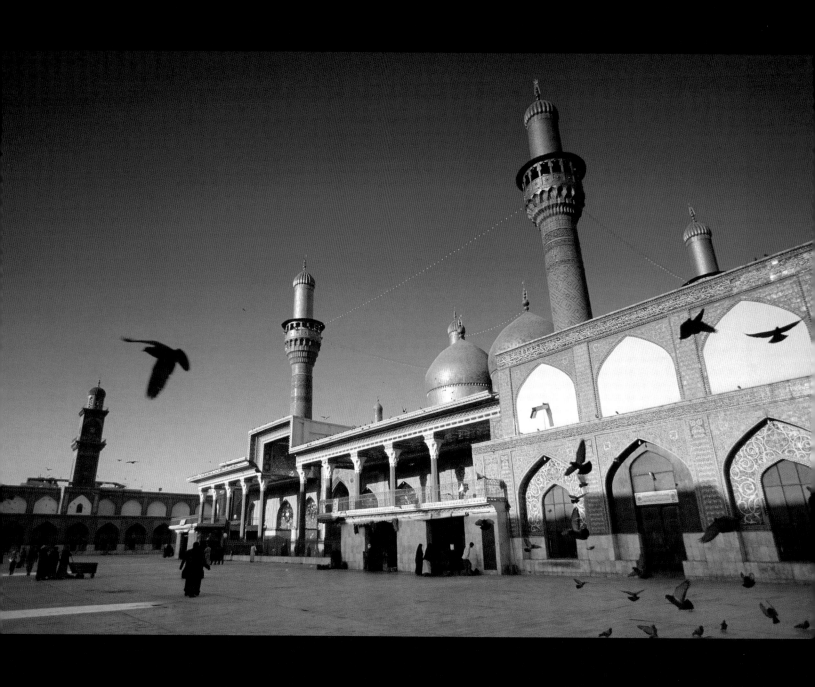

Chapter X

BAGHDAD THROUGH THE AGES

Vincenzo Strika

I first visited Baghdad in 1971 at the invitation of the Iraqi Director General of Antiquities, who asked if the Oriental Institute of the University of Naples would be willing to assist his department in carrying out a cultural-heritage assessment of the city. The goal of the project was to document Baghdad's surviving antiquities and historic architecture in light of an urban-renewal scheme that the then-president Saddam Hussein was proposing to beautify the city and "recapture the glories of the past." He felt and certainly we felt that it was important that any surviving historical architecture be incorporated as much as possible into any redevelopment project.

The challenge seemed uncomplicated, yet it would prove difficult to address. Simply put: What exactly was Baghdad? What was it that we sought to preserve? And how would its architectural evolution be told in the city's many streetscapes?

Volume after volume in Arabic and in all the Western languages have come up with bits of information and even some fairly detailed surveys. Without going into excessive detail, the city's history was something like the following:

Founded by the Caliph al-Mansur in A.D. 762 on the remains of a town dating back at least a thousand years, Baghdad was to be the capital of the newly established Abbasid caliphate. The Abbasids had seized power in a revolution against the earlier Umayyad caliphate, which had been centered in another of those very ancient Middle Eastern cities, Damascus, in Syria.

Fig. 1. Minarets of Al-Kazimiyyah.

The Abbasids were anxious that their new capital express the glory and power of their state and in a period of construction lasting many years they not only lavished much of the revenue of their empire on it but also laid it out symbolically to express the "centrality" of their realm among the powers of the world.

Mansur named the city *Madina as-Salam*, the city of peace. And for a time Baghdad came close to realizing the caliph's dream as a center of calm in a turbulent world. But, peace was not often experienced in Baghdad. Coups were led by a sort of Praetorian guard, a system of "warlords" who squeezed the inhabitants and disrupted civic institutions. Civil wars were endemic but were themselves outdone by the horrific thirteenth- and fourteenth-century Mongol and Turkish invasions. Nor did Mansur's name stick. A much older term, "Baghdatu" dating from the times of the great lawgiver Hammurabi, was taken up by the Persians and has remained the popular designation of the city to this day.

According to the writings of visitors from Europe, few as they were before the nineteenth century, Baghdad was often confused with Bahil or Babylon and sometimes even with Seleucia and Ctesiphon, some thirty kilometers away. It was the Italian traveler Pietro della Valle, who was in Baghdad in 1616–1617 and married a Nestorian girl, who finally corrected the mistake and taught Europeans that the proper name of the city was Baghdad.

Mansur focused development on a so-called round city (*mudawwarab*)—its circular plan symbolic of the caliph's worldwide power. The names of its four gates represented major trade routes, underscoring the city's mercantile prominence in the then-known world. Mansur himself is quoted as having said, "Now there is no obstacle between me and China." As a matter of fact, a Chinese market in the city developed quickly. Baghdad and Basra soon became important financial centers. Iraqi merchants opened trading offices throughout this financial

sphere from al-Mansura in India up to Sigilmasa in Morocco on the Atlantic. Trade was supported by a strong currency. The Abbasid dinar was recognized up through the Scandinavian Peninsula, the Baltic Sea, and Russia, and was even considered a strong currency in Britain. Its coins are still found everywhere in Europe and throughout Asia and Africa.

The importance Iraqis of the Middle Ages placed on the economy is further attested to by the fact that one of the best-known contemporary writers, the journalist and geographer al-Jahiz, placed the merchant above the ruler in importance to the health and wealth of his society. For Jahiz and, apparently, for many of his contemporaries, the Afro-Asian-European world was Baghdad's "neighborhood."

It wasn't only in trade that Baghdadis delighted. They took a keen interest in the way other peoples lived and incorporated colonies of them into the city. Alongside the merchants of China were Jews from Russia, representatives from the remnants of the Roman Empire in the far west of Europe, Buddhists from Central Asia, and Zoroastrians from Iran and India.

Scholars from Baghdad went out to distant lands and translated or adapted the literature of distant peoples. They also lured into their circles alien scholars who delighted in Arabic poetry and philology so that much of what we know of pre-Islamic literature and life was written down by the multinational scholars in this cosmopolitan city.

Baghdad was notable for the vigor of its civic institutions. Each neighborhood had its schools, mosques, churches, or temples—as the city was made up of Muslims, Christians, Jews, and smaller groups of other religions—and even clinics or hospitals. Sponsored either by the government or by pious foundations, these institutions were the leaders in public health of their times. The notion of segregating patients according to the nature of their illnesses was one of their lasting contributions. Scholarly exchange with the then relatively backward

Europe was an integral part of the practice of medicine. The Salerno School of Medicine and the famed Montecassino Abbey in Italy, for example, were in constant contact with Baghdad's House of Wisdom (Bayt al-hikmah), which had been founded in the ninth century and is thought to be one of the world's first universities.

And each neighborhood took a strong part in establishing not only its own security, with perhaps the first police patrols, but also its relationship to the central government by collecting its own taxes and negotiating with the government over the amounts due. Neighborhoods also ensured a degree of public health by organizing garbage disposal.

In addition to its vigorous ventures abroad, interest in foreign cultures and foreign trade, Baghdad was an industrial city, too. Cotton, silk, crystal, paper, and leather products were exported or re-exported to India, China, and the Byzantine Empire.

The educational system was complex. Private teaching was restricted to the upper class. The most characteristic system was the circle (*halqah*) usually practiced in mosques, where students attended lessons, sitting in the typical Oriental way —and in the more open *madrasas*. Women had relative freedom, and it was only with the economic decline toward the end of the tenth century that the segregation of men and women became a rule. According to some scholars, Iraq had attained a precapitalistic stage, which had the potential of leading to a kind of democracy or at least an experiment with secularism where the *divina maiestas*, or divine majesty of Allah or of Mohammed, did not always prevail. Harun ar-Rashid, when rebuilding the mosque of al-Mansur, inscribed on the facade the name of the architect as well as his own name.

Today, the intellectual influence Baghdad had in the West remains little known, yet it was significant. The caliph al-Ma'mun, (813–833) developed the Bayt al-hikmah and established an advanced observatory for astronomy where

the size of the earth was carefully calculated on the understanding that the earth was round. The works of al-Battani (Albategnius) were used in Europe up to 1749. The *Treatise of Medicine (al-Hawi)* written by ar-Razi (Rhazes, 865–925) was translated and published several times in Europe. Its fifth edition appeared in Venice in 1542, while al-Khawarizmi's work on mathematics, *Kitab hisab al-jabr wa 'l-muqabalah*, was translated by Gerald of Cremona. The author is also known for his astronomical tables, from which Indian and Greek systems were originally developed. Arabic numbers were introduced in Europe by Leonardo Fibonacci. Iraq was also the platform for launching the mass marketing of paper—actually a Chinese invention—which came from Samarkhand to Baghdad. It is likely, too, that some Western literary genres such as the *amour courtois* and the *novella picaresca* may be traced back to the poems of Abbas ibn al-Ahnaf, and Muslim ibn al-Walid, and to the rhymed-verse humorous tales known as *maqamat*.

Fig. 2. Tomb of Zumurrud Khatun.

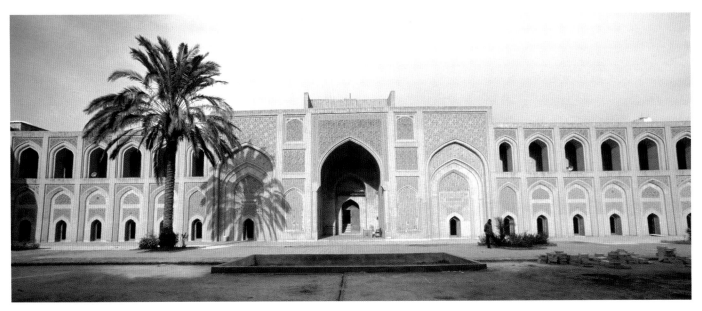

Fig. 3. The Qasr Abbasi.

Although Iraq has an art tradition of its own, during the Abbasid period the country was in touch with all major ancient civilizations. The influence of Byzantine art is especially evident in the miniatures of the Mosul School, while in Baghdad Central Asian motifs prevailed. Iraq also played a role in the development of Islamic painting. The main achievement of Iraq was the so-called Samarran art, actually a byproduct of the lost imperial art developed in Baghdad, which for a while influenced art development in many countries. The mosque of Rusafah, built by al-Mahdi, was the same size as the Samarra mosque. The mosque of Ibn Tulun in Cairo clearly shows the architectural influence of Samarra, as does the mosque of Balkh in Iran. Ghaznavid architecture in Afghanistan also shows the same influences. It was not just architectural, but also ornamentalist, carried forward by a new ceramic style as is shown in the decoration of the *mihrab* in the Kairohuan mosque in Tunisia. The styles of Samarran decoration became the basic trend in most Islamic countries up to the sixteenth century.

While it is not commonly known, some features of Islamic art in Iraq can be linked to ancient Mesopotamia. The architecture of the minaret of Samarra was probably influenced by

the ancient ziggurat, and the large courtyards of Iraqi mosques may well go back to the same Mesopotamian sources. Even some features of the typical Iraqi mausoleum such as the one in Zumurrud Khatun (usually known as Sitta Zubayda) might go back to the same origin (fig. 2). The statuettes found in Wasit may represent the continuity of a long Mesopotamian tradition that began in prehistory, and lasted at least up to the tenth century as a remnant of some pre-Islamic cult.

The melding of these styles and their elaboration suggests a kind of renaissance, similar to what happened in Umayyad, Syria, where, for instance, at Qusayr Amra, the nude human body was portrayed once again in classical terms. Similar artistic trends happened elsewhere as a consequence of affluence, a burgeoning influential bourgeoisie, and the emergence of a trading class. But, in Iraq the "renaissance" was interrupted in the ninth century by the emergence of a military class and a system of moneyless economic organization, comparable to feudalism in Europe.

The prosperity of Baghdad also rested, of course, on the agricultural riches of Iraq. The Persian word from which "Iraq" comes into Arabic meant "the lowlands." It was the rich silt carried south from the mountains of Turkey and Kurdistan that gave rise to the notion of a "Garden of Eden" and provided Iraq's sustenance in the heyday of Baghdad.

Water is a key to Iraqi history. Baghdad had an advanced system of water distribution. The round city was surrounded by the 'Isa and the Sarat rivers. These were probably augmented by those built by Harun ar-Rashid in Raqqa. The city also had many public baths. The sources give wildly different figures, but over time they seemed to have ranged anywhere from 1,500 up to 60,000 baths. It is likely that a single bath had to fulfill the needs of some 200 houses. Each bath was supplied with hot and cold water. This was an elaborate system given the technology of the times and obviously had social implications, although the system never attained the social purposes of the Roman bath.

Water was even more important for the land around Baghdad. Given the intense solar energy striking the lowlands and the fact that they are nearly flat, Iraqis have always had to struggle to keep them fertile. Deforestation of the uplands of the Euphrates and Tigris rivers caused devastating floods, which silted up canals and broke dams. Only a strong, central government manned by competent and observant officials could keep the system working. Where such officials existed they had to struggle not only against the forces of nature but against human veniality. The conflict between the peasant, trying to plow his field, and the tax collector, trying to squeeze a profit from the peasant's labor, is a persistent theme of Iraqi history; parallel to it is the struggle between the government's attempt to control irrigation with the farmer's demand for more and more water.

While these struggles lasted throughout Iraqi history, they were virtually eclipsed in the thirteenth century by the devastating invasion of the Mongols. As nomadic herdsmen, the Mongols were hostile to irrigation farming and were even more hostile to the city centers that managed it. Baghdad was one of the most tragic victims. In the fearful 1258 invasion, estimates for the casualties run as high as 800,000. Socially, at least, the city was nearly wiped out.

So what of the city's long history actually remained?

Samarra represented the peak of Abbasid art. Its ruins survived because the city was abandoned. Unfortunately, no building from its heyday, the middle of the ninth century, is standing in Baghdad, where Abbasid art is represented only by a few monuments—the Madrasah Mustansiriyyah, the Zumurrud Khatun tomb, the Qasr Abbasi (fig. 3), and some minarets (Suq al-Ghazl, Qumriyyah, Khaffafin, and Ma'ruf al-Karkhi).

Of these, the most important is the Mustansiriyyah, an educational institution, which was built by the caliph al-Mustansir a few decades before the Mongol conquest. The institute was

Fig. 4. Al-Kazimiyyah.

used for religious teachings. It included facilities for the
students, a bath, a hospital, and a pharmacy. The Zumurrud
Khatun tomb was built in 1190 for the wife of the caliph
an-Nasir. The tomb, as is common for mausoleums, has an
octagonal plan, the octagon being related to the concept of
resurrection. The upper structure is a conical dome on stalac-
tites, whose origins might be traced back to old Mesopotamian
tradition. A map of Baghdad from the sixteenth century shows
many tombs of the same type. The Suq al-Ghazl mosque has
a controversial origin, as only the minaret belongs to the origi-
nal mosque. The purpose of the Qasr Abbasi is uncertain. It
seems to have been a cultural institution, probably built by the
caliph an-Nasir, perhaps a library of the Bayt al-hikmah. In
the middle of its courtyard there is a marble *nafura* (fountain),
which was carried from Samarra. The modern Bayt al-hikmah
has been built just near the original building.

Other monuments have been worked on repeatedly over time
so that the original plan is almost completely lost. Baghdad's
architecture was composed of mud brick which was severely
damaged by the frequent floods of the Tigris. The effects were

carefully studied by Ahmed Susa, a Jew who remained in Baghdad after the Arab-Israeli war of 1948. Susa was a rare survivor of the once flourishing Jewish community that began in the twelfth century when Benjamin of Tudela founded many rabbinical schools in Baghdad. His great contribution was *The Atlas Baghdad*. In a significant cultural collaboration, he worked with the Muslim Mustafà Jawad to produce the invaluable *Guide of Baghdad Map*.

As a consequence of the decline of Baghdad, the center of Islamic art shifted to other cities. After the Mongol destruction in 1258 only a few monuments, such as the Khan Mirjan, built in 1358, can be mentioned as being notable. Then, in the sixteenth century the Muslim world was divided into three main entities: the Ottoman (Turkish), the Safavid (Iranian), and the Mughal (Indian) empires, and each one developed a particular style of art, mainly inspired by local sources. Iraq itself became increasingly passive, the field for political rivalries between Turkey and Iran. Baghdad was conquered by Shah Ismail in 1508, then by Sulaiman the Magnificent, then again

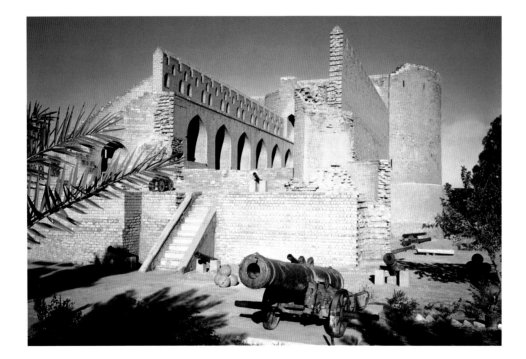

Fig. 5. The Bab al-Wastani.

by the Persians under Shah Abbas in 1622, and definitively in 1638 by the Turks who held it until the end of World War I. As one power was replaced by the other, it left significant groups of followers—Sunnis by the Turks and Shi'ites by the Persians—so that archicture was influenced by both. The larger buildings were primarily, but not exclusively, under Ottoman influence. While much of the decoration of minarets and domes was under Persian influence. The latter is known as *kashi* (from Kashan in Iran but locally called *Kerbeli*, from the culturally Persian Holy city of Karbala). Only a few decorative motifs can be considered independent, mainly as a remnant of Samarran art.

Whatever survived from the long, glorious past fell into ruin or was "mined" to make new buildings or walls. Some buildings were markedly transformed. For example, the Mustansiriyyah College was transformed into a military building. Only sites of pilgrimage attracted the attention of the authorities and pious foundations and were thus maintained. For instance, the Abd al-Qadir shrine is the most important Sunni building. It was built in the twelfth century but was repeatedly worked on and subsequently restored. A new mosque was built by Sulaiman the Magnificent. At present, the shrine consists of the tomb with its elegant mirror decoration, a quite modern mosque, a school, and a library. By law the director of this holy place must belong to the family of Abd al-Qadir al-Gailani (or Kilani), who was the founder of the *qadiriyyah* brotherhood, one of the most influential in Islam.

More important still is the Al-Kazimiyyah shrine (figs. 1, 4), where the imams Musa al-Kazim and Mohammed Jawad are buried. The original building goes back to the Abbasid necropolis, which was placed outside the wall of the circular city of al-Mansur. The building underwent a lot of reworking and additions, especially after the Mongol conquest, when the building was almost destroyed by a fire. The general plan and decoration belong to the sixteenth century. Shah Ismail

Fig. 6. *Mirhrab* of al-Jawijati Mosque.

ordered a complete rebuilding of the shrine. The floors were covered with marble slabs, and the decoration of the two sarcophagi was renewed. Suleiman the Magnificent, though a Sunni, completed the planned works.

Our survey of Baghdad considered all these monuments. But the main purpose was to catalogue the unpublished antiquities. Therefore, we investigated tombs and baths mostly belonging to the Ottoman period that were sometimes a reworking of older buildings. More important locally, though of perhaps little artistic value, are other tombs where famous mystics such as al-Hallaj, al-Junaid, Abu Bakr ash-Shibli, and Ma'ruf al-Karkhi are buried. The tomb and mosque of Bohlul are more important for Indians than for Arabs. This is due to the visit paid by the great Indian saint Guru Nanak who had been inspired by Baghdadi mystics. Only a few of the old baths have survived, and all belong to the Ottoman period. A special mention is due to the Bab Wastani (fig. 5), the only existing part of the city walls built during the Seljukid period, now an army museum.

Until recently, fragments of the city's architectural past could still be found within the galleries of the Iraq Museum. On view were some important pieces, including the marble *mihrab* or prayer niche of the al-Khassaki mosque, purported to have belonged to the mosque of al-Mansur, the founder of Baghdad. Although this view has now little support, the *mihrab*, with its simple and beautiful decoration, shows the close connection between Iraq and Syria in early Muslim art. The *mihrab* of al-Jawijati mosque (from the eleventh century) (fig. 6), probably taken from an earlier building, is an interesting example of how Seljuk and Christian art influenced one another. To the Seljuk period belongs also a marble slab from Mosul, on which an older representation of the Ka'aba is shown, in the perspective later typical of Persian and Ottoman art. Slabs of Samarran decoration, pottery, and a rich collection of coins could also

be found in the museum. Among the wooden pieces, there is the sarcophagus of Salman al-Farisi, originally in the Kazimayn shrine, and the sarcophagus taken from the Aquli mosque, dating back to the fourteenth century.

The memory of the past has deep roots for the Iraqis. Ancient architecture is present in many important buildings. The past has also affected literature and sculpture. The sense of the past is kept alive by local associations such as the Association of Arab Historians and its Academy of Sciences was among its leading research centers. Some cultural institutions, such as the Mustansiriyyah University and the Bayt al-hikmah, remind us of well-known medieval institutes. Thus, there is much from which to reconstitute the now shattered city. We hope that when the international community is able to set a reconstruction plan, all this will be duly taken into account, in order to give the city its old dignity. Baghdad, for all its tumult and suffering, has the potential to become again, as it was in the Middle Ages, the cultural bridge between East and West.

The Tigris River originates in the southeastern Taurus Mountains at Lake Hazar and in several conjoint streams in the tangled hill country of the north. It then flows generally southeastward for about 1,900 km toward the Gulf, which it enters as a joint stream, the Shatt Al-'Arab, 193 km long, with the Euphrates River.

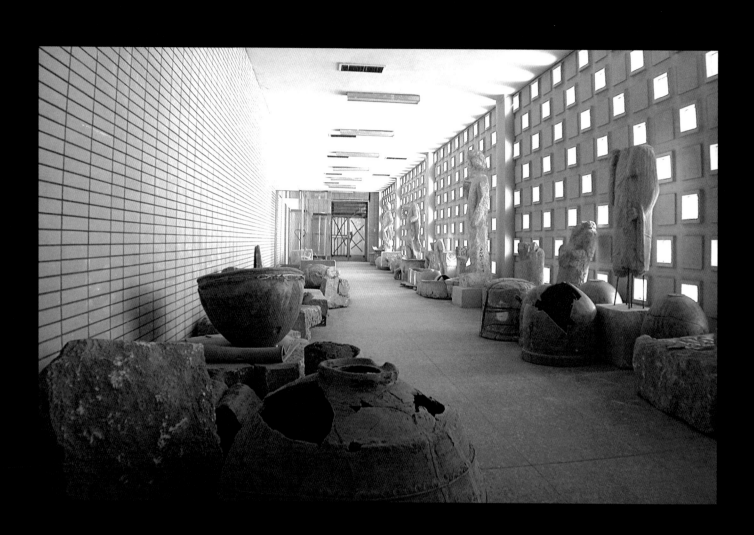

Chapter XI

THE RAVAGES OF WAR AND THE CHALLENGE OF RECONSTRUCTION

Selma Al-Radi

Not long after I graduated from Cambridge University in 1963, I was hired as an archaeologist at the Iraq Museum in Baghdad. Perhaps I was a natural choice for the position, having been born in Baghdad. The museum collection was still housed in the old building, near the old market or souq, which Gertrude Bell had established in 1923. The building was old and ratty with very little space for storage; burgeoning collections of artifacts filled tiny exhibition rooms to capacity, and our offices were cramped and lacking in any sort of modern amenities. Nonetheless, the museum had a magical atmosphere that compensated for all of its deficiencies. My stay in this old building was brief, however, as construction of a new museum was drawing to a close and we would soon be moving to new quarters.

Located on the west bank of the Tigris, the new museum had been designed by German architect F. March more than two decades before ground for the institution had even been broken. At the time its location was chosen, the site of the future museum had been virtually free of buildings. By the time the museum building was inaugurated in 1966, however, the area was awash in auto repair shops and garages rather than the usual learned institutions and concert halls one would normally expect to see near a national museum full of treasures.

The monumental Assyrian reliefs and the winged bulls were the first of the pieces to be moved, as they had to be mounted and built onto their pedestals before individual galleries could

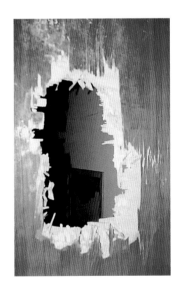

Above: Door to storerooms smashed by looters.

Opposite: Museum entrance with damaged and missing objects.

207

be completed. What remained to be transported were the thousands of smaller objects—clay tablets, cylinder seals, ivories, and exquisite ancient jewelry—that would fill case after case in the building's numerous galleries, plans for which had been drawn up in great detail.

Lamia Al-Gailani Werr and myself, with the help of a few young archaeologists, carried the artifacts from the old museum to the new one, where we placed them on a series of long tables in a suite of study rooms in order to sort and prepare them for presentation.

We were careful to handle each with the utmost care. I must confess, however, that at some point temptation got the best of us and we simply could not resist trying on a few pieces of jewelry from the 4,500-year-old royal cemetery of Ur. And for one brief, euphoric moment I was queen of the whole ancient world. Adorned with an exquisite necklace about my neck and a delicate gold crown upon my head, I paraded around, and it was grand! I know that modern-day curators will surely view our actions with disdain, but we did the objects no harm.

Following the move, I worked for the Iraq Museum for four years, during which I spent most of the time carrying out excavations in the field. Between seasons, however, I returned to the museum where I cleaned and consolidated the thousands of finds unearthed during our excavations—exquisite polychromed ivories from a ninth century B.C. Assyrian palace at Nimrud and hundreds of 4,600-year-old clay tablets from Abu Salabikh, including some of the earliest ever found. It was wonderful and exciting work. Over time, however, politics began to make it difficult to work in Iraq, so I resigned and went abroad to continue my studies. However, I returned to Baghdad as often as possible, checking in on the museum on every visit.

Then came the Gulf War in 1991. The objects remained safe in the Iraq Museum, but the regional museums were looted by mobs during the uprising that followed the war. When the

Statue from Hatra, damaged in the looting.

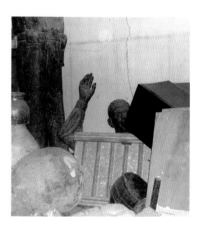
A museum storeroom, after the looting.

dust settled, I was sent by UNESCO to try and assess the damage and compile a list of the missing objects. Weeks of work in the museum followed under difficult conditions. Electricity was sporadic; every time I started typing the lights would go out and we all had to stop what we had been doing. But with help from the local staff, we managed to pore through the catalogs not only of the Iraq Museum, but of the small regional institutions throughout the country and compile a list of what was missing, which would be sent to all the interested authorities as well as Interpol.

Sadly, few of those objects have surfaced since the first Gulf War. We also made a list of objects that had been removed from the Kuwait Museum and stored in the basement of the Iraq Museum for safekeeping. On my return to UNESCO headquarters in Paris, I handed the list to cultural property officials so that they could begin the repatriation of those objects known to have been from Kuwait. That was successfully accomplished the following year.

Fully aware of the extraordinary toll the Gulf War had taken on Iraq's cultural heritage, the archaeological community in America banded together on the eve of the most recent conflict in an effort to avert a similar disaster. Although the State Department and the Pentagon assured us that they would look after the museum, it was not to be. Shortly after the war broke out, the museum was looted as soldiers looked on, and thousands of objects went missing.

Luckily, the larger objects survived, albeit with substantial surface damage, being far too difficult to cart away. The entire seal collection—both cylinders and stamps—was taken,

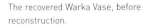
The recovered Warka Vase, before reconstruction.

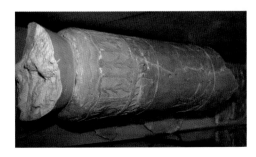

which in itself comprised more than 5,800 objects. In the melee, the building was also destroyed. Offices were ransacked, archives were trashed, and any and all equipment was either stolen or damaged. The mess was unimaginable, requiring countless man-hours to clean up.

Within weeks, however, US authorities appointed Col. Mathew Bogdanos to be responsible for the Iraq Museum. It was a good choice. He declared a general amnesty and adopted a "no questions asked" policy for anyone willing to return stolen objects. It worked in part, and hundreds of objects were returned. He also started a dialogue with the mullahs of certain mosques—the more liberal ones—talking to them and asking them to talk to their congregations, getting the word out that anyone bringing objects back would not be harassed or even questioned. Still more objects began to trickle in. The museum staff set aside the large tables in the library for that specific purpose. Small objects came in first, mostly brought in by locals who apologized, saying they had taken them for safekeeping. The 4,300-year-old Warka Vase arrived in the back of a pickup truck; the Warka Head, which is of similar date, was found in an orchard in Baqubah. Even copies of objects for sale in the museum shop were returned!

Over the past year and a half, UNESCO and individual governments from Japan to nearby Jordan have sponsored meetings for archaeologists and experts from all over the world to discuss the future of the museum and the many archaeological sites, of which there are more than 10,000, that continue to be pillaged to this day. Lengthy discussions have fostered constructive ideas, which now await implementation.

The physical damage to the museum can in large part be repaired, a process now well under way. But far more is required—new showcases, the revamping of gallery spaces and conservation facilities, and the training to carry out much needed work.

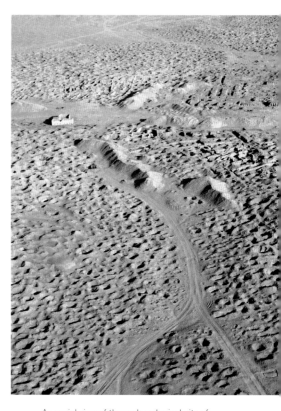

An aerial view of the archaeological site of Umma, showing some of the thousands of holes dug by looters.

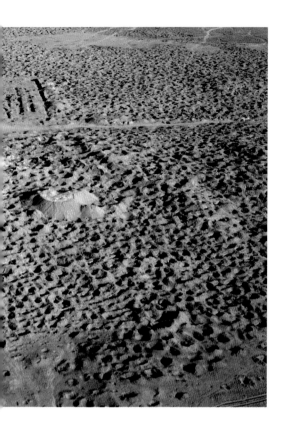

Of far greater concern to archaeologists is the country's extraordinary cultural patrimony, which remains at risk. Fueled by an insatiable appetite for Near Eastern antiquities, sites throughout Iraq are being worked daily by teams of looters in search of "merchandise."

Today, the smuggling of ancient art is the single most devastating development for the antiquities of Iraq. If it continues unchecked it will destroy much archaeological evidence that has not been studied or published. For certain types of collectors the provenance of their objects is immaterial. For archaeologists, however, it is of vital importance, for without provenance an object loses its point of reference, its history, and its context.

What can be done to stop the destruction? First, the guards who used to protect these sites need to be reinstated. This has been done on some sites, but the past years of neglect have destroyed some of the honesty, honor, and pride that these guards had in their job. Now, most of them are robbing their own sites to feed their families. One possible scenario would be to raise their salaries and see whether that would stop the pillaging. Aerial surveillance is another method but a very costly one. In the present state that Iraq is in, neither of these possibilities is viable.

With its strategic location on a fertile plain, Iraq has long been a desirable prize. Over the course of three or four millennia, the country has been invaded or attacked on numerous occasions. The most devastating was in 1258, when the Mongols massacred most of Baghdad's population. Out of the two to three million inhabitants, only 30,000 survived. The country eventually recovered, but it took more than 500 years before it came into its own again. Today, it is not Iraq's agricultural bounty that is eyed but its oil.

With war comes destruction. For Iraq, it is the loss of thousands of years of human history. The situation looks very bleak indeed.

The Recovery of the Nimrud Gold

Diana McDonald

One of the greatest and most mysterious treasures to be found in Iraq in recent times is the hoard of gold jewelry found in tombs below the floor of the Assyrian palace of Ashurnasirpal II at Nimrud. This astonishing collection of objects interred with Assyrian queens has been little published and only briefly seen in Iraq. In the hours after the looting of the Iraq Museum in 2003, many scholars were afraid that the gold had disappeared along with so many other major (and minor) antiquities. Fortunately, the gold jewelry had been stored away, before the first Gulf War in 1991, in the subterranean Central Bank vault and was recovered intact, though with difficulty, because the bank was flooded. The story of the so-called "Nimrud Gold" weaves together both the drama that is the political history of modern Iraq and the splendor and enigma of ancient Assyria.

The ancient city of Nimrud (Biblical Kalah, near modern Mosul) was the capital of the Assyrian Empire in the ninth and eighth centuries B.C. Assyrian art has, until now, been best known and celebrated for the remarkable carved stone reliefs that graced the palace walls of the Assyrian kings, depicting their military campaigns, sacred rites, and the famous royal lion hunts. Yet we know little about the Assyrians' skills in metalworking or of the trappings of royalty. The find of such extraordinary quantities of Assyrian gold jewelry and vessels between 1988 and 1990 by Iraqi archaeologists challenged our notions of Assyrian aesthetics: we now come face-to-face with the actual, extremely colorful, even gaudy, and complex accoutrements of queens. The treasure itself rivals Tutankhamen's in terms of splendor, and similarly involves an undisturbed royal tomb. Few could imagine that in Assyria a find of such sheer quantity and astonishing quality of gold jewelry could still be made in modern times. Yet it has only just begun to be studied, photographed, and put in proper context by scholars.

In the 1950s, the famed British archaeologist Max Mallowan (husband to author Agatha Christie) excavated at Nimrud in the Northwest Palace, clearing a room in what had been the harem. He did not notice a modification of the floor-tile pattern, which was only later seen by, and which piqued the interest of, Iraqi archaeologist Sayid Muzahim Mahmud Hussein in 1988.

Subsequent excavations under the floor revealed four tombs in the south wing of the northwest palace of King Ashurnasirpal II (883–859 B.C.). A number of skeletons and bone fragments were found in the tombs, and a sarcophagus identified one occupant, of Tomb III, as Mulissu, Queen of Ashurnasirpal II. More than fifty pounds of gold and silver items were found in the antechamber to her tomb. In Tomb II, thirty-one pounds of gold (157 items) were found, along with a stone tablet naming one of the occupants as Queen Yaba, wife of Tiglath-pileser III (744–727 B.C.). The inscription on this tablet even included a "curse of restlessness" on the spirit of those who would disturb the tomb, also translated as a warning that those "who lay hands on my jewelry with evil intent, or whoever breaks open the seal

of this tomb, let his spirit wander in thirst." Ironically, this very jewelry was retrieved from a flooded vault.

This unprecedented and extraordinary find was briefly exhibited in Iraq and then stowed away in bank vaults before the advent of the first Gulf War in 1991. Its fate was uncertain. The treasure included a gold crown, a headband of golden links, a gold-mesh diadem with tassels and tiger's eye agates, seventy-nine gold earrings, thirty rings, fourteen armlets, ninety necklaces, four gold anklets, and gold and rock crystal vessels. Some objects were crafted of solid gold, and some were chased (beaten), some were of mesh and some of silver.

The Central Bank vaults where the precious finds were stored were flooded during the Iraq war, some believe deliberately in order to prevent Saddam Hussein's sons or henchmen

from making off with the gold or the currency reserves also stored there. A National Geographic team organized the draining of half a million gallons of water, which took three weeks. Three boxes that contained the treasure were then found, undisturbed since being placed there.

On July 3, 2003, a small selection of the contents of the Assyrian queens' tombs was put on display at the Iraq Museum. The public, museum staff, and officials from the Coalition Provisional Authority no doubt marveled at the exceptional skill and richness exhibited by these examples of Assyrian gold work. The display was brief, however, and the gold was stashed away once again. The postwar lack of security and proper conditions in the museum dictate that it must wait to be exhibited anew.

THE FALL OF BABYLON

Zainab Bahrani

For thousands of years the ancient city of Babylon endured waves of war and upheaval with the waxing and waning of empires. Yet, few could have predicted its current destruction at the hands of American-led coalition forces.

Ironically, Babylon—along with many other archaeological sites—survived the bombing campaign of 2003. It has been in the aftermath, during the occupation, that the most extensive cultural destruction has taken place. At first, sites fell prey to looters. This problem has increased under the occupation. As of this writing, however, damage to the historical record continues unabated at those archeological sites occupied as military camps—among them legendary Babylon.

At Babylon, I have seen the continuing construction projects, the removal of and digging into the ancient mounds over the past three months, despite a coalition press release early in June 2004 stating that the camp would close.

Construction of a helipad in the heart of the ancient city required the removal of layers of archeological earth from the site. The daily flights of the helicopters rattle the ancient walls and the winds created by their rotors blast sand against the fragile bricks. When my colleague at the site, Maryam Moussa, and I asked military personnel in charge that the helipad be shut down, the response was that it had to remain open for "security reasons, for the safety of the troops."

Between May and August 2004, the wall of the Temple of Nabu and the roof of the Temple of Ninmah, both of the sixth century B.C., collapsed as a result of the movement of helicopters. Nearby, heavy machines and vehicles stand parked on the remains of a Greek theater from the era of Alexander of Macedon.

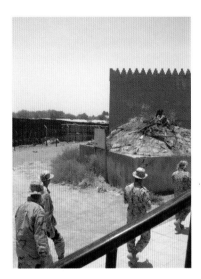

Coalition troops stationed in Babylon.

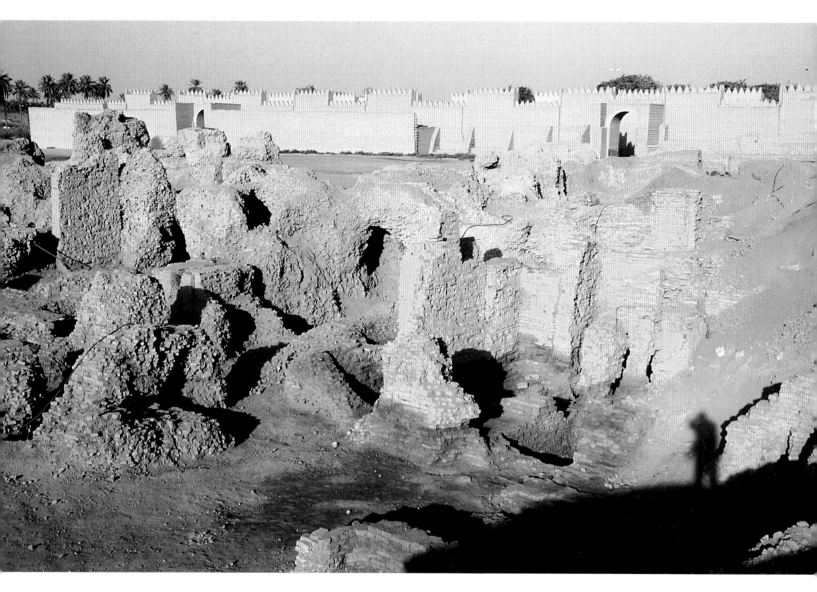

Above: Ruins of Babylon in the foreground, walls of the ancient inner city in the distance.

Right: The helipad in the heart of the ancient city. Temples that had survived from the 6th century have been badly damaged by the helicopter vibrations and winds.

Far Right: Heavy machines and vehicles remain parked on and near remains of the ancient Greek theater.

The minister of culture has asked for the removal of military bases from all archaeological sites, but none has yet been relocated.

Beyond the wanton destruction of sites in the name of security, other national treasures have been put at risk.

In Baghdad, the National Library and State Archives building is a burned-out shell in which the employees work in the most horrendous conditions. The Ottoman archive that records the history of the country, spanning the sixteenth to the early twentieth centuries, is in the gravest danger. Having been soaked by flooding last year, the archive began to mold. Upon the advice of conservators, the entire archive was removed to freezers in the abandoned and bombed building that had previously been a Ba'athist officers' club. It was one of only a few non-military buildings in the city where electricity could be maintained. Most of the city rarely has power more than nine hours a day. If the archives should thaw, the documents will be destroyed. The loss of the archive would be the loss of the modern historical records of Iraq; much of this has not been studied or published.

In the midst of the disasters of Iraq under occupation, the condition of its cultural heritage may seem a trivial matter. But, as a historian of antiquity, I am painfully aware that there is no parallel for the amount of historical destruction that has taken place during the war in Iraq. The Geneva and Hague conventions make the protection of heritage the responsibility of the foreign powers during occupation. Instead, what we have seen is a general policy of neglect and even an active destruction of the historical and archaeological record of the land.

New York, September 2004

Ancient walls of Babylon, 6th century B.C.

This article first appeared under the title "Days of Plunder: Coalition forces are doing little to prevent the widespread looting and destruction of Iraq's world-famous historical sites," in *The Guardian* on August 31, 2004.

Epilogue

Assembling the extraordinary cadre of contributors to this volume was no easy task, not for the usual reasons of time, distance, or even language, but for the extraordinary circumstances under which many of the individual chapters were produced.

From the outset, our Iraqi colleagues—Donny George, Lamia Al-Gailani Werr, Selma Al-Radi and Zainab Bahrani—endured war-time conditions in their quest to save what they could of the beleaguered Iraq Museum and begin the onerous task of rehabilitating its building and restoring its collections and archives. On numerous occasions, our discussions with authors regarding content and image selection were shadowed by the haunting squeals of mortar shells in the distance. Days and weeks would often pass without our knowing the fate of our colleagues, much less their promised contributions to this book. Publisher's deadlines aside, our pressing for resolution seemed at times so inappropriate in light of the circumstances.

Then, on August 13, 2004, we learned that one of our authors, Micah Garen, and his interpreter, Amir Doshe, had been kidnapped in Nasiriya while researching the chapter on the looting of Iraq's archaeological treasures. Although the museum is the focus of this book, the history of Iraq, and indeed the whole of the cradle of civilization, lies in its soil, which time entrusted with our collective cultural heritage. The vestigial remains of so many sites dot this most ancient of landscapes; nearly all remain under siege in the lawless environment that has flourished in the wake of war. Garen and his partner Marie-Hélène Carleton have devoted the better part of a year to documenting the loss. Thanks to the intervention of numerous colleagues, friends, family, and even the Shia leader Muqtada al-Sadr, Garen and Doshe were released unharmed.

Historians and politicians will no doubt debate the events that unfolded in Iraq for years to come. What happened and what did not happen with regard to that country's heritage, however, cannot be changed. What we can do, however, is

support our Iraqi colleagues and help them to salvage all that can be salvaged. It will require an international effort. First steps already have been taken by Iraqi, Italian, American, and British teams. Recently, the New York-based World Monuments Fund, the Getty Conservation Institute in Los Angeles, and Iraq's State Board of Antiquities and Heritage signed a memorandum of understanding paving the way for redevelopment of the country's ability to conserve, protect, and manage its ancient sites and historic monuments, of which there are more than 10,000. But far more will be needed in the years to come.

We hope you will join us in this effort and work to ensure that in the future, those who choose the devastating path of war understand not only its human cost but its cultural cost as well.

Milbry Polk and Angela M. H. Schuster
New York, September 2004

SELECTED REFERENCES
AND RESOURCES

Barbara A. Porter

Ancient Mesopotamian Art and Archaeology: Early Periods

Adams, Robert McC. *Land Behind Baghdad: A History of Settlement on the Diyala Plains.* Chicago: University of Chicago Press, 1965.

————. *Heartland of Cities: Surveys of Ancient Settlement and Land Use on the Central Floodplain of the Euphrates.* Chicago: University of Chicago Press, 1981.

Adams, Robert McC., and Hans Nissen. *The Uruk Countryside: The Natural Setting of Urban Societies.* Chicago: University of Chicago Press, 1972.

Amiet, Pierre. *Art of the Ancient Near East.* Translated by John Shepley and Claude Choquet. New York: Harry N. Abrams, Inc., 1980.

Aruz, Joan, ed., with Ronald Wallenfels. *Art of the First Cities.* New York: The Metropolitan Museum of Art, 2003.

Braidwood, Robert J., and Bruce Howe. *Prehistoric Investigations in Iraqi Kurdistan.* Studies in Ancient Oriental Civilization 31. Chicago: University of Chicago Press, 1960.

Collon, Dominique. *First Impressions: Cylinder Seals in the Ancient Near East.* 1987. Reprint. Chicago: University of Chicago Press; London: British Museum Press, 1994.

Crawford, Harriet. *Sumer and the Sumerians.* 1991. Cambridge: Cambridge University Press, 2004.

Curtis, John, ed. *Fifty Years of Mesopotamian Discovery: The Work of the British School of Archaeology in Iraq: 1932–1982.* With an introduction by Seton Lloyd. London: British School of Archaeology in Iraq, 1982.

Curtis, J. E., and J. E. Reade, eds. *Art and Empire: Treasures from Assyria in the British Museum.* New York: Metropolitan Museum of Art, distributed by Harry N. Abrams, Inc., 1995.

Damerji, Muayyad Said Basim. *Gräber Assyrischer Königinnen aus Nimrud.* Mainz: Jahrbuch des Römisch-Germanischen Zentralmuseum 45, 1998.

Forest, Jean-Daniel. *Mésopotamie: L'apparition de l'Etat-VIIe -IIIe Millénaires.* Paris: Méditerranée, 1996.

Frankfort, Henri. *Stratified Cylinder Seals from the Diyala Region.* Oriental Institute Publications 72. With a chapter by Thorkild Jacobsen on the inscriptions. Chicago: University of Chicago Press, 1955.

————. *The Art and Architecture of the Ancient Orient.* 1954. 5th ed. With supplementary notes and additional bibliography by Michael Roaf and Donald Matthews. New Haven: Yale University Press, 1996.

Al-Haik, Albert R. *Key Lists of Archaeological Excavations in Iraq: 1942–1965.* Coconut Grove: Field Research Projects, 1968.

———. *Key Lists of Archaeological Excavations in Iraq: 1966–1971.* Coconut Grove: Field Research Projects, 1971.

Ivories from Nimrud (1949–1963). Multi-authored series. Edited by Max Mallowan, D. J. Wiseman, Leri Glynne Davies, and Georgina Herrmann. London: British School of Archaeology in Iraq, 1967–ongoing; volume published in 2004 co-sponsored with the Institute of Archaeology, University College London.

Mallowan, M. E. L. *Nimrud and Its Remains,* 2 vols. London: Collins, 1966.

Matthews, Roger J. *The Archaeology of Mesopotamia: Theories and Approaches.* Approaching the Ancient World. London and New York: Routledge, 2003.

Moorey, P. R. S. *Ur 'of the Chaldees': A Revised and Updated Edition of Sir Leonard Woolley's "Excavations at Ur."* Ithaca: Cornell University Press, 1982.

———. *Ancient Mesopotamian Materials and Industries: The Archaeological Evidence.* Oxford: Clarendon Press, 1994.

Moortgat, Anton. *The Art of Ancient Mesopotamia: The Classical Art of the Near East.* Translated by Judith Filson. London and New York: Phaidon, 1969.

Oates, David, and Joan Oates. *The Rise of Civilization.* The Making of the Past. Oxford: Elsevier-Phaidon, 1976.

Oates, Joan. *Babylon.* London: Thames and Hudson, Ltd., 1979.

Oates, Joan, and David Oates. *Nimrud: An Assyrian Imperial City Revealed.* London: British School of Archaeology in Iraq, 2001.

Postage, J. N. *Early Mesopotamia: Society and Economy at the Dawn of History.* London and New York: Routledge, 1992.

Potts, D. T. *Mesopotamian Civilization: The Material Foundations.* Ithaca: Cornell University Press, 1997.

Reade, Julian. *Mesopotamia.* 1991. Cambridge: Harvard University Press; London: British Museum Press, 2000.

———. *Assyrian Sculpture.* 1983, 2d ed. 1998. Reprint. Cambridge: Harvard University Press; London: British Museum Press, 2003.

Roaf, Michael. *Cultural Atlas of Mesopotamia and the Ancient Near East.* New York: Facts on File, 1990.

Roux, Georges. *Ancient Iraq.* New York and London: Penguin Books, 1992.

Solecki, Ralph S. *Shanidar: The First Flower People.* New York: Alfred A. Knopf, 1971.

Solecki, Ralph S., Rose L. Solecki, and Anagnostis P. Agelarakis. *The Proto-Neolithic Cemetery in Shanidar Cave.* College Station: Texas A & M University Press, 2004.

Strommenger, Eva. *5000 Years of the Art of Mesopotamia*. New York: Harry N. Abrams, Inc., 1964.

Trinkaus, Erik. *The Shanidar Neanderthals*. New York: Academic Press, 1983.

Zettler, Richard L., and Lee Horne, eds. *Treasures from the Royal Tombs of Ur*. Philadelphia: University of Pennsylvania Museum of Archaeology and Anthropology, 1998.

Ancient Mesopotamian Art and Archaeology: Later Periods

Astin, A. E., et al., eds. *The Cambridge Ancient History*, Vol. 7.1, *The Hellenistic World;* Vol. 7.2, *The Rise of Rome to 220 B.C.;* Vol. 8, *Rome and the Mediterranean to 133 B.C.*, 2d ed. Cambridge: Cambridge University Press, 1989.

Cartledge, Paul. *Alexander the Great*. New York: Overlook Press, 2004.

Ghirshman, Roman. *Persian Art: Parthian and Sassanian Dynasties, 249 B.C.–A.D. 651*. Translated by Stuart Gilbert and James Emmons. New York: Golden Press, 1962.

Harper, Prudence Oliver. *The Royal Hunter: Art of the Sasanian Empire*. With contributions by Jens Kröger, Carol Manson Bier, and Martha L. Carter. New York: Asia Society in association with John Weatherhill, 1978.

Herrmann, Georgina. *The Iranian Revival. The Making of the Past*. Oxford: Elsevier-Phaidon, 1977.

Karvonen-Kannas, Kerttu. *The Seleucid and Parthian Terracotta Figurines from Babylon in the Iraq Museum, the British Museum and the Louvre*. Firenze: Le lettere, 1995.

Kuhrt, Amélie, and Susan Sherwin-White, eds. *Hellenism in the East: the Interaction of Greek and non-Greek Civilizations from Syria to Central Asia after Alexander*. London: Duckworth, 1987.

Lane Fox, Robin. *Alexander the Great*. 1973. Reprint. New York and London: Penguin Books, 1986.

Parthica. Pisa: Istituti Editoriali e Poligrafici Internazionali, 1999–ongoing.

Savage, Elizabeth. *Seleucia-on-the-Tigris: an exhibition of the excavations at Seleucia, Iraq, by the University of Michigan, 1927–32, 1936–37*. Ann Arbor: The Museum, 1977.

Sherwin-White, Susan, and Amélie Kuhrt. *From Samarkhand to Sardis: A New Approach to the Seleucid Empire*. London: Duckworth, 1993.

Splendeur des Sassanides: l'empire perse entre Rome et la Chine (224–642). Exhibition in Brussels, February 12 to April 25, 1993. Brussels: Musées royaux d'art et d'histoire; Crédit communal, 1993.

Islamic Art and Archaeology

Abd al-Khâliq, Hanâ'. *The Islamic Glass in the Iraqi Museums and Stores*. Baghdad, 1976.

Blair, Sheila S., and Jonathan M. Bloom. *The Art and Architecture of Islam: 1250–1800*. Pelican History of Art. New Haven and London: Yale University Press, 1995.

Creswell, K. A. C. *Early Muslim Architecture*. Vol. 2. Oxford: Clarendon Press, 1940.

Creswell, K. A. C. *A Short Account of Early Muslim Architecture*. 1958. Revised by James W. Allan. Aldershot: Scolar Press, 1989.

The Encyclopaedia of Islam, Leiden: Brill, 1954–2003.

Ettinghausen, Richard, Oleg Grabar, and Marilyn Jenkins-Madina. *Islamic Art and Architecture 650–1250*. Pelican History of Art. New Haven and London: Yale University Press, 2001.

Gordon, Matthew S. *The Breaking of a Thousand Swords: a History of the Turkish Military of Samarra (A.H. 200–275/815–889 C.E.)*. Albany: State University of New York Press, 2001.

Herzfeld, Ernst. *Ausgrabungen von Samarra*. Vol. 1. *Der Wandschmuck der Bauten von Samarra und seine Ornamentik*. Berlin: D. Reimer, 1923.

———. *Ausgrabungen von Samarra*, Vol. 3. *Die Malereien von Samarra*. Berlin: D. Reimer, 1927.

———. *Ausgrabungen von Samarra*, Vol. 6. *Geschichte der Stadt Samarra*. Hamburg: Eckardt & Messtorff and Berlin: D. Reimer, Andrews & Steiner, 1948.

Hitti, Philip K. *History of the Arabs*. 10th edition. London: Macmillan, 1970.

Janabi, Tariq Jawad. *Studies in Mediaeval Iraqi Architecture*. Baghdad: Republic of Iraq, Ministry of Culture and Information/State Organization of Antiquities and Heritage, 1982.

Kennedy, Hugh. *The Early Abbasid Caliphate: a political history*. London: Croom Helm, 1981.

———. *The Prophet and the Age of the Caliphate: The Islamic Near East from the sixth to the eleventh century*. London and New York: Longman, 1986.

King, G. R. D., and Averil Cameron. *The Byzantine and Early Islamic Near East*. Vol. 2, *Land Use and Settlement Patterns*. Princeton: Darwin Press, 1994.

Lassner, Jacob. *The Topography of Baghdad in the Early Middle Ages*. Detroit: Wayne State University Press, 1970.

———. *The Shaping of the Abbasid Caliphate*. Princeton: Princeton University Press, 1980.

Leisten, Thomas. *Excavation of Samarra*. Vol. 1, *Architecture: Final Report of the First Campaign 1910–1912*. Baghdader Forschungen 20. Mainz/Rhein: Verlag Philipp von Zabern, 2003.

Northedge, Alastair. "An Interpretation of the Palace of the Caliph at Samarra (Dar al-Khilafa or Jawsaq al-Khaqani)," *Ars Orientalis* 23 (1993): 143-71 (archived at http://archnet.org/library/documents/one-document.tcl?document_id=8748).

———. *The Historical Topography of Samarra*. Samarra Studies 1, British Academy Monographs in Archaeology. London: British School of Archaeology in Iraq, 2004.

Northedge, Alastair, Andrina Bamber, and Michael Roaf. *Excavations at `Ana: Qal'a Island.* Warminster: Aris & Phillips for the British School of Archaeology in Iraq and the Directorate of Antiquities, 1988.

Robinson, Chase R., ed. *A Medieval Islamic City reconsidered: an interdisciplinary approach to Samarra.* Oxford Studies in Islamic Art 14. Oxford: Oxford University Press, 2001.

Rogers, J. M. "Samarra, a Study in Medieval Town-Planning," in *The Islamic City,* edited by A. H. Hourani and S. M. Stern, pp. 119–55. Oxford: Cassirer, 1970.

Rousset, Marie-Odile. *L'Archéologie Islamique en Iraq: bilan et perspectives.* Damascus: Institut français de Damas, 1992.

Sarre, Friedrich. *Ausgrabungen von Samarra.* Vol. 2, *Die Keramik von Samarra,* Berlin: D. Reimer, 1925.

Sarre, Friedrich, and Ernst Herzfeld. *Archäologische Reise im Euphrat- und Tigris-gebiet,* 4 vols. Berlin: D Reimer, 1911-20.

Strika, Vincenzo, and Jabir Khalil. *The Islamic Architecture of Baghdad.* Naples: Istituto Universitario Orientale, 1987.

Zaman, Muhammad Qasim. *Religion and Politics under the Early 'Abbasids,* Leiden and New York: Brill, 1997.

Ancient Mesopotamian History, Religion, and Texts

Black, Jeremy, and Anthony Green. *Gods, Demons and Symbols of Ancient Mesopotamia: An Illustrated Dictionary.* Illustrations by Tessa Rickards. London: British Museum Press, 1992.

Bottéro, Jean. *Religion in Ancient Mesopotamia.* Translated by Teresa Lavender Fagan. Chicago: University of Chicago Press, 2001.

Cuneiform Digital Library Initiative. Web link http://cdli.ucla.edu. University of California at Los Angeles and the Max Planck Institute for the History of Science, Berlin. 2002–ongoing.

Foster, Benjamin R. *From Distant Days: Myths, Tales and Poetry of Ancient Mesopotamia.* Bethesda: CDL Press, 1995.

————. *Before the Muses: An Anthology of Akkadian Literature.* 2 vols. 2d ed. Bethesda: CDL Press, 1996.

George, Andrew R. *The Epic of Gilgamesh: The Babylonian Epic Poem and Other Texts in Akkadian and Sumerian.* 1999. Reprint. London: Penguin Books, 2003.

Glassner, Jean-Jacques. *The Invention of Cuneiform: Writing in Sumer.* Translated and edited by Zainab Bahrani and Marc Van De Mieroop. Baltimore: Johns Hopkins University Press, 2003.

Jacobsen, Thorkild. *The Treasures of Darkness: A History of Mesopotamian Religion.* New Haven and London: Yale University Press, 1976.

———. *The Harps that once… Sumerian Poetry in Translation.* New Haven and London: Yale University Press, 1987.

Kramer, Samuel Noah. *Sumerian Mythology: A Study of Spiritual and Literary Achievement in the Third Millennium B.C.* Philadelphia: University of Pennsylvania, Press, 1961.

———. *The Sumerians: Their History, Culture, and Character.* Chicago and London: University of Chicago Press, 1963.

Kuhrt, Amélie. *The Ancient Near East c. 3000–330 BC.* Routledge History of the Ancient World. 2 vols. London and New York: Routledge, 1995.

McCall, Henrietta. *Mesopotamian Myths.* The Legendary Past. London: British Museum Publications, 1990.

Michalowski, Piotr. *The Lamentation Over the Destruction of Sumer and Ur.* Mesopotamian Civilizations 1. Winona Lake: Eisenbrauns, 1989.

Pritchard, James B. *Ancient Near Eastern Texts relating to the Old Testament.* 3rd ed. with supplement. Princeton: Princeton University Press, 1969.

Roth, Martha T. *Law Collections from Mesopotamia and Asia Minor.* Society of Biblical Literature Writings from the Ancient World Series. 2d ed. Atlanta: Scholars Press, 1997.

Van De Mieroop, Marc. *A History of the Ancient Near East ca. 3000–323 B.C.* Oxford: Blackwell Publishing, 2004.

von Soden, Wolfram. *The Ancient Orient: An Introduction to the Study of the Ancient Near East.* Translated by Donald G. Schley. Grand Rapids: William B. Eerdmans Publishing Company, 1994.

Walker, Christopher. *Reading the Past: Cuneiform.* London: British Museum Press, 2000.

Encyclopedias and Scholarly Dictionaries and Journals for Ancient Mesopotamia

The Assyrian Dictionary of the Oriental Institute of The University of Chicago. Chicago-Glückstadt, 1956–ongoing.

Bienkowski, Piotr, and Alan Millard, eds. *Dictionary of the Ancient Near East.* Philadelphia: University of Pennsylvania Press, 2000.

Iraq. London: British School of Archaeology in Iraq (Gertrude Bell Memorial), 1934–ongoing.

Meyers, Eric M., ed. *The Oxford Encyclopedia of Archaeology in the Near East.* 5 vols. New York and Oxford: Oxford University Press, 1995.

Reallexikon der Assyriologie und Vorderasiatischen Archäologie. Berlin-Leipzig, Berlin-New York: Walter de Gruyter, 1932–ongoing.

Sasson, Jack M., ed. *Civilizations of the Ancient Near East.* 4 vols. New York: Scribners/Macmillan Library Reference, 1995.

Sumer: A Journal of Archaeology and History in the Arab World. Baghdad: Ministry of Culture and Information/State Organization of Antiquities and Heritage, 1945–ongoing.

The Sumerian Dictionary of the University Museum of the University of Pennsylvania. Babylonian Section of the University of Pennsylvania, 1984–ongoing (working files of the electronic Pennsylvania Sumerian Dictionary are available at http://psd.museum.upenn.edu).

Catalogues of the Iraq Museum and of Traveling Exhibitions Featuring Objects from the Iraq Museum

Basmachi, Faraj. *Treasures of the Iraq Museum.* Baghdad: Al-Huria Printing House, Al-Jumhuriya Press, 1975/76.

————. *Cylinder Seals in the Iraq Museum: Uruk and Jamdat Nasr Periods.* EDUBBA 3. Edited by Lamia Al-Gailani Werr. London: Nabu Publications, 1994.

Guide-Book to the Iraq Museum. 3rd. ed. Baghdad: Ministry of Information/Directorate General of Antiquities, 1976.

Parrot, André, ed. *Trésors du Musée de Bagdad au Musée du Louvre.* Paris, 1966.

Der Garten in Eden: 7 Jahrtausende Kunst und Kultur an Euphrat und Tigris. Exhibition in Berlin at Schloss Charlottenburg, October 28, 1978–February 25, 1979; in Hamburg at the Museum für Kunst und Gewerbe, March 16–May, 1979; in Aachen at the Neue Galerie, June 1 –August 26, 1979; and in Munich at the Prähistorischen Staatssammlung, September 14– December 16, 1979 under auspices of the Museum für Vor-und Frühgeschichte, Berlin/Staatliche Museen Stiftung Preussischer Kulturbesitz. Mainz/Rhein: Verlag Philipp von Zabern, 1978

Kunst aus Mesopotamien von der Frühzeit bis zum Islam/Ausstellung von Kunstwerken aus dem Irak-Museum, Baghdad. Exhibition in Hamburg from October 1964 to January, 1965. Hamburg, 1964.

The Land between Two Rivers: Twenty Years of Italian Archaeology/The Treasurers of Mesopotamia. Translated by Juliet Haydock and Michael Binns. Exhibition in Turin, 1985; Florence, 1986; Rome, 1986. Turin: Il Quadrante Edizioni, 1985.

Schätze aus dem Irak von der Frühzeit bis zum Islam. Exhibition in Cologne from June 27– September 20, 1964. Cologne, 1964.

Schätze aus dem Irak von der Frühzeit bis zum Islam/Ausstellung in der Akademier der Künste. Exhibition in Berlin from February 14 to March 28, 1965. Berlin: Der Akademie, 1965.

Sumer, Assur, Babylone: 7000 ans de culture et d'art sur le Tigre et l'Euphrate. Exhibtion at the Neue Galerie—Sammlung Ludwig, Aix-la-chapelle, June 1–August 26, 1979. Mainz/Rhein: Verlag Philipp von Zabern, 1979.

Sumer, Assur, Babylone: Chefs-d'Oeuvre du Musée de Bagdad. Exhibition at the Musée du Petit Palais de la Ville de Paris, March 24–June 14, 1981. Paris: Association Française d'Action Artistique, 1980.

Trésors du Musée de Bagdad: 7000 ans d'histoire mésopotamienne. Exhibition in Geneva, December 10, 1977–February 12, 1978. Mainz/Rhein: Verlag Philipp von Zabern, 1977.

Exploration Accounts and Autobiographies and Biographies of Archaeologists and Historians Involved in Mesopotamian Studies

Andrae, Ernst Walter, and Rainer Michael Boehmer. *Bilder Eines Ausgräbers: Die Orientbilder von Walter Andrae 1898–1919—Sketches by an Excavator.* English translation by Jane Moon. 2d ed. Berlin: Gebr. Mann Verlag, 1992.

Fales, F. M., and B. J. Hickey, eds. *Austen Henry Layard: tra l'oriente e Venezia: symposium internazionale, Venezia 26–28 ottobre 1983.* Rome: L'Erma di Bretschneider, 1987.

Larsen, Mogens Trolle. *The Conquest of Assyria: Excavations in an Antique Land: 1840–1860.* London and New York: Routledge, 1996.

Lloyd, Seton. *Foundations in the Dust: The Story of Mesopotamian Exploration.* 1947. Revised. London: Thames and Hudson Ltd., 1980.

————. *The Interval: A Life in Near Eastern Archaeology.* Oxford: The Alden Press, 1986.

Mallowan, Max. *Mallowan's Memoirs: The Autobiography of Max Mallowan.* London: Collins, 1977.

McCall, Henrietta. *The Life of Max Mallowan: Archaeology and Agatha Christie.* London: British Museum Press, 2001.

Wallach, Janet. *Desert Queen: The Extraordinary Life of Gertrude Bell: Adventurer, Adviser to Kings, Ally of Lawrence of Arabia.* New York: Bantam, Doubleday Dell Publishing Group, Inc., 1996.

Winstone, H. V. F. *Woolley of Ur: The Life of Sir Leonard Woolley.* London: Secker & Warburg, 1990.

————. *Gertrude Bell.* 1978, London: Barzan Publishing, 2004.

Loss of Cultural Property in Iraq

Art Loss in Iraq. Special Issue of IFAR Journal. International Foundation for Art Research. Vol. 6, nos. 1–2 (2003): 30–62.

Bahrani, Zainab. "Lawless in Mesopotamia," *Natural History* 113, no. 2 (March 2004): 44–49.

Baker, H. D., R. J. Matthews, and J. N. Postgate. *Lost Heritage: Antiquities Stolen from Iraq's Regional Museums.* Fascicle 2. London: British School of Archaeology in Iraq, 1993.

Culture Without Context: The Newsletter of the Near Eastern Project of the Illicit Antiquities Research Centre. Cambridge: McDonald Institute for Archaeological Research, 1997–ongoing.

Deblauwe, Francis, "The Rape of Iraq's National Museum," *Archaeology Odyssey* (July/August 2003): 16–23.

———. "Iraq Update," *Archaeology Odyssey* (September/October 2003): 19–21.

———."Going Going Going Gone: A Report on Archaeological Sites in Iraq," *Archaeology Odyssey* (November/December 2004): 41–51.

Eisenberg, Jerome M. "Mesopotamia—Masterworks and Minor Works from the Iraq Museum," *Minerva* 14, no. 4 (July/August 2003): 9–40.

———. "The National Museum of Iraq—Looting and Recovery," *Minerva* 15, no. 1 (January/February 2004): 33–35.

Gibson, McGuire, and Augusta McMahon. *Lost Heritage: Antiquities Stolen from Iraq's Regional Museums.* Fascicle 1. Chicago: American Association for Research in Baghdad, 1992.

Fujii, Hideo, and Kazumi Oguchi. *Lost Heritage: Antiquities Stolen from Iraq's Regional Museums.* Fascicle 3. Tokyo: Kokushikan University Institute for Cultural Studies of Ancient Iraq, 1996.

Lawler, Andrew. "Saving Iraq's Treasures," *Smithsonian* (June 2003): 42–55.

———. "Beyond the Looting: What's Next for Iraq's Treasurers." *National Geographic Magazine* (October 2003): 58–75.

Polk, William R. "The Baghdad Museum: A Casualty of War?" *ICON: World Monuments* (Spring 2003): 26–27.

Russell, John M. "A Personal Account of the First UNESCO Cultural Heritage Mission to Baghdad, May 16–20, 2003," American Institute of Archaeology, 2003 (archived at http://www.archaeological.org/)

———. "Iraq in the Crosshairs: 8,000 Years of History Hang in the Balance," *ICON: World Monuments* (Spring 2003): 28–29.

Web Links

http://www.baghdadmuseum.org/

http://www.thebritishmuseum.ac.uk/iraqcrisis/

http://icom.museum/redlist/irak/en/index.html

http://oi.uchicago.edu/OI/IRAQ/iraq.html

http://cctr.umkc.edu/user/fdeblauwe/iraq.html

http://www.britac.ac.uk/institutes/iraq/

About the Authors

Selma Al-Radi, Ph.D., is a native of Baghdad, and has worked in her native country on behalf of the Iraq Museum in the 1960s and throughout the Middle East for more than four decades. She is currently director of the AMIRIYA Restoration Project in Rada, Yemen and an advisor to the Yemeni government on cultural affairs.

Zainab Bahrani is the Edith Porada Professor of Ancient Near Eastern Art History and Archaeology at Columbia University. She is a specialist in the art and architecture of Mesopotamia and has written extensively on the cultural heritage of Iraq. She is the author of, among other publications, *Women of Babylon: Gender and Representation in Mesopotamia* (Routledge, 2001), and *The Graven Image: Representation in Babylonia and Assyria* (Philadelphia: University of Pennsylvania Press, 2003). Professor Bahrani was born in Baghdad, Iraq, and educated in Europe and the United States. She received her MA and Ph.D. degrees (Ph.D.1989) in Art History and Archaeology from New York University's Institute of Fine Arts. Prior to her appointment at Columbia University, Professor Bahrani taught at the University of Vienna in Austria, and The State University of New York at Stony Brook, New York and was a curator in the Metropolitan Museum of Art's Near Eastern Antiquities Department from 1989–1992. She is the recipient of numerous fellowships and awards, including awards from the American Schools of Oriental Research, the Metropolitan Museum of Art, the Getty Foundation, the Mellon Foundation, and most recently, the Guggenheim Foundation.

Robert D. Biggs recently retired as professor of Assyriology after more than forty years at the Oriental Institute, University of Chicago. He has worked many years on the *Assyrian Dictionary*, and presently serves on its editorial board. He has been editor of the *Journal of Near Eastern Studies* since 1972. One of his major publications is a large volume, titled *Inscriptions from Tell Abu Salabikh* (Chicago, 1974), in which he published several hundred cuneiform texts of the mid-third millennium B.C. He has served as an epigrapher on a number of archaeological expeditions in Iraq, principally at Nippur and Abu Salabikh, which also entailed frequent study periods in the Iraq Museum.

Marie-Hélène Carleton is a writer, photographer, documentary film-maker and co-founder of Four Corners Media. She has worked with the *New York Times*, *US News and World Report*, *the Financial Times*, Die Zeit, the Associated Press, APTN, PBS, *Archaeology* magazine, Westside Productions, and Oxygen Media. Her photographs have been published in several

books, including *Water Culture*. In 2004, she worked for several months in Iraq documenting the looting of archaeological sites through photography and video. She has a Master of Arts degree from the Johns Hopkins School of Advanced International Studies. She lives in New York City.

Harriet Crawford, Ph.D., is chairman of the British School of Archaeology in Iraq and an honorary visiting professor at the Institute of Archaeology, University College London. She has excavated throughout Syria, Iraq, and the Gulf region. A student of Max Mallowan, Crawford is the author of numerous books and scholarly works, including *Sumer and the Sumerians* (Cambridge University Press,1991; revised and updated edition, 2004), *Dilmun & Its Gulf Neighbours* (Cambridge University Press, 1998), and *The Architecture of Iraq in the Third Millennium B.C.* (Copenhagen, Akademisk Forlag, 1977).

Paul Collins, **Ph.D.** is the assistant curator in the Department of Ancient Near Eastern Art of the Metropolitan Museum of Art, New York, and was part of the team who organized the 2003 landmark exhibition and accompanying catalogue *Art of the First Cities: The Third Millennium B.C. from the Mediterranean to the Indus*. In the past he has worked in the British Museum's Department of the Ancient Near East and lectured extensively on the collections for the Education Department. He has traveled widely throughout the Near East, written both popular and academic publications, including *The Uruk Phenomenon* (Oxford: Archaeopress, 2000), and taught courses on the art and archaeology of ancient Western Asia for the universities of London and Oxford.

Micah Garen is a journalist, photographer, documentary film-maker and co-founder of Four Corners Media. His work has appeared in the *New York Times, New York Times Magazine, New York Times Digital, US News and World Report, Newsweek,* the Associated Press, APTN, PBS, Carnegie Council on Ethics and International Affairs, Westside Productions, and *Archaeology* magazine. His illustrations have appeared in two Arabic textbooks published by Yale University Press. He spent over a year traveling throughout Iraq documenting the looting of archaeological sites. He studied Near Eastern Languages and landscape architecture at Cornell University. He lives in New York City.

Usam Ghaidan, a native of Iraq, is a conservation architect. He studied architecture in London and is a member of the Royal Institute of British Architects. He has practiced and taught in the Middle East, Europe, and Africa. He was a UNESCO staff member for about twenty years, as a school-building architect, regional specialist and Focal Point for Culture in Iraq. In 1975 he wrote a book about the Islamic architecture on the East African coast, entitled *Lamu — A Study of the Swahili Town*. In 1976 he coordinated a conservation planning study for Lamu that was also published. In 1983 the Organization of Islamic Capitals and Cities awarded him its prize for writing in the field of planning.

Donny George received his doctorate in archaeology from the University of Baghdad in 1995 and has been associated with the Iraq Museum since 1976. He has served as Director of Documentation in the State Board of Antiquities and Heritage and as Assistant Director General of Antiquities. He has given lectures in the department of Archaeology at the University of Baghdad; he has conducted archaeological field work at several sites in Iraq, including the Bekhma Dam project, Tell Al-Namel, Nineveh, and Umm Al-Aqarib; and he was field director of the Babylon restoration project. He is the author of *The Architecture of the Sixth Millennium B.C. in Tell Es-Sawwan* (London, 1997) and *The Stone Industries in Tell Es-Sawwan* (London, in press). He is currently the Director of the Iraq Museum, to which this book is dedicated.

Diana Krumholz McDonald, Ph.D., is an art historian on the faculty of the Boston College Department of Fine Arts, where she teaches both ancient Mediterranean Art and Precolumbian Art. She lectures widely, particularly on animals in ancient art. McDonald received her undergraduate training in Near Eastern and Egyptian art at Harvard University and her doctorate from Columbia University, where she wrote her dissertation on serpent imagery in the ancient Near East. She has worked at the National Museum in Jakarta, Indonesia, at museums in Warsaw, Poland, and the Metropolitan Museum in New York City. She has also worked for the Arthur M. Sackler Foundation on numerous projects and exhibitions. She was also the recipient of a Henry Luce Scholarship to Asia and a Fulbright Fellowship.

Alastair E. Northedge is professor of Islamic Art and Archaeology at Université de Paris I (Panthéon-Sorbonne) and specializes in the archaeology of the period of the caliphs in Islam (seventh to eleventh centuries). His doctoral thesis was on the Umayyad Palace at Amman in Jordan (early eighth century), and he has worked on the Islamic period in Iraq since 1983, particularly on the capital of the Abbasid caliphs at Samarra (A.D. 836–892). *The Historical Topography of Samarra* (Oxford University Press/British Academy, 2004) is the first of the planned series of volumes on the archaeology of Samarra. A second volume titled *The Archaeological Atlas of Samarra* is to be published in 2005. He has also worked in Turkey, Saudi Arabia, and Kazakhstan.

Anna Paolini is an architect and urban planner specializing in developing countries. She holds a Ph.D. in architecture on the influence of the Islamic culture on the settlements of sub-Saharan and eastern Africa. She worked and carried out research in the field of conservation and urban renewal, and upgrading in the historical centers in northern Africa, the Middle East, and Africa, after having worked for quite a few years in a conservation practice in Venice. She joined UNESCO in 1992 and held a post for five years at the UNESCO Regional Office in Jordan in charge of cultural heritage in the region. Among other projects, she worked on the establishment of a management plan for the World Heritage site of Petra. She is a member of several associations and is presently chief of the

Unit for Arab Countries at the Division of Cultural Heritage at the UNESCO headquarters in Paris. She is in charge of projects in the field of movable and immovable cultural heritage, including the restoration and establishment of new archaeological and art museums, management of sites, conservation of archaeological sites and historic buildings, and development of strategies for the management and promotion of cultural heritage.

Milbry Polk is a photojournalist who has journeyed throughout the Middle East. A Fellow of the Royal Geographic Society and of the Explorers Club, Polk is the editor of *A History of Arabian Transportation*; has edited a series of biographies on women explorers (Chelsea House, 2004); authored *Egyptian Mummies* (Dutton Penguin, 1998); and co-authored the award-winning *Women of Discovery* (Clarkson Potter, 2001), which recounts the accomplishments of women explorers. Polk is a contributing editor for *The Explorers Journal* and is currently the director of Wings Trust, a non-profit organization working with women explorers and scientific exploration.

William R. Polk, Ph.D., served as a member of the Policy Planning Council in the Kennedy administration and also founded the Center for Middle Eastern Studies at the University of Chicago. A former professor of history at University of Chicago and president of the Adlai Stevenson Institute of International Affairs, Polk is the author of *The United States and the Arab World* (Harvard University Press, 1975), *The Arab World Today* (Harvard University Press, 1991), *The Elusive Peace* (Palgrave Macmillan, 1979), *Passing Brave* (Knopf, 1973), *Neighbors and Strangers: The Fundamentals of Foreign Affairs* (University of Chicago, 1997), and, most recently, *Polk's Folly* (Doubleday, 2000). His book, *Understanding Iraq*, will be published by HarperCollins in 2005.

Barbara A. Porter, Ph.D., a specialist in the art and archaeology of the ancient Near East as well as ancient Egypt, has excavated in Syria, Jordan, Austria, England, and Italy. Porter grew up in Lebanon in the 1960s where her interest in the region was first kindled. In the 1980s she was an assistant curator in the Department of Ancient Near Eastern Art at the Metropolitan Museum of Art in New York City. She received her Ph.D. from Columbia University, and her dissertation dealt with cylinder seals. She lectures in the New York area as well as on trips conducted in the Middle East ranging from Tunisia to Iran.

Julian Reade, Ph.D., received his doctorate from the University of Cambridge. He worked at Nimrud and Tell al Rimah in Iraq, and directed his own excavations at Tell Taya in Iraq and Ra's al Hadd in Oman. He was formerly assistant keeper in the Ancient Near East Department of the British Museum and is now honorary professor at the University of Copenhagen. He has written extensively on the history and culture of Iraq and neighboring countries, and is the author of *Assyrian Sculpture* (British Museum, 1983, and Harvard University Press, 1991), *Mesopotamia* (British Museum, 1991, and Harvard University Press, 1991), and editor of *The Indian Ocean in Antiquity* (Kegan Paul International, 1996).

Angela M. H. Schuster, editor of the preservation quarterly *ICON* and *The Explorers Journal*, is also a contributing editor of *Archaeology* magazine and is a frequent contributor to the *New York Times* and the Italian daily, *Corriere della Sera*.

Ralph S. Solecki is professor emeritus at Columbia University in New York City and an adjunct professor in the Department of Anthropology at Texas A & M University in College Station. His first professional position was with the Smithsonian Institution under whose auspices he worked extensively in the Near East. After joining the faculty at Columbia University, he continued archaeological field work in the Near East.

Fiorella Ippolitoni Strika has been a researcher at the Department of Oriental Studies at the University of Rome "La Sapienza." Her doctoral thesis on Assyriology, titled *The Abstraction and Naturalism of the Prehistoric Mesopotamian Ceramics from Hassuna, Samarra, and Halaf*, and her specialization thesis in Near Eastern Archaeology, on the ceramics of the prehistoric site of Tell es Sawwan, were presented at the University of Rome. In the 1970s she worked in Iraq as an antiquities expert for the Italian Foreign Ministry, and in subsequent years she continued her research in Iraq and other Near Eastern countries on behalf of different institutions. She has also participated in several archaeological excavations in Iraq. For the last 30 years she has studied, catalogued, and restored the Tell es Sawwan ceramics and figurines. She has lectured extensively on such themes as the prehistoric art of the Near East; the relationship between Mesopotamia, the Gulf, and the Indus Valley civilization; and the Great Goddess of the Ancient Near East. She has published many scholarly articles on Tell es Sawwan, the Great Goddess, the symbols found on pottery, as well as gender studies and other related subjects in many Italian and international encyclopedias, journals, and publications.

Vincenzo Strika has been a professor of Islamic Art at the Venice University (Ca' Foscari), and since 1979 has held the chair of Contemporary Arab History at the Oriental Institute in Naples. He worked as Director of the Istituto per l'Oriente in Rome, and was a consultant for the Diplomatic Institute of the Ministry of Foreign Affairs. From 1971 to 1978 he worked in Baghdad on the survey of Islamic monuments and in 2003 was included in the Italian team working on the archaeological heritage in Iraq. Vincenzo Strika is the author of many articles, and several books on Islamic Art and Arab modern and medieval history and literature.

Elisabetta Valtz Fino is an associate curator at both the Ancient Near Eastern Art Department at the Metropolitan Museum of Art in New York City and the Egyptian Museum in Turin, Italy. She worked as an archaeologist for twenty years in Iraq, in yearly excavation campaigns conducted from 1969 to 1989 by the Italian Archaeological Mission: as field director in Diyala Valley within the Hamrin rescue project (1977–1980), she

carried out excavations in various sites spanning from the third millennium B.C. to the late Sasanian age; on the Haditha rescue project (1981–1983), she was engaged in the excavation of a major Roman settlement on the Euphrates, in the eastern frontier of the Roman Empire; from 1984 to 1989 she was director of the Italian Archaeological Mission to Seleucia on the Tigris, writing many scholarly articles on her excavations' results. She was co-curator in the landmark exhibit "The Land between the Two Rivers" which brought to Italy the masterpieces of the Iraq Museum, and worked also on many exhibitions and catalog projects both in Italy and at the Metropolitan Museum of Art.

Lamia Al-Gailani Werr, formerly of the Iraq Museum and founder of its Children's Education Department, is the author of *Studies in the Chronology and Regional Style of Old Babylonian Cylinder Seals* (Undena Publications, 1988) and editor of the recent volume *Of Pots and Plans, Papers on the Archaeology and History of Mesopotamia and Syria Presented to David Oates in Honor of His 75th Birthday* (NABU Booksellers, 2002). She is currently working to help rebuild the Iraq Museum.

ART ACKNOWLEDGMENTS

JACKET COVER
Cover photo © Patrick Baz/AFP/Getty Images

COPYRIGHT PAGE
Museum entrance © Zainab Bahrani

TABLE OF CONTENTS
Relief from Assyrian palace © La Scala/Art Resource

FOREWORD
Page xiv © Corbis/Reuters
Page 1 © Patrick Robert/Corbis
Pages 2, 3 © Lamia Al-Gailani Werr

INTRODUCTION
Page 6 © Institut du Monde Arabe, Paris
Page 7 © La Scala/Art Resource
Page 8 © BaghdadMuseum.org
Page 9 © Fiorella Ippolitoni Strika

THEFT OF TIME
Page 10 © Zainab Bahrani
All other photos © Marie-Hélène Carleton

ERASING THE PAST: LOOTING OF ARCHAEOLOGICAL SITES IN SOUTHERN IRAQ
All photos © Micah Garen and Marie-Hélène Carleton

A SHORT HISTORY OF THE IRAQ NATIONAL MUSEUM
Pages 21, 25 © UNESCO
Pages 22, 23, 24 © Noreen Feeney, BaghdadMuseum.org

CHAPTER I: A MUSEUM IS BORN
Pages 26, 27, 28, 29, 31 © Newcastle University, The Gertrude Bell Archive
Pages 30, 33, © Iraq Museum
Page 32 © Lamia Al-Gailani Werr

CHAPTER II: IN THE BEGINNING
Pages 34, 37, 38, 39, 40, 44, 45, 46, 47, 49 © Ralph Solecki
Pages 35, 41, 42, 43, © Erik Trinkaus

CHAPTER III: THE DAWN OF CIVILIZATION
Figures 1, 10 © Joan Oates
Figures 2, 11, 12, 13, 16 © Iraq Museum
Figure 3 © Zozlowski
Figure 4 © Schneider-Lengyel
Figures 5, 6, 7a, 7b, 9 © Georgina Herrmann
Figure 8 © Fiorella Ippolitoni Strika
Figure 14 © Journal of Near Eastern Studies
Figure 15 © British School of Archaeology
Figure 17 © Alwo von Wickede

CHAPTER IV: SMALL TREASURES OF THE IRAQ MUSEUM
All figures pages 66–77 © Fiorella Ippolitoni Strika
Page 79 © A. Invernizzi
Page 81 © La Scala/Art Resource

CHAPTER V: FROM VILLAGE TO EMPIRE: THE RISE OF SUMER AND AKKAD
Figures 1, 12, 16 © Centro Ricerche Archeologiche e Scavi di Torino per il Medio Oriente e Asia
Figures 2, 3, 8, 10, 11, 14, 15, 17, 18, 19, 20, 21, 23, 24 © La Scala/Art Resource
Figures 4, 5, 7, 9, 13, 22 © A. Invernizzi
Figure 6 © Iraq Museum
Figure 25 © Michael S. Yamashita /Corbis
Pages 101, 103 © La Scala/Art Resource

CHAPTER VI: THE BIRTH OF WRITING, THE DAWN OF LITERATURE
Figures 1, 3, 5, 6, 7, 8, 9, 10, 12, 13, 15, 16, 17, 18, 21, 22, 23, 26, 27 © The Oriental Institute, University of Chicago
Figures 2, 24 © The British Museum
Figure 4 © "The World's Writing Systems," edited by Peter T. Daniels and William Bright
Figures 11, 14, 19a © R. Biggs
Figure 19b © Al-Hiba Expedition
Figure 20 © Reunion des Musées Nationaux, Louvre
Figure 25 © Muayad Said Damerji
Figure 28 © Gernot Wilhelm
Figure 29 © Ashmolean Museum
Page 123 © Lynn Abercrombie

CHAPTER VII: BABYLONIANS AND ASSYRIANS
Figures 1, 2, 4, 5, 6, 7, 8, 9, 10, 12, 13, 14, 16, 17, 20, 21, 22, 23 © La Scala/Art Resource
Figures 3, 11, 15 © Lynn Abercrombie
Figures 18, 19 © Directorate of Antiquities and Heritage, Baghdad
Page 143 © Book Laboratory
Page 145 © La Scala/Art Resource

CHAPTER VIII: IN THE WAKE OF ALEXANDER THE GREAT
Figures 1, 10, 18a, 18b, 21 © La Scala/Art Resource
Figures 2, 3 © Iraq Museum
Figure 4 © The Kelsey Museum
Figures 5, 6, 7, 9, 11, 16, 22 © Il Quadrante
Figures 8, 17 © Henri Stierlin, Le Seuil
Figure 12 © Elisabetta Valtz Fino
Figure 13 © Georg Gerster
Figures 14, 15 © Peter Langer, Associated Media Group

Figures 19, 20 © Lynn Abercrombie
Figure 23 © The Metropolitan Museum
of Art
Figure 24 © The Berlin Museum
Page 173 © The American Numismatic
Society

CHAPTER IX: THE COMING OF ISLAM
Figures 1, 2, 3a, 4, 5, 6, 7, 8, 9, 10, 11, 12,
14, 15 © Alistair E. Northedge
Figures 3b, 16, 19 © Peter Langer,
Associated Media Group

Figure 13 © Los Angeles County Museum
Figure 17 © Eric Delpont, Institut du
Monde Arabe
Figure 18 © La Scala/Art Resource

CHAPTER X: BAGHDAD THROUGH THE AGES
Figure 1 © Michael S. Yamashita /Corbis
Figures 2, 5 © La Scala/Art Resource
Figure 3 and page 205 © Peter Langer,
Associated Media Group
Figures 4, 6 © Vincenzo Strika

CHAPTER XI: THE RAVAGES OF WAR AND
THE CHALLENGE OF RECONSTRUCTION
Pages 206, 208, 209 (top) © Zainab
Bahrani
Page 207 © Selma Al-Radi
Page 209 (bottom), 213 © Noreen Feeney
Page 210 © Italian Carabinieri TPC

THE FALL OF BABYLON
Page 215 (top) © Peter Langer,
Associated Media Group
All other photos © Zainab Bahrani

DONATION DETAILS

A portion of the royalties earned through the sale of each book are earmarked for Iraq's State Board of Antiquities and Heritage (SBAH), charged with the enormous task of caring for thousands of sites and museums in the wake of war. In addition, the World Monuments Fund and the Getty Conservation Institute have partnered with SBAH in the establishment of an Iraq initiative, the purpose of which is to provide emergency assistance for imperiled sites throughout the country and to enhance the Board's ability to manage Iraq's extraordinary cultural heritage.

If you would like to find out more or contribute a greater donation, please write to:
World Monuments Fund
95 Madison Avenue
New York, NY 10016

UNESCO has also set up a fund for Iraq's State Board of Antiquities and Heritage. If you would like to contribute to this fund, follow the instructions below:

For USD transfer:
THE CHASE MANHATTAN BANK
International Money Transfer Division
4 Metrotech Center Brooklyn
NEW YORK NY 11245 USA
A/C N 949-1-191558
SWIFT: CHASUS33; ABA N 021000021

For EURO transfer:
SOCIETE GENERALE
Agence Paris St. Dominique
106 rue St. Dominique
75007 Paris France
A/C N 30003-03301-00037291909-97
SWIFT: SOGEFRPPAFS

Both transfers should be done mentioning "Special account for the Iraqi Cultural Heritage, budgetary code 449IRQ4000."

ACKNOWLEDGMENTS

Throughout this process, which involved coordinating people all over the world, many hard if not at times impossible to reach, Manuela Dunn was the touchstone not only for the book but also for unfolding events in Iraq. She really is responsible for the creation of this book.

This book is the result of a great collaborative effort between authors, editors, the staff of Harry N. Abrams, and a cast of individuals without whom this book would not have happened. In particular, grateful acknowledgment goes to everyone at Book Laboratory:

Philip Dunn for his publishing vision and enduring belief in the worth of projects, however difficult they may seem. Priya Hemenway for the heart and soul she pours into each project, and for picking up and bringing the book to the final stage, when Manuela took leave to give birth to her daughter Isabel Roosevelt; without you we would never have gone to press! Kimberley Roosenburg for assisting us all in the great and small tasks that are the backbone of book creation. And last but not least, Elizabeth Polk-Baumann, who took two months off her summer vacation before going off to Wellesley College, to bring order and make sense of the hundreds of images we had to track down.

A huge and very special thank you goes to Victoria Pohlmann, whose wonderful flair for great design, precision, and skill made this book the wonderful project we are all so proud of. You go well beyond what we ask of you and are always amazing.

A great thank you also goes to John McKenna for creating all the maps in the book.

The positive support and guidance of everyone at Harry N. Abrams helped us all and made the publishing process a joy. In particular thanks go to Christopher Sweet, our wonderful editor who believed in the project from the beginning; Michael Jacobs, President and CEO for his unwavering support; Michael Walsh, for his masterful design guidance; Carol Morgan, chief publicity director; Dan Johnson, for his help at every stage of production.

Special thanks to William Polk who introduced us to Raja Sidawi and Monique Duroc-Danner whose generous grant enabled us to acquire the most beautiful images possible of Iraq. And to Wings Trust and its Board through whose auspices this grant was made. To David Howe who made it possible.

We are very grateful to Abdul Aziz Said, Director of International Peace and Conflict Resolution School of International Service, American University and to Jacqueline Lee for supplying us with the Idrissi map image.

We also want to thank the following wonderful participants: Barbara A. Porter who was on the team from the beginning helping to identify contributors and her sister Joan Porter MacIver, Secretary of the British School of Archaeology in Iraq who helped us enormously with contacts and support; Leila Hadley Luce for continued support and interest; and our fantastic families, who temporarily put up with absentee mates—especially Carl G. Schuster without whose love and support Angela's work would not be possible.

INDEX

Page references followed by *fig* indicate an illustrated figure or photograph; references followed by *m* indicate a map.

W

Warka Head, 105, 210

Warka (or Uruk) Vase, 3*fig*, 80–81*fig*, 88*fig*, 105, 209*fig*, 210

Waterman, Leroy, 148, 154

Werr, Lamia Al-Gailani, 27, 208, 217

wooden Minbar (pulpit) [Al-Amadiyah Mosque], 23*fig*

World Monuments Fund, 218

writing development

 cuneiform tablets as part of, 108–116, 132

 early examples of pictographic, 107–108

Z

Ziggurat of Ur, 14*fig*, 99*fig*

Zorastrian religion, 170, 171

Zumurrud Kahatum tomb (Sitta Zubayda), 197, 198, 199, 200, 201